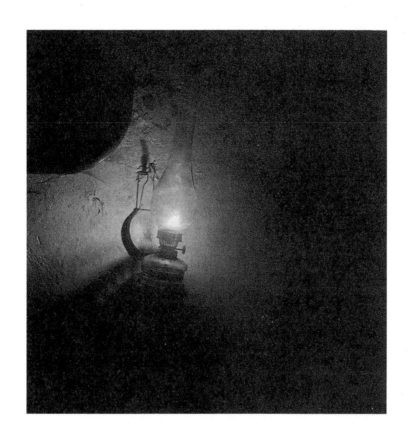

A VANISHED WORLD

ROMAN VISHNIAC

With a foreword by Elie Wiesel
The Noonday Press
Farrar, Straus & Giroux
New York

I dedicate these pages with love to my Grandfather Wolf; my son, Wolf; and his son Obie. Wolf, my only son, fell to his death from a glacier in Antarctica while leading a scientific expedition seeking insights into the origins of life. To this tragedy is added the death at age ten of Wolf and Helen's oldest son, Obie, who was already a philosopher. I often think of the further contributions to knowledge and humanity my son and grandson might have made had they lived their full life-spans.

Through my personal grief, I see in my mind's eye the faces of six million of my people, innocents who were brutally murdered by order of a warped human being. The entire world, even the Jews living in the safety of other nations, including the United States, stood by and did nothing to stop the slaughter. The memory of those swept away must serve to protect future generations from genocide. It is a vanished but not vanquished world, captured here in images made with hidden cameras, that I dedicate to my grandfather, my son, and my grandson.

R.V.

The Noonday Press
A division of Farrar, Straus and Giroux
19 Union Square West, New York 10003

FOREWORD

One picture is worth a thousand words—or is it? In most cases, I would say: no, a poet's word is worth at least a thousand pictures. But then I would have to admit that Roman Vishniac is a special case.

This astonishing man's eyes seem to pierce our memory, to sift its shadows. We are afraid to follow him, but we do, even so. Who can resist the lure of the past?

Dear Roman Vishniac, where did we first meet? Somewhere in the Carpathians, a timid Jewish boy waved you away, for it was dangerous for an outsider to venture along the brink of the abyss: was that me? was that you? A dreamy Hasid paces heavily down the noisy street, his shoulders stooped under an invisible burden. Gentle and vulnerable though he is, the melamed terrorizes his students into giving their hearts to the adventures of Abraham and Isaac and Jacob: as if he were telling two stories at once, one to the children, the other to the photographer... And these vendors, these poor peddlers who buy and sell anything to keep body and soul together one more day, one more sigh... And these beautiful girls, so thirsty for love and life, perhaps for virtue too: do they suspect they are already singled out by an implacable enemy determined to annihilate them?

I am walking—we are walking—behind Roman Vishniac, and we are caught by a thousand glances which enliven the alleys of the little Jewish villages. Our eyes, too, see two things at once: living beings yesterday, a void today.

A supreme witness, Vishniac evokes with sorrow and with love this picturesque and fascinating Jewish world he has seen engulfed by fire and darkness.

It is his love for the dead which touches us so deeply. He loves them all: the rabbis and their pupils, the peddlers and their customers, the beggars and the cantors, the sad old men and the smiling young ones. He loves them because the world they live in did not, and because death has already marked them for its own—death and oblivion as well.

Not to forget, not to allow oblivion to defeat memory: that is his obsession. Defying all dangers, surmounting all obstacles, he travels from province to province, from village to village, capturing slums and markets, a gesture here, a movement there, reflections of hope and despair, so that the victims will not wholly vanish into the abyss—so that they will live on, past torture and past massacre. And he has won the wager: they live still, these victims of the villages, more alive than we who "read" without understanding them. And yet—such is the miraculous range of his gift—Roman Vishniac can make them speak. Sometimes I think I prefer the storyteller in him to the photographer. But aren't they one and the same? It is always the man who is revealed in his work.

A generous man, a warmhearted man whose mission has made him bold. Each of his pictures conceals a risk. Someday he will tell us how he fooled the Gestapo. And the informers. And death. Someday he will tell us—I mean in detail, in a whole, separate book—about Berlin and Mukachevo, Moscow and Warsaw. The deceptions, the disguises, the tricks he had to play to get into this place, to approach that student, to catch the dim light of a certain school. Someday he will tell us about the looted sanctuaries, the wreckage of prayer, the desolation he had foreseen, had seen before taking it with him, in his camera, to entrust to us for safekeeping.

Poet of memory, elegist of ruined hopes, Roman Vishniac stands first and foremost under the sign of fidelity.

Elie Wiesel

Translated from the French by Richard Howard

PREFACE

From earliest childhood, my main interest was my ancestors. My Grandfather Wolf and my parents told me about the activities of my forefathers following the establishment of the Pale of Settlement by the pseudo-liberal tsarina, Catherine II. They told me of the restrictions against Jews, and how Nicholas I forced the conscription of Jewish boys with the intention of converting them to Christianity. My great-grandparents "bought" these child-soldiers from the Russian officers for the weekends and taught them how to remain Jews. By doing so, my great-grandparents were risking persecution and exile to Siberia, but they persisted.

My own activities began when I was eighteen, early in the First World War. The Jews of the Pale who resided in the battle zone were declared German spies and were forcibly transported to the Russian interior in cattle cars, without food or water, and without any provision for housing once they arrived. Together with a few other Jewish students—I was in medical school at the time—I collected money in Jewish communities and tried to save these unjustly accused Jews. Hundreds of thousands were affected, and thousands died. This was but a prelude to what was to come two decades later.

I was living in Germany in the thirties, and I knew that Hitler had made it his mission to exterminate all Jews, especially the children and the women who could bear children in the future. I was unable to save my people, only their memory.

None of my colleagues was ready to join me. Rather, they warned me of the danger and called my project impossible. A man with a camera was always suspected of being a spy. Moreover, the Jews did not want to be photographed, due to a misunderstanding of the prohibition against making graven images (photography had not been invented when the Torah was written!). I was forced to use a hidden camera, and there were other problems as well. The technical aspects of photography were in their infancy. The sophisticated cameras of today were, of course, not available then. My means were meager, but my will was unbreakable. I was thrown into prison, but still I persisted.

During my journeys, I took over sixteen thousand photographs. All but two thousand were confiscated and, presumably, destroyed —although perhaps they will reappear someday, just as this book has appeared. It contains less than ten percent of the photographs in my possession, but I hope it enables the reader to envision a time and place that are worthy of remembrance.

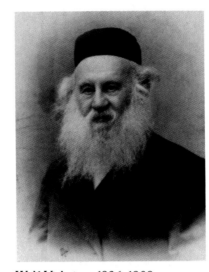

Wolf Vishniac, 1836-1908

This book, published sixty years after Hitler vowed to extinguish all memory of the Jews and their shtetl, would have been impossible without the assistance and support of many people.

I am so proud that Elie Wiesel has contributed a soul-stirring foreword. I know he was aided in this task by his wife, Marion.

During the years when the photographs were taken, I had the sympathy of that heroic Rabbi of Berlin, Joachim Prinz, and of his wife, Hilde. They spoke out against Hitler and raised the spirits of the condemned Jews.

My father remained in hiding in Clermont-Ferrand, France, during the entire war, in order to save my precious negatives. Wolf, my son, was at my side and helped me constantly, as did his wife, Helen. My daughter, Mara, appears in some of the photographs taken in Nazi Germany.

In the United States, I found a friend in Cornell Capa, the organizer of the International Center for Photography. Mrs. Ellen Liman helped me in hard times. Dan and Frances Berley and the late Lee Witkin made possible many of my exhibits and portfolios. Mike Steinfeld, a warm friend, assisted me with the writing of a book about life in Poland, Czechoslovakia, Rumania, Hungary, and Latvia in the thirties, which will appear in the future. Roger Straus has expended unusual effort on behalf of *A Vanished World*, well beyond the usual publishing interests. He has shown concern for the eternal. Michael di Capua and Janet Halverson have dedicated great efforts to choosing and arranging the photographs so that the book will have the fullest meaning.

My friend and adviser, the lawyer Jerome Lurie, unselfishly helped me to overcome the consequences of my error in credulity. The late Paul Henkind, my closest friend, did an excellent job of editing my commentary and captions for the photographs. The cooperation of his wife, Jaye, and especially of my little friend Aaron was of great help.

I feel a special gratitude to the master printer Igor Bakht, who produced miracles with negatives that had been crudely developed by my prison guards. Martin Axon was most helpful in making improvements in technology. Many images of historic importance would never have been captured if not for the revelations provided by Henryk Schwartz.

At the end, as in the beginning, I have the unbounded love and constant assistance of my wife, Edith. We are one.

R.V.

COMMENTARY ON THE PHOTOGRAPHS

Why did I do it? A hidden camera to record the way of life of a people who had no desire to be captured on film may seem strange to you. Was it insane to cross into and out of countries where my life was in danger every day? Whatever the question, my answer is the same: It had to be done. I felt that the world was about to be cast into the mad shadow of Nazism and that the outcome would be the annihilation of a people who had no spokesman to record their plight. Mind you, their utter faith in God might have precluded their looking for any human savior. I knew it was my task to make certain that this vanished world did not totally disappear.

If I am to breathe life into the pictures that follow, it is by providing you, the reader, with my thoughts about them. The pictures depict people and places that no longer exist, yet in my memory they do exist.

The kerosene lamp on the first page is today a torch burning in memory of the six million martyrs.

1: This is the face of a sage. He was the rosh, or head, of the renowned yeshiva at 4 Twarda Street in Warsaw during the 1930s. He embodied the learning of generations and spent his life passing on traditions and knowledge.

2: In the shtetl, people lived in poverty but were rich in the wisdom of Jewishness. These books, as crowded together as the people, were like living beings. I can almost hear, still, the krechtzen (groans) and moans of suffering and feel the hopes and expectations of the worshippers reading the pages. Like the undernourished children of the shtetl, the books were frail. So tragic, that the books and the people shared a common fate. Three years after this picture was taken, this community and its books were destroyed by the Nazis.

3: It was 1938, but warmth and light were provided in the dwellings of the village of Upper Apša by burning branches and logs. I remember so well the firelight illuminating the hands and face of this village elder, whose advice was sought by members of his community. How wise and comforting a man he seemed to be.

4: This singer at the home of the Hasidic rebbe of Mukachevo wore a richly ornamented prayer shawl, a tallis. He was not paid to sing, he sang to God. To the Hasidim, singing was like praying, and they sought to achieve a state of ecstasy in which to express their love of God.

5: A portion of a Hasidic choir singing their prayers. The Hasidic movement was founded in

the eighteenth century by Israel Baal Shem Tov, and it flourishes today.

6, 7, and 8: Boys were admitted to cheder from about the age of four. In their dimly lit schoolroom, these youngsters read and wrote Hebrew. They became knowledgeable about the Five Books of Moses—the first five books of the Old Testament—and they studied the commentaries on the Talmud, particularly the commentaries of Rashi, a famed scholar of the eleventh century. The Talmud is the compendium of Jewish law and lore which forms the basis of religious life. In the cheder, seeds of learning were planted, and "tradition" was continually renewed and reviewed. Perhaps I should call these pictures "The Faces of Learning."

9: Even after the cheder day was over, the students continued their scholarly deliberations. There was so much to learn, so much to discuss.

10 and 11: The type of hat a scholar wore was typical of his town. In Warsaw they wore caps; similar ones were worn in Lodz. Soft, brimmed hats were characteristic of the towns of Czechoslovakia, Rumania, and Hungary.

12: His books are his companions, an integral part of his life. For the rabbi, there is no end to learning from the books.

14: How ironic! Hitler, "the Corporal," aligned with Hindenburg, "the Marshal." "Peace" is the catchword.

15: The height of lunacy. In the window of a store formerly owned by a Jew, an instrument to measure the size of human heads is displayed. Aryans were supposed to have long, thin skulls, and here they could obtain a certificate proving their Aryanship.

16: Aliyah, the movement to transform Palestine into the independent State of Israel. The members, drawn from many walks of life, were preparing to return to the Promised Land, where they would till the soil and make the desert bloom. In a Germany mobilizing for war, these were people of peace.

17: The map on the wall is the Promised Land. Only a few members of Aliyah ever reached Palestine. Most were turned to ashes in Hitler's ovens.

18: On this Sabbath day in 1937, there was still peace. This was the Jewish neighborhood that in 1941 was walled off from the rest of Warsaw. In this ghetto the Jews put up their heroic resistance to the Nazis. Haggard people, without food and with few weapons, fought against an army

equipped with tanks. The ghetto succumbed, but not without delivering a message.

20: An economic boycott of Poland's three and a half million Jews occurred in the late 1930s. Fostered by the government and the Church, oppression and persecution took their ugliest forms. This disaster was ruining the lives, minds, and health of a large portion of the Jewish inhabitants.

After I took this picture of the obviously worried couple, I followed them, introduced myself in Yiddish, and inquired about their problem. The husband told me that he had just been fired from his job as manager of his firm. The owner had been well satisfied with him for twenty years, but that morning three men came to the office to check whether any Jews were employed there. He was immediately dismissed, with no compensation, no hope of another job. The good life was over in an instant.

(Why was I there, at that moment?)

22: For one hundred years, the Nalewki had been the shopping district for the Jews of Warsaw, a place to meet friends and hold business discussions. Starting in 1937, the discussions I heard concerned the danger threatening all Jews unable to leave Europe. Many of these people applied for a visa to the United States, but the waiting time was measured in years, and they didn't have years. This became their death trap.

23: If a peddler was caught on a forbidden, non-Jewish street, his wares were confiscated. This one told me the police liked his bagels.

27 and 28: After the boycott, transporting freight by handcart or on their backs was the only occupation permitted the Jews of Warsaw. For a month, I joined a group of ten porters and pulled my loads. In this way I came to understand the unquenchable spirit and endurance of my people. Even though their task was menial and their life hard, they never forgot their traditions and their heritage.

29: The porter Nat Gutman and his family invited me to partake of their meal. This was an "empty" day, when no money was made. The bread was stale, and there were only the remains of some dry, salty herring.

30: Nat Gutman's wife—I don't remember her first name—was only twenty-six years old when I took this picture.

31: It was common to treat a child's toothache by tying a bandage around his face. Few parents had money for dentists. What money was available was better spent on milk.

32: On the main street of Leopoldstadt. Mrs. Salzer sold shoes because her husband had been killed in the First World War and inflation made her small pension even smaller. She had to sell at least eighteen pairs of shoes every day to keep her household going. This was difficult, but Mrs. Salzer was a brave woman.

33: The porters had to use all their strength. Their carts lacked tires, their shoes lacked soles. This man, the oldest member of the artel, had four more deliveries to make that day. I followed him and got this picture. Later, he fell asleep on the cobblestones.

34: His wife died of a heart attack in the pogrom, but his little son survived and was now a grown man, a porter of heavy loads. Every day, before searching for work, he brought his father out to the street and gave him bread and water for the day. In the evening he took his father home.

35: In the foreground is the garbage bin for this apartment house, and at the left a stand for beating carpets. Water was carried in pails from a square two blocks away.

37: These children of the shtetl had only worn and torn clothing to cover their undernourished bodies. They were feeling the effects of the boycott.

38: After working as a bank cashier for six years, Nat Gutman was dismissed. Mind you, it was not for embezzlement, but something much worse: he was a Jew. After two months of searching for employment, he became a porter.

If a truck driver demanded a certain fee to deliver a load of freight, a team of Jewish porters would agree to make the delivery for less. The loads usually weighed forty-five to ninety pounds each and might have to be transported a distance of several miles. This was the kind of work that bank cashier Gutman, a man with a bad hernia, was reduced to in order to support his wife and son. I learned, upon my return to Poland after the war, that the family had been exterminated. What a shock—these kind, honest people who had befriended me.

39: Twenty-six families lived in this basement, which was partitioned with wooden boards. When I told my basement friends that I lacked accommodation for the night, I was invited to join three men sleeping together in one bed. I could barely breathe, little children cried; I learned about the heroic endurance of my brethren.

40: The children were begging for something to eat. If the father found work with his artel, they might eat. The mother was a typist. She had to wait in the employment office until all the non-Jewish girls got jobs. Then she might get some work. Children do not understand about work, they simply ask for food.

41: In this cellar cubicle, a workman was hammering on metal while his young son watched. The man's face was troubled, and as we talked I found out why. His brother died the year before, and his sister-in-law and her children came to stay with them. Another in-law had already been living with them for six years. The bed on the right slept five; the one on the left, four. Behind me was the kitchen stove. The previous week this man worked in a factory: that ended when three examiners of the anti-Semitic National Democratic Party discovered that he was a Jew. The boss had to fire him, but he tried to give him some work to do—at home, of course—at lesser pay. Now the union workers had found out and threatened to kill him if he worked for less than the union rate. What should he do? What would I do?

42: Many people have told me that they are especially moved by this image. Sara was ten, and the darling of her family. When I returned to the site of her home after the war, the home was no more, and there was no Sara.

45: The wage earners of these two families had lost their jobs. At night, a sheet attached to the ceiling was lowered to provide a semblance of privacy.

47: The beloved grandfather filled his days looking out at the street. He had no shoes. Only wage earners had shoes.

49: Gesia Ulica was a busy street, a thoroughfare paved with cobblestones. Housewives were wrapped against the cold, their shabby clothing covering their ill-fed bodies. The good saleslady was ready to give her apples to every child. But if no one paid, what would her own children eat? I saw all this in 1937. After the war, the city was only a desert of rubble—streets, houses, people swallowed up by a monster.

51: The old coat is thoroughly examined. It must serve a long time.

52: Not everybody needs a chair to sit on. Some of the family can sit on boxes. Perhaps the price of the chair will be enough for a meal.

54: After the boycott, the Jewish community pooled its assets to purchase machinery left idle by discharged workers. In the town of Grodzisk, necessities were produced at the lowest possible price. Still, this could not substitute for the money needed to pay the rent, buy groceries, pay off the police.

55: The Jewish Health Society consisted of doctors, dentists, nurses, social workers, and specialists dealing with handicapped and retarded children. They helped to reduce infant mortality by half, and brought a ray of hope to the children of poverty.

The children are placing their shoes in a circle before taking their afternoon nap. After the war, I saw huge heaps of such shoes, taken from the child martyrs of the Holocaust and intended for the use of Aryan children.

58: The homeless man eyed me suspiciously. As always, my camera was hidden. After taking the picture, I walked up to him and heard his story. He had lost his job, his room. He had no means, no hope, no aim. I wanted to say something comforting, give him some consolation. I could find no words, I was ashamed. Are we not all one family, and isn't our main aim to help?

59: In the summer of 1939, the repairs on the old synagogue were completed and it was reopened. In September, Nazi gangs occupied Warsaw, broke into the synagogue, destroyed the Holy Ark, and tore up the sacred scrolls. By 1942, there were no more synagogues in Warsaw.

60: These Jewish street vendors were "privileged" peddlers who enjoyed the "compassion" of the local police. The sympathy of the policemen was insured by a payment of one zloty per week. Their protection was limited, however: sometimes patrolmen on horses would make a lightning raid from around the corner. The peddler would lose all his wares and then his family might starve, for the merchandise was bought with a one-week loan from the gemiles chesed, the peddlers' non-profit, self-help organization. If the loan was not repaid on Friday, no more money was lent.

64: The mother, a widow, brought her only treasure, her brilliant son, to the famous yeshiva on Twarda Street in Warsaw. The boy's entrance examination revealed him to be a gifted pupil, and he was accepted without tuition. In addition, he was to receive a free dinner each Sabbath. Furthermore, a balebos (the head of a household) invited the young student home for another meal on Tuesdays. But two meals a week were insufficient even for his tiny stomach, and when he studied he thought about food.

The boy met a friendly-looking man of learning, and saw the chance of a lifetime. If he could get a meal on Thursdays, he could become a great scholar, a Talmudist. I listened to the boy's voice tremble, and took a picture of the man's face, for it looked so promising. I rewound my camera, hoping to capture the boy's happy face. We were both getting nervous, the decisive moment had come. Yes, the man gave the boy Thursday as his "ess tog," eating day. The boy fainted from excitement. He got his wish, but I lost the opportunity to record that moment.

65: What does the granddaughter tell her grandfather? According to the rules, a Jewish girl cannot get regular employment. She must arrive at the employment office before 8 a.m. and wait. The non-Jewish girls are sent to work as soon as a phone call is received. If after 2 p.m. a call comes in and no non-Jewish girl is available, the Jewish girl might get a job. Today was an "empty" day. At home, her parents are in poor spirits. Her father has a severe hernia from carrying heavy loads, and her mother has a weak heart. The grandfather listens, always silent—what can he say? After the war, I heard about this family from a survivor. The grandfather died when he was seized by the Nazis, the granddaughter was shipped to a camp where she was raped and later gassed. An ordinary story. But this picture and its story will remain when I am gone.

66: Here on a street in Warsaw that is off limits to Jewish peddlers a family is selling fresh bagels. On Jewish streets nobody had money to buy anything but ordinary bread. Almost immediately after I took this picture, policemen who had been hiding behind a house gate rushed out, grabbed some of the bagels, and kicked over the basket. The peddlers shouted. I ran, with my concealed camera. The bagels lay in the gutter.

67: I had to visit Slonim, birthplace of my father. It was pouring when my much delayed train pulled into the station. At the far end of a large square was a lonely figure; it proved to be a coach driver. He took me to a small inn, and when I asked him how much, he responded that I should pay him on my departure. I remained longer than I thought I would and took many pictures. Several days later I was ready to depart and the coachman brought me back to the station. I asked him what his fee was for the two trips. He cried bitterly, "For the trips, only for the trips, is that all?" I was astonished—what else had he done for me? He wrung his hands and wailed, "Who will pay for the freezing nights I waited? For the nights when nobody came, and for my suffering? My wife was sick and my child died, I had to borrow money for the tiny coffin." I tried to say something. Was I responsible for his misfortunes? Fate demanded a response. I embraced the coachman, turned my pockets out, and gave him all the money I had. He cried and blessed me. I had to run to catch the moving train.

68: Walking through the open-air market, I came across a dealer who sold parts for baby carriages. I decided to take a picture of a customer buying something, anything. Hours went by, the anxious dealer did not get a customer, and I did not get a picture of a sale.

69 and 70: Isn't it odd? In the past, carts were pulled by horses. But in pre-war Poland, Jews had to take over the job. They were more economical and more dependable. Horses had to be fed before they would work; Jews had to agree to carry the goods first and eat later.

72: This porter showed me how to build a wooden carrying frame like the one he is sleeping on. It was heavy even while empty; filled, it was quite a burden to carry on one's back.

In the background, my friend Lipshitz is discussing the conditions of a new assignment with two members of the artel. He is the man who bargained for a whole year with the municipal authorities and hammered out the only "profession" permitted to Jews. (You know, in a sense, it is this ability to adjust to life's adversities, to work at hard tasks when the situation demands it, that explains the vitality and strength of Israel.)

75: By the light of a candle, mekubalim (cabala scholars) studied the Teachings. The ancient teaching was absorbed through a combination of intuition and ecstasy, so different from the logical discussions during study of the Talmud.

This may be the only existing photograph of the ancient cabala contemplation, the spiritual approach to nearness to God.

76: I wanted to test this village wise man. I asked him: "What shall I do?" He responded: "Do what you do." Was he wise?

78 and 79: The fundamentals of prayer, according to some Hasidic commentators, are speech and thought. A prayer starts with reading. Initially the letters are seen, but gradually they dissolve and fade away. In this ecstasy, a connection is established between the human mind and the divine world of thought. The worshipper becomes Nothing on the road to Everything. The state of Nothingness is a mystic revelation of the soul, a ladder to unity with Divinity.

In the largest room of the rabbi's house—a modest hall crowded with dozens of students—discussions of the Talmud and examinations of the students took place. At mealtime the hall became the dining room.

The head of the yeshiva, Rabbi Baruch Rabinowitz, is seated between the candles. This is in accordance with the tradition of the Shapira family, known as the Mukachevo "dynasty." Its founder, Solomon Shapira (1832-1893), was appointed Rabbi of Mukachevo in 1881. Rabbi Rabinowitz survived the Holocaust and lives in Israel.

80: The inscription on the great lamp in the synagogue of Lask is a quotation from the Book of Numbers: "Let the seven lamps give light at the front of the lampstand."

81: It was a Thursday, and the boy had been called up to read the Torah. He had just been bar mitzvahed, and this reading was a symbol of his maturity, his first public demonstration of his role as a full member of the community. It was customary among the Jews of Eastern Europe to call the new "man" to the Torah on the Monday or Thursday following his bar mitzvah.

82: The man is wearing his tallis (prayer shawl) and has applied the tefillin, two leather boxes which contain short quotations from the Old Testament. One box with a long leather ribbon is placed on the left arm and pointed toward the region of the heart. Seven turns of the ribbon bring it to the hand. There, three rotations form the first letter of the Hebrew word "Shma" ("Hear, O Israel"). The second box is placed on the forehead, with its two ribbons falling to the right and left of the breast.

I wore the same attire and prayed with this man. I also had my hidden camera. After the prayer I chatted with him, as was my custom. "The words," he said, "I say six mornings a week except on Holy Days. But what counts are not only the same words but the thoughts that are different and always the same—the desire to be closer to God."

87: I made three visits to Lask, taking still and motion pictures with hidden cameras. I wanted to find out how the seventy percent of the population who were Jews could be terrorized into submission by a small minority carrying out the boycott. Rabbi Leibel Eisenberg, an admirer of my Grandfather Wolf's books, and a liberal who was also a Zionist, tried to explain.

After the war, there were no Jews in Lask. Most, together with Rabbi Eisenberg, perished in the death camp at Chelmno in 1942.

88: Study of the Talmud and disputation were usually conducted by students in pairs. Here a single student is reading the text in order to learn to reason and to prepare for argumentation.

89 and 90: These old Jews appeared to be crushed, as if by the screw press of destiny. They seemed to me to have no aim or purpose in their weary lives.

91: Discussions of the Talmud are a never-ending, everlasting spiritual "game." The methods of study and the decisions are countless. The vast material, the numerous reasons and possibilities challenge and sharpen the mind of the gifted scholar. Every teaching can be rejected, every opinion accepted. I know of a situation where murderers broke into a yeshiva. The Talmudists went on arguing, trying to reach an answer before their slaughter—so they could enter the world of

God, of eternity, with greater knowledge. This is Judaism.

94: I first met Henryk Schwartz on a train to Mukachevo. We became close friends and I entrusted him with the secret of my mission. He was convinced that it was essential that words and pictures be combined to save the memory of the Jewish traditional life that Hitler wished to extinguish. My debt to Mr. Schwartz is immeasurable. Without his aid, the important photograph of Rabbi Rabinowitz's study room [78] could not have been taken. Mr. Schwartz lost most of his family in the Holocaust, but he miraculously survived and now lives in Israel.

97: How important is the shoemaker? "Without soles, nobody can exist, neither porters nor peddlers. Even to go to synagogue, you need soles on your shoes. And to feed your family, you must walk on the cobblestones—everybody needs soles. To buy leather, I need mezumen [cash]. But all my customers are Jews, no one has money. To pay me, they must earn, and that means they need shoes. Leather soles last six weeks on stones. I work day and night, all my customers work hard. It's hard to be a Jew."

100: What a bind! The boycott forced non-Jewish customers to stay away, and the Jews had no money for fruits and berries.

101: His only hope is the credit union, which gives loans from Sunday to Friday. How much money is in the bank this week? Will he get a chance?

103: The two sisters seemed to be lost in thought while eating their soup. I asked what was troubling them, and the older one, on the right, told me: "We have our soup, but how can we get some for our mother at home? She has nothing to eat."

104: These students studied the two Talmuds, the Babylonian Talmud and the Jerusalem Talmud. In the former, they encountered the rules of life, customs, beliefs, and superstitions. It is a source of science and medicine, astronomy and agriculture, botany and zoology, philosophy and psychology. Is it possible that the study of the Talmud has kept Jewish culture and tradition alive when many other Western civilizations have crumbled to dust?

105: I wanted to know why the woman was carrying the cabinet. I was told: She is married and has a three-year-old son. She had a nice one-room apartment on the third floor, with a window onto the street, and a complete set of furniture—a table, two chairs, and a bed. Her husband had a good, steady job, until lightning struck in the form of a three-man boycott committee. Immediately,

her husband was fired. Now they can't afford their apartment and are forced to move into a cubicle in the cellar.

106: The young children of the shtetl were wary of strangers. It took a while, but we became friends and they told me about their experiences.

108: Every opening on the lower level of these buildings was rented and used for a business. I inquired: How is business? It was not good.

109: The water carrier had a hard time not spilling his cargo. One mile over cobblestones, and then a climb to the third floor. His pay, the smallest copper coin. I don't know how he did it. I tried to imitate him, but spilled one-third, and the woman refused to pay me.

110: The ghetto of Lublin had old houses and fences of broken boards. The streets were crooked and winding. The horse-drawn farm carts were fragile, their wheels shaking on the cobbles. Bent figures emerged from around corners like phantoms. Every time I visited this street, the sky was gray and a sinister veil covered the buildings. The house in the middle was the home of the great tzaddik Jacob Isaac ha-Hozeh, the Seer of Lublin. To my knowledge, this is the only picture of this house, which was destroyed by the Nazis.

113: Guided by my friend the famous historian Meir Balaban (1877-1942), I photographed the historical Jewish buildings of Lublin.

Rabbi Meir Ben Gedaliah was the greatest teacher of his generation and became head of the yeshiva of Lublin at the age of twenty-four. His house remained unchanged when I took this picture, but later the Nazis established military headquarters in it. The building in the background was known as the preachers' house. Here visiting rabbis could find lodging and kosher food.

115: A gaon is a rabbi of genius, the exceptionally learned head of a Talmudic academy. Elijah of Vilna was one of modern Jewry's greatest intellectual leaders. He studied the Torah and the cabala. He attempted to create a golem, but was unable to finish it, and said God prevented him from doing so. The gaon was a man about whom legends arose, and his study was a place of pilgrimage in the 1930s. This holy site was destroyed by the Nazis as soon as they entered Vilna.

118: In the shtetl, children revered their parents and provided for them as best they could. Twenty years before, in a pogrom, the mother lost her husband, the daughter lost her father. Now they have each other.

119: Her father had returned home smiling. All day he had carried heavy loads, walking endless miles, but now he had some money and the family would be able to eat a good meal. I was present on

this "happy" day, and saw how little is needed to give some joy.

120: One of the great characteristics of the shtetl was the intimate relationship of parents and children. These children are playing outside their home, while inside their mother does piecework for a tailor. They watched and loved each other through the window.

126: I engaged this storekeeper in a lengthy conversation. The total value of his merchandise was less than ten dollars in today's money. He asked me how he could make enough profit to pay the rent, feed his family, and buy new merchandise. I had no idea; and, I should add, he had few customers.

127: The salesmen traveled all week, but on Friday they came home to spend the Sabbath with their families.

132 and 133: In 1648 a group of Jews crossed the Carpathian Mountains seeking refuge from the massacres and tortures of Bohdan Khmelnitsky. In this bleak, desolate part of the world, they founded the village of Upper Apša, which was unknown to the outside world. Here farmers still grew the same type of corn Columbus brought from the New World. It took great exertions and heavy pressure for their plows to furrow the earth.

I stayed for a long time, openly taking photographs and movies. The villagers had never heard of such things. I felt myself transported several centuries back in time.

The Torah scrolls the villagers used were the ones their ancestors had carried over the mountains. They presented me with an ancient wooden mezuzah containing a parchment scroll. The verses on this parchment were written in square Assyrian characters.

134 and 135: In 1938, when I went to photograph Khust, it had a population of twelve thousand Jews. Their primary occupation was dealing in livestock, both sheep and cattle.

When the Nazis entered Khust, eleven thousand Jews were confined in a ghetto. They were deported to the death camps in April 1944. A cable was sent to Hitler stating that Khust was "Judenrein"—cleansed of Jews.

140: Perhaps this house wasn't too sturdy, but it was attractive, and it had a blooming lilac bush. Every Jew longed to have something living—a pigeon, a potted flower, but especially a blooming lilac in the country.

142: Immersion in the waters of the mikva serves as a spiritual cleansing. The children were dressed in their finery and behaved with dignity, for they knew that this was a Jewish ritual.

145: Thursday was market day in Lask. The

man with the cap, in the background on the far right, is a "watcher" from the anti-Semitic National Democratic Party. He is there to intimidate non-Jews and make sure they don't buy from Jewish merchants.

146: These boys were taught by a friendly melamed. First they learned to become good companions, but there was also book learning.

147: Only one eye peeks out from behind his friend's shoulder. The Jewish boy is afraid of strangers; the Russian youth, on the other hand, has nothing to fear. I thought: The little Jew is inspecting me from behind his stronghold.

148: This little Hasidic boy is unafraid of the stranger. His payess, the sidelocks of Hasidic tradition, had been carefully groomed since early childhood, and he is very proud of them.

150: Goose breeding was a relatively new occupation for Jews. In order to be profitable, it had to be done on a large scale. These people with their few geese were condemned to failure.

151: In a village high in the Carpathian Mountains, I came across this Hasid. The meeting provoked my curiosity. Who is he? Who is his rebbe? How often does he attend discussions of the Talmud? What books and commentaries does he read? How exciting, how interesting, to be a Jew!

152: These boys were interested in me, a stranger in their village. I was friendly and smiled at them and spoke to them in their mama-loshen — their mother tongue, Yiddish. I came from far away and might tell them stories they had never heard, about places they had never been.

154: I had heard that a boy of four would be starting cheder the next day. It would bring luck to be the first person to meet him that morning. I arose before 5 a.m. and took a picture of the boy's entrance into a new life. I wished him the best.

155: The next day I visited the boy at school. He was already getting accustomed to his new life.

156: The old-clothes peddlers expected to find few buyers for their pitiful wares, but staying home alone was unbearable. Here there was a semblance of togetherness, a bit of hope.

157: This thoroughfare was built in 1335 and was broad enough for the traffic then. Today it no longer exists except in this picture, and there are no Jews in Kazimierz.

158: This famous Talmudist was greatly admired and honored.

161: When a death occurs in a Jewish family, the relatives sit shivah for seven days. They stay at home and are visited by friends who recall the life and good deeds of the deceased. Here a Torah is being brought from the synagogue to the house of mourning, where a portion of it will be read.

164: "And you should love your God with all your heart and with all your soul and with all your strength. And the words I tell you should be with you when you are at home and when you are walking."

165: The boy is perplexed. What the teacher said yesterday in cheder contradicts what the rabbi just said in the synagogue. What should he do?

166: This man's rabbi was a tzaddik, a righteous and holy man. In Hasidism, a tzaddik brings his people nearer to God, and brings God's bounty to his people.

168: For Mrs. Shmulevich, a widow with four children, business had never been good, but now it was going from bad to worse. The boycott hurt everyone, and it was no different for her. She had nothing to bring to her stand in the open-air market. But she had come for countless Thursdays, so out of habit she was there, she just couldn't stay home. She sat in the snow, without a single customer. I was there when the tax collector appeared and demanded three zlotys, or else he would confiscate her merchandise. "I don't have anything." "Then I'll take your food." "I don't have bread, and the sugar tin is empty. Only salt is left, to eat it alone is too bitter." I heard her story and took the picture.

169: Here at the entrance to Kazimierz, there was a white dove of peace.

170: The trees, leafless in winter, stretch their limbs toward heaven and say a prayer for the Jews buried in Stary (Old) Kirkut.

171: Like the living, the dead want to have their books close by.

172: The largest Jewish welfare organization in Germany, the Hilfsverein, tried, with only modest success, to obtain emigration visas for German Jews. I was there when this man inquired about emigration. The clerk said he could offer him a visa to Australia for his entire family. "Australia? So far!" "Far from where?" asked the clerk. Then there was silence.

173, 174, and 175: Beginning on the night of October 27, 1938, the SS deported ten thousand Polish Jews who had lived most or all of their lives in Germany, and indeed considered themselves German. They were awakened, given ten minutes to dress and gather their belongings, and then they were herded into railroad cars. The trains headed toward the Polish border but stopped six miles short. From there, the Jews were forcibly marched into Poland. The march was especially exhausting for the elderly, among them the mother and father of seventeen-year-old Herschel Grynszpan. On November 7, Grynszpan, a refugee in Paris, shot and killed the third secretary of the German Embassy in that city. This assassination prompted the infamous Kristallnacht, the "Night of the Broken Glass." I marched in a Nazi uniform to record this awful event in still and motion pictures.

The exiled Polish-German Jews were put in filthy barracks in Zbaszyn, close to the German border. Conditions there led to disease, particularly because of the winter weather, and sixty-eight people died of pneumonia. The American representative to the League of Nations demanded that something be done. The Polish ambassador labeled the report a "Jewish fabrication." I felt the need to document the conditions of life in the Zbaszyn camp. Entry was easy; I simply joined a group of new arrivals. Leaving was much more complex, but I had to get the pictures out, and rapidly. After two failed attempts, I left the camp by jumping from the second floor of the barracks at night. It was very dark, but fortunately I was able to avoid the barbed wire and broken glass. I prayed "Hear, O Israel" and the gomel bentschen, a prayer of gratitude for deliverance from danger. Before dawn, I was able to creep away from this inhospitable place.

When my photographs arrived in Geneva, the Polish representative reportedly shouted: "Who took these pictures?" I'm sorry I wasn't there to tell him that I did.

176: In preparation for the invasion of Poland, Goebbels encouraged anti-Semitic demonstrations like this one. He arranged for the National Democratic Party to receive 200,000 German marks.

178 and 179: The pogromshchiki are coming. But the iron door was no protection.

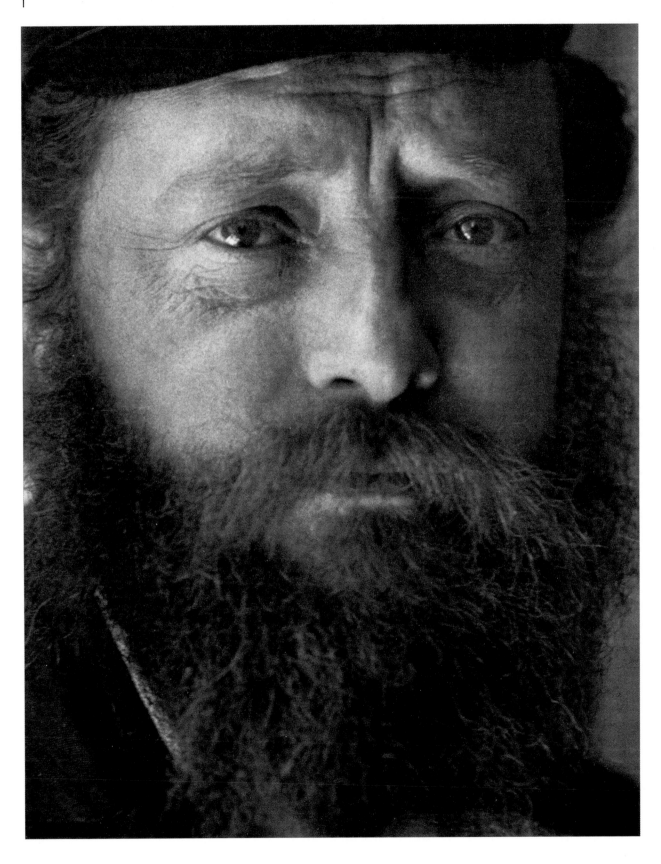

1: The rosh yeshiva (head or director) of a religious school. Warsaw, 1936

2: The books of Rabbi Hayyim Eleazar Shapira. Mukachevo, a city in
Carpathian Ruthenia, 1938. (The region known at that time as Carpathian
Ruthenia became part of the Ukrainian S.S.R. in 1945.)
3: An elder of the village. Vrchni (Upper) Apša,
Carpathian Ruthenia, 1938

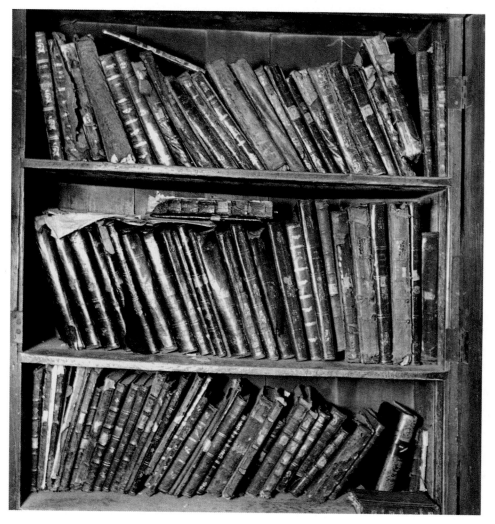

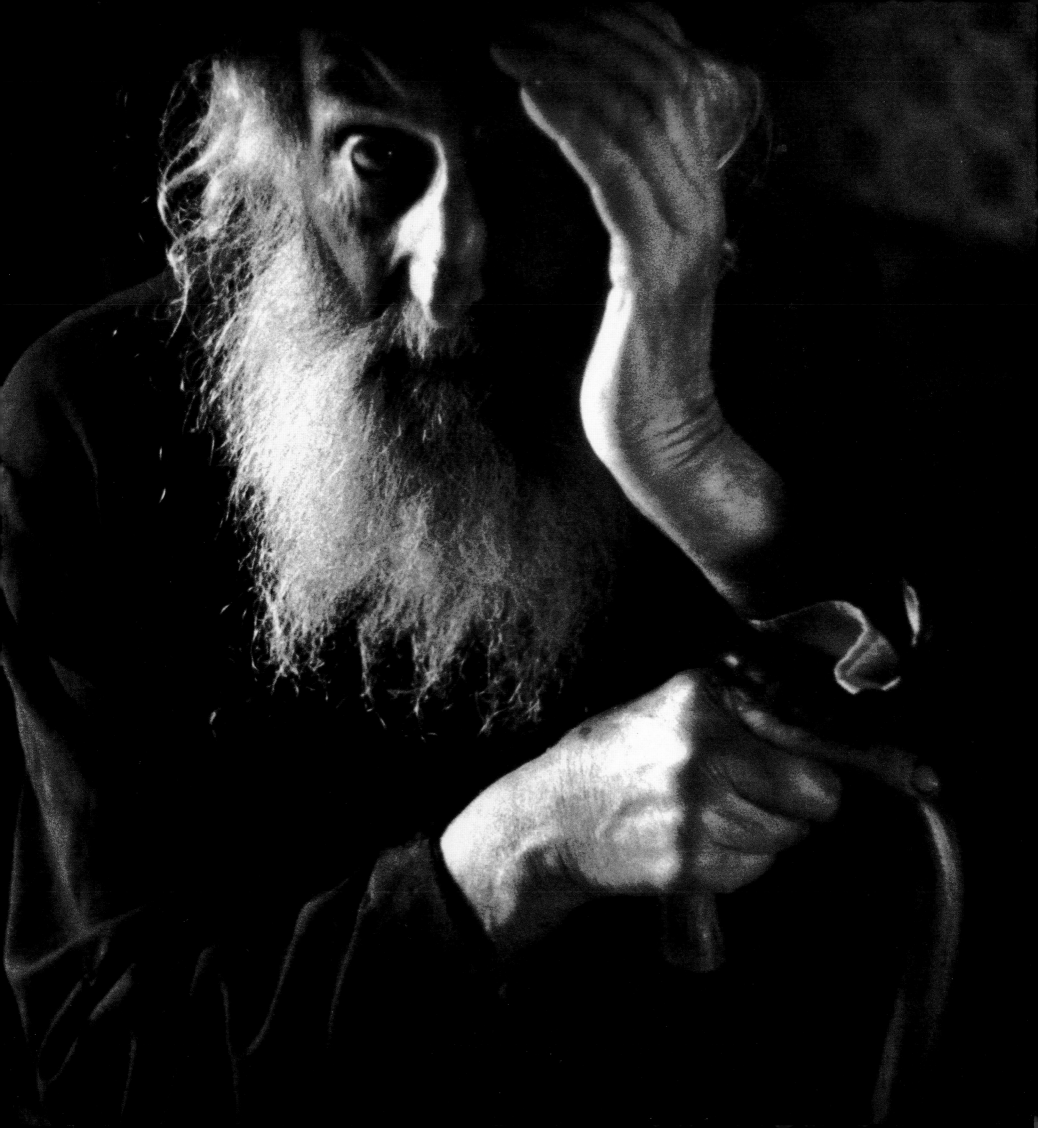

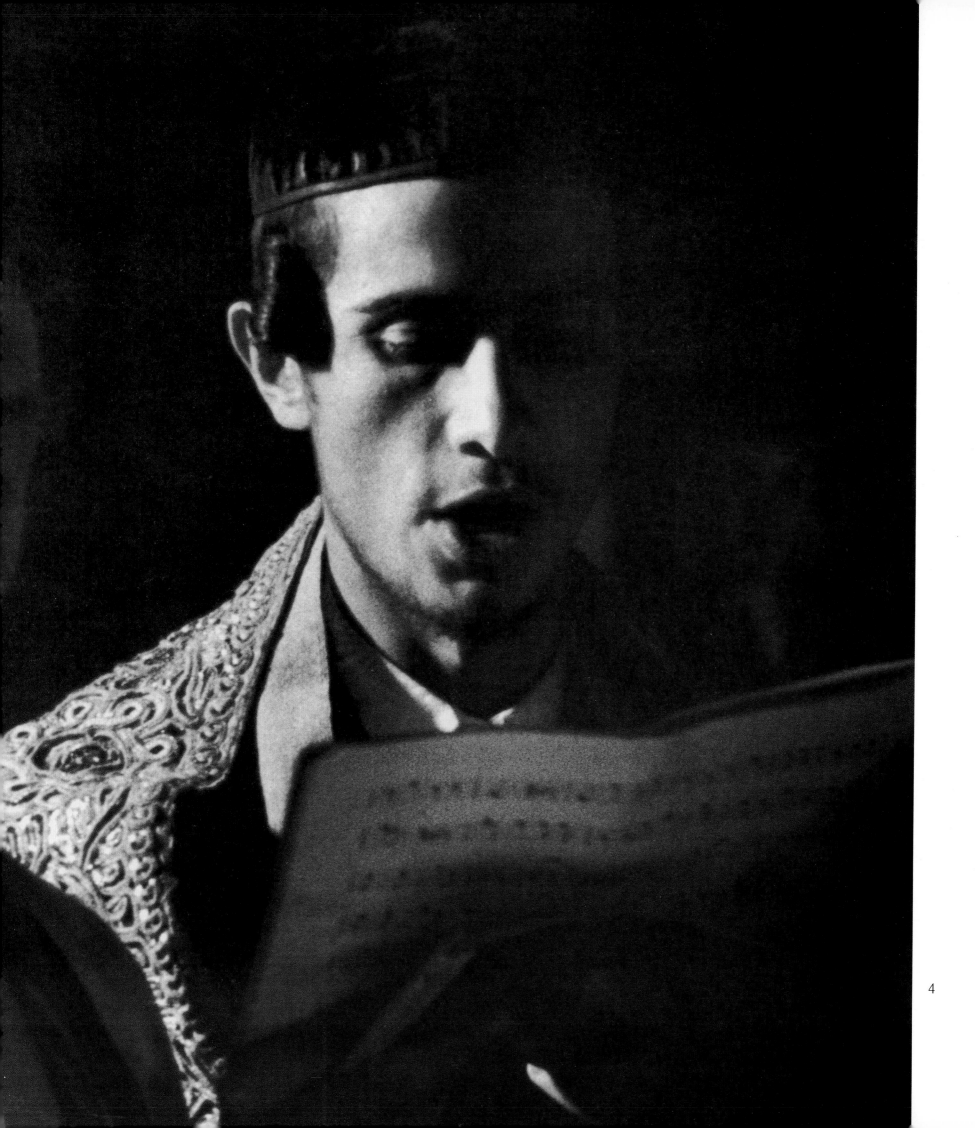

4 and 5: Meshorerim (choir singers) at the house of Rabbi Baruch Rabinowitz. Mukachevo, 1938

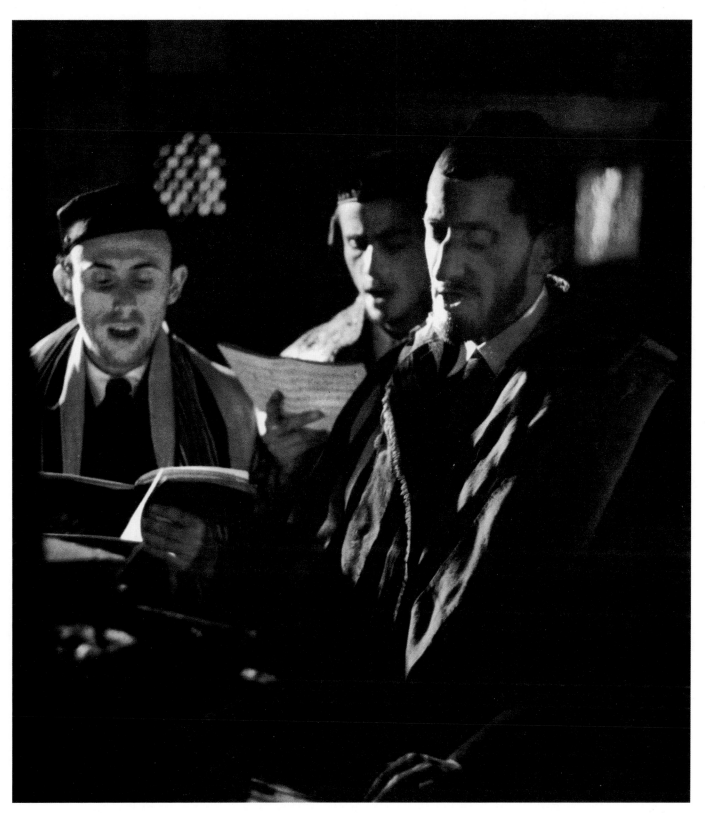

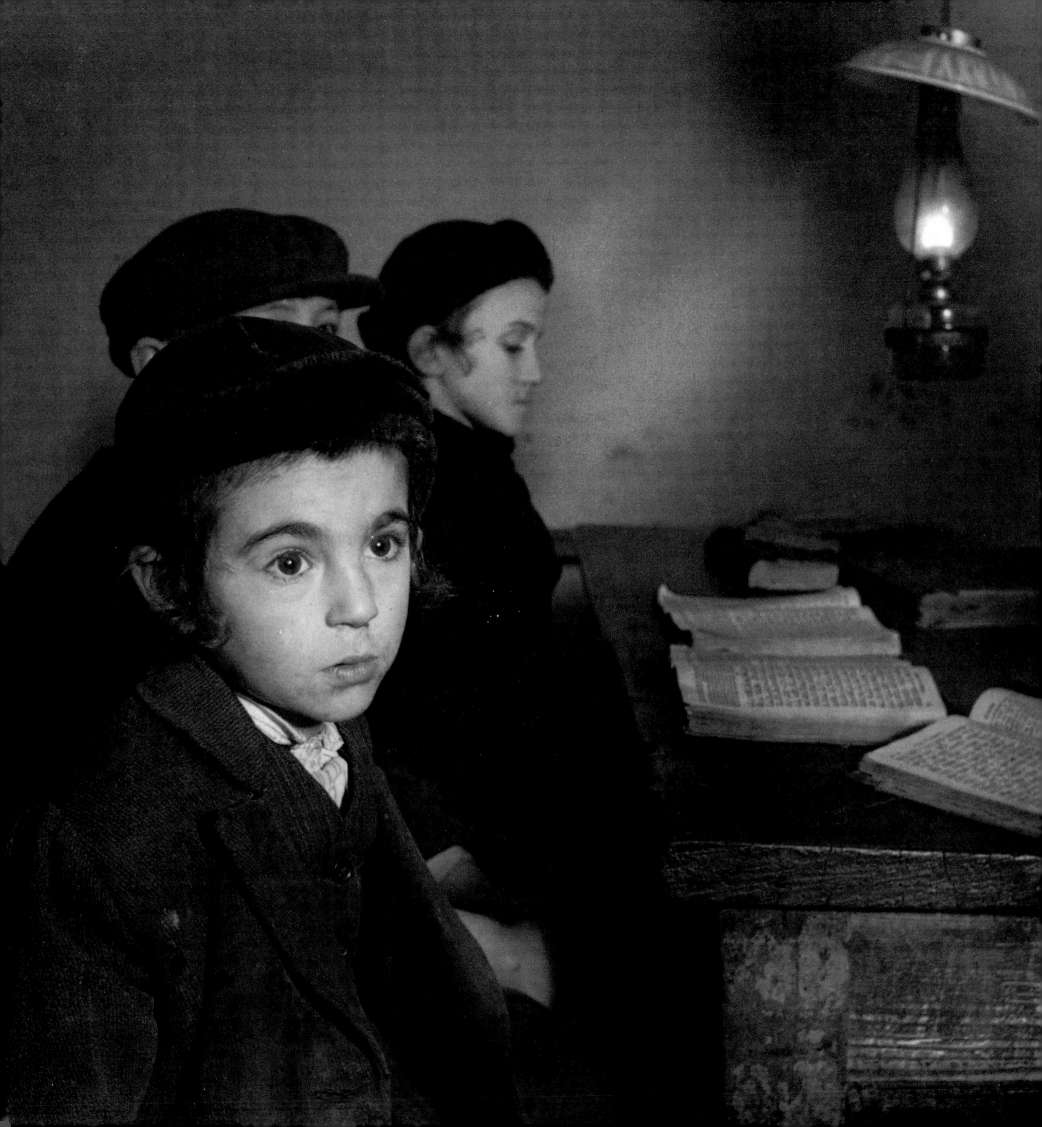

6: Cheder boys. Vrchni Apša, 1937
7 and 8 *(overleaf)*: Students of the Talmud. Trnava, Czechoslovakia, 1937

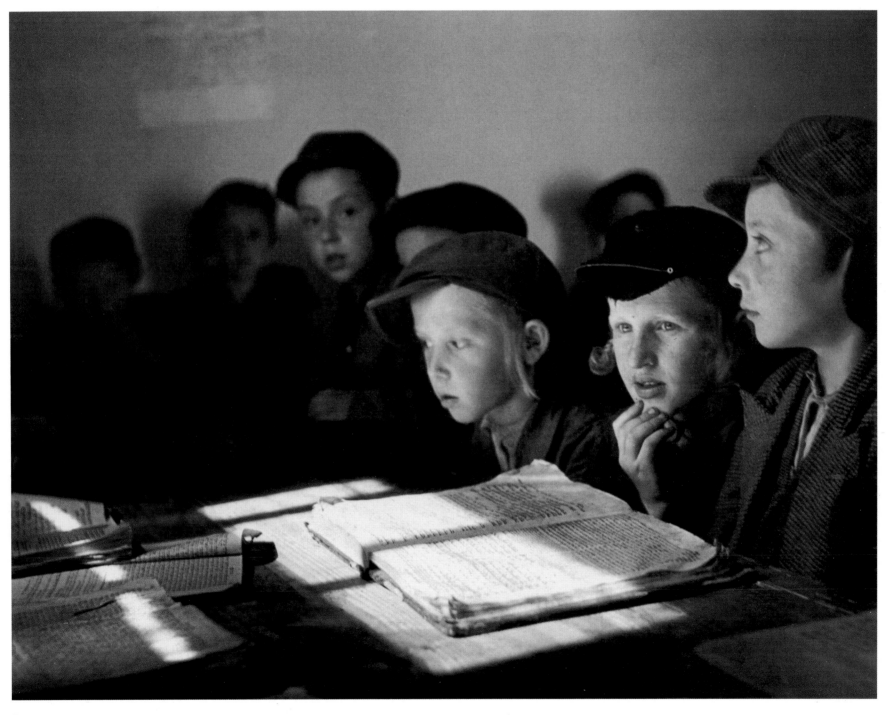

8: Talmud students. Trnava, Czechoslovakia, 1937
9: Talmud students of Mukachevo, 1938

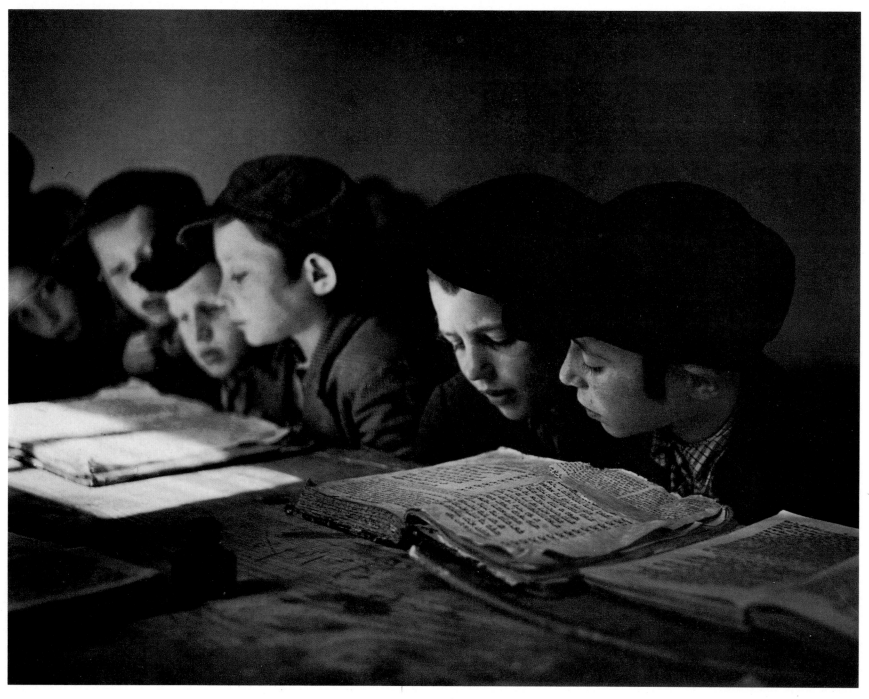

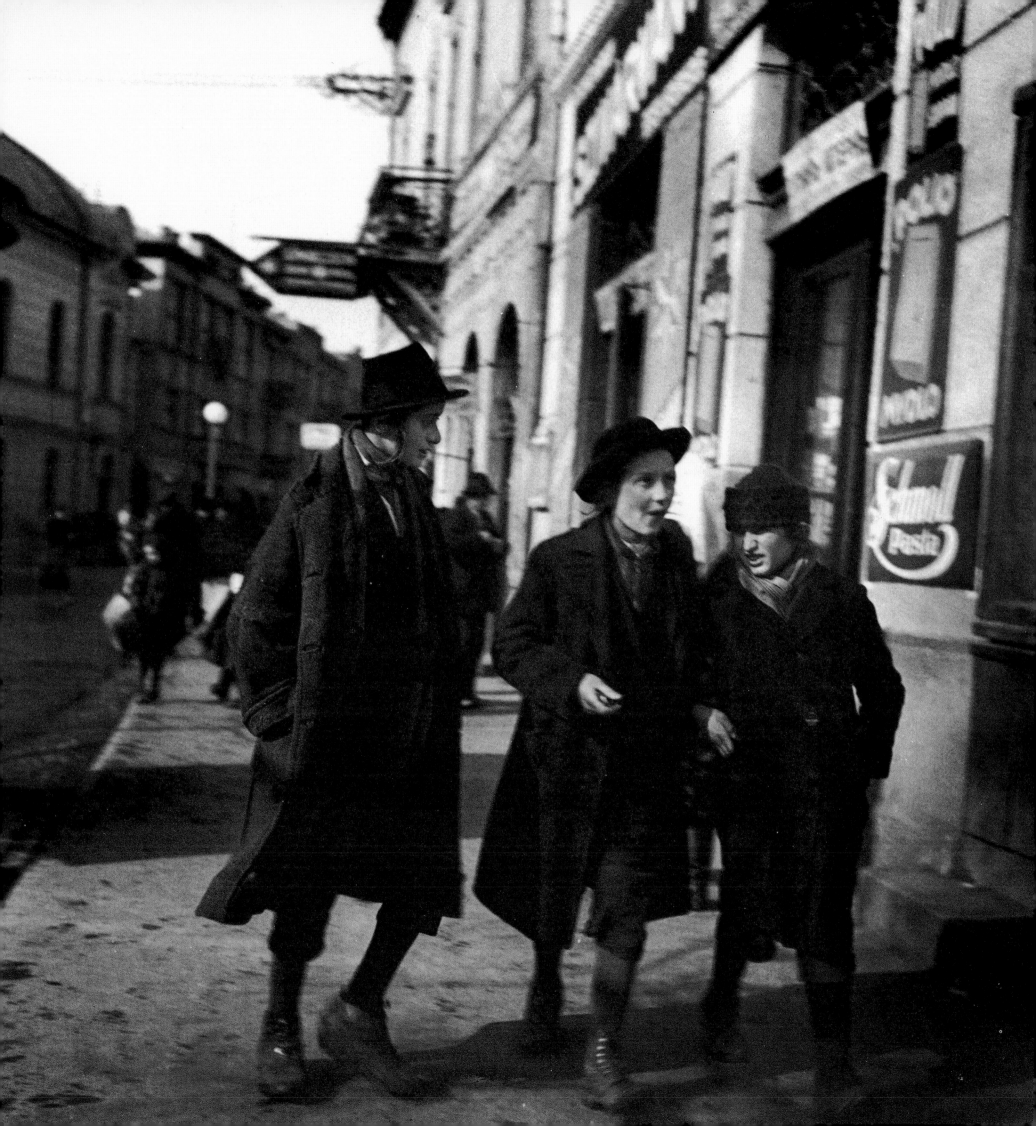

10: Discussion with the rabbi. Warsaw, 1938
11: Exchange of news. The cloth bag holds a tallis, or prayer shawl. Mukachevo, 1938

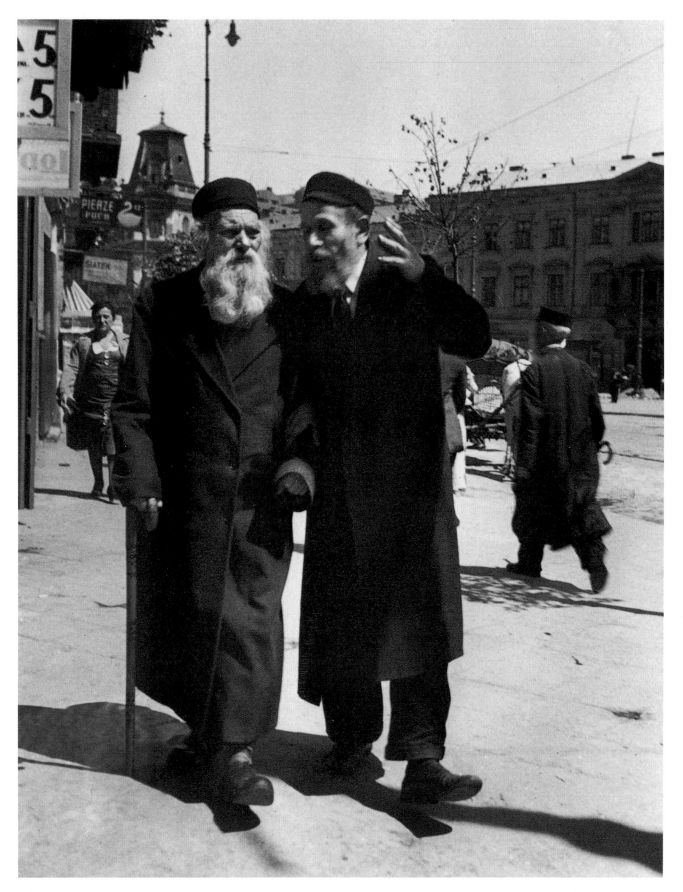

10

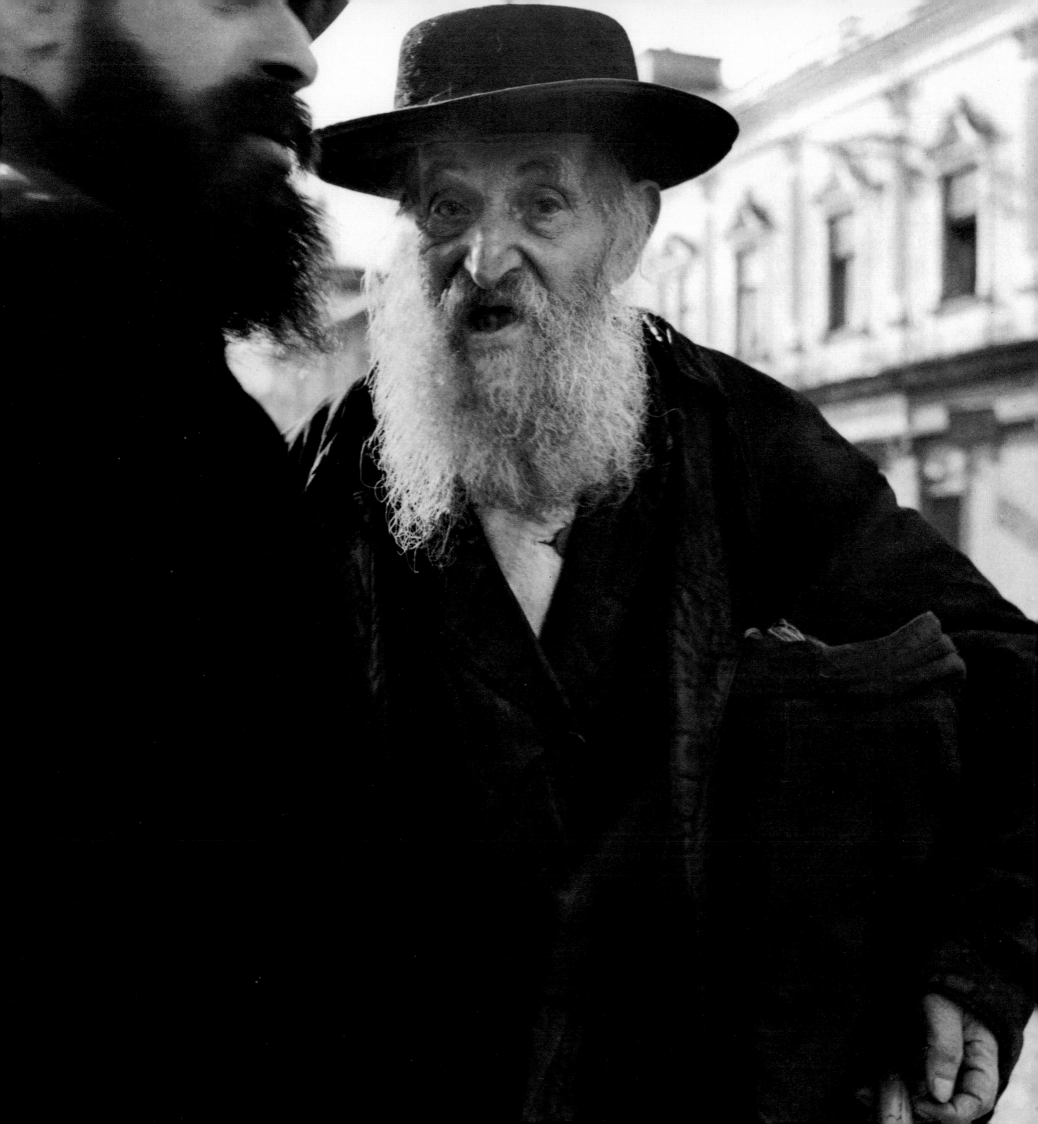

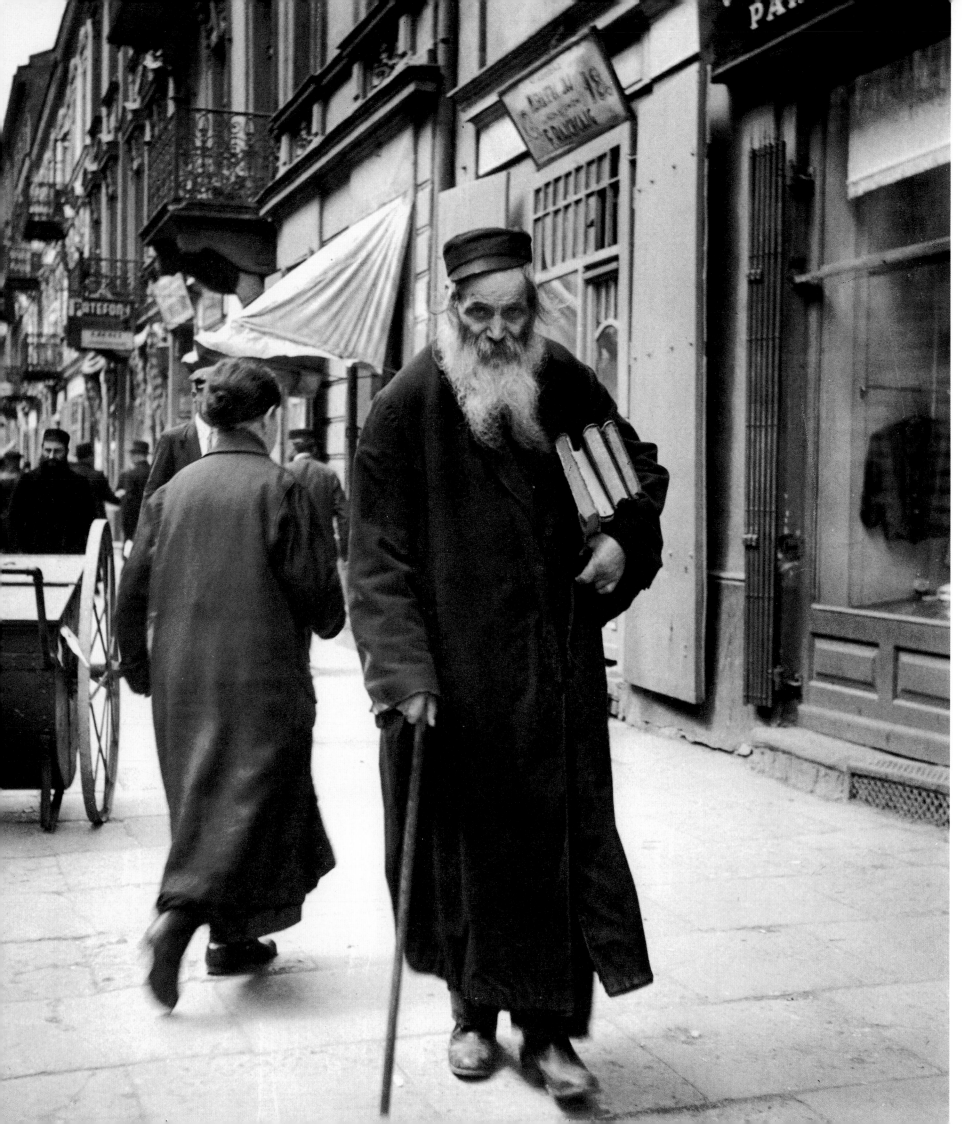

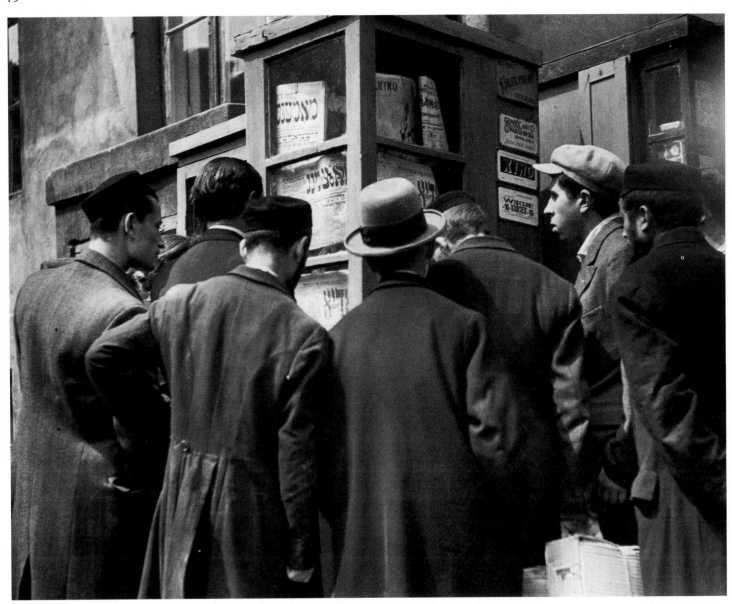

12: A rabbi. Warsaw, 1938. Books were treated with respect and veneration
13: Readers scrutinize the latest newspapers, which they cannot afford to buy. Warsaw, 1934

14: My daughter, Mara. Berlin, 1933. The poster for the November 12 plebiscite reads:
The Marshal and the Corporal. Fight with Us for Peace and Equal Rights
15: Mara poses in front of a device for measuring the difference in size between
Aryan and non-Aryan skulls. Berlin, 1933

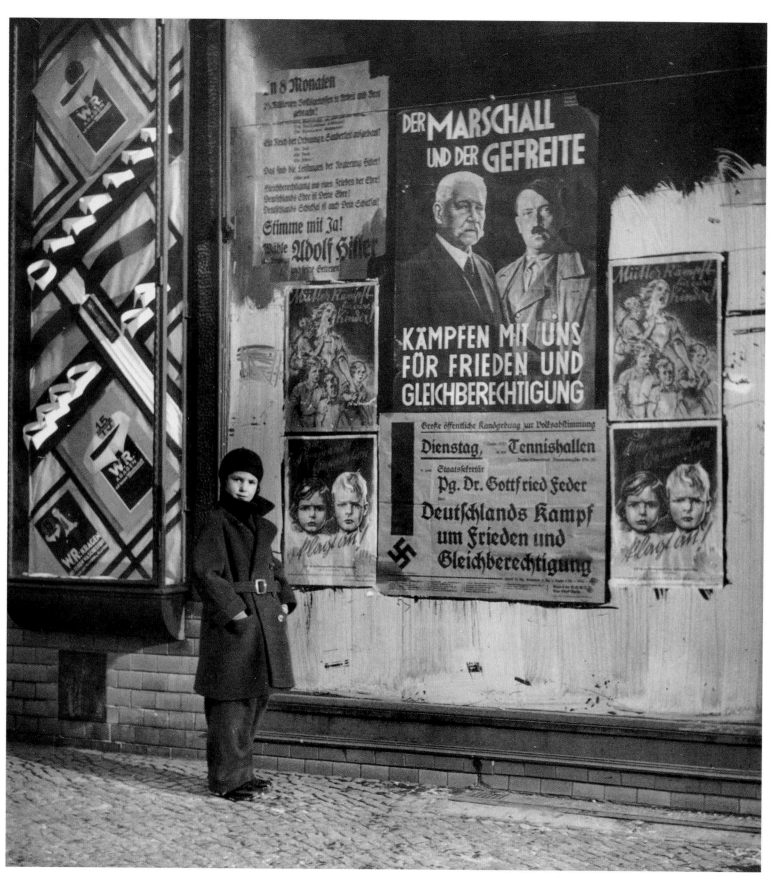

Raffenpflege!

Der Raffeforscher K. Burger-Villingen Berlin
entdeckte die menschlichen Formengesetze u. begründete eine höhere
Menschenkenntnis.

Der von Burger-Villingen
erfundene
Plaftometer.

16 and 17: In 1934, on a farm near Berlin, members of the Aliyah movement learn about farming. Emigration to Palestine was their ultimate goal

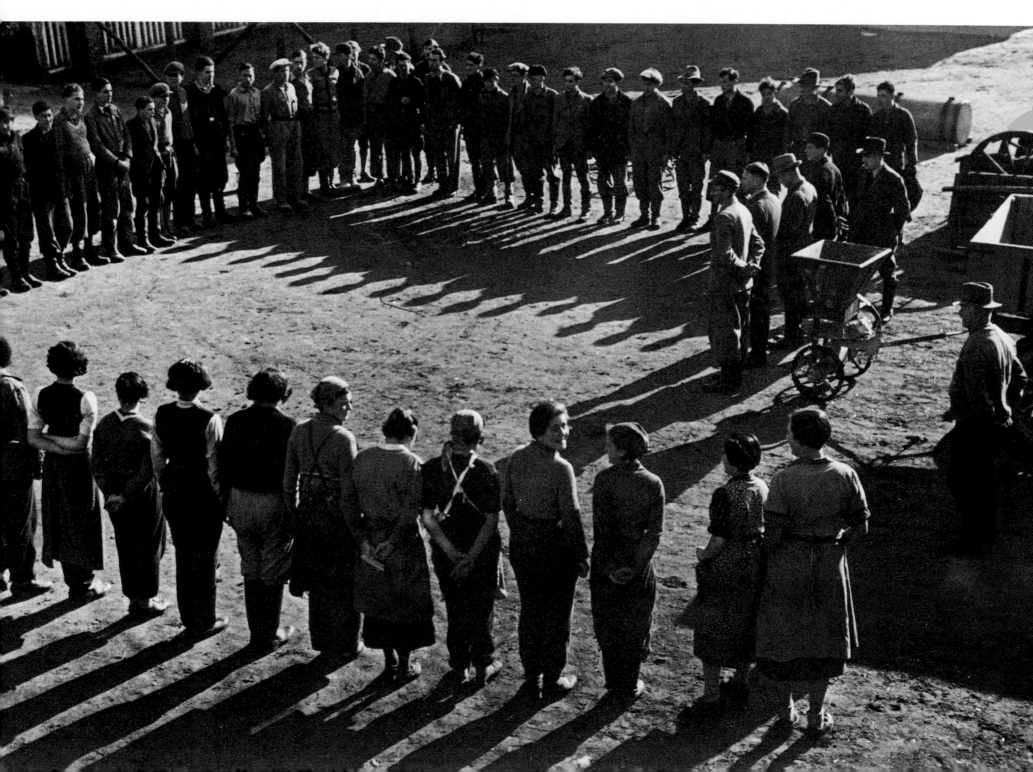

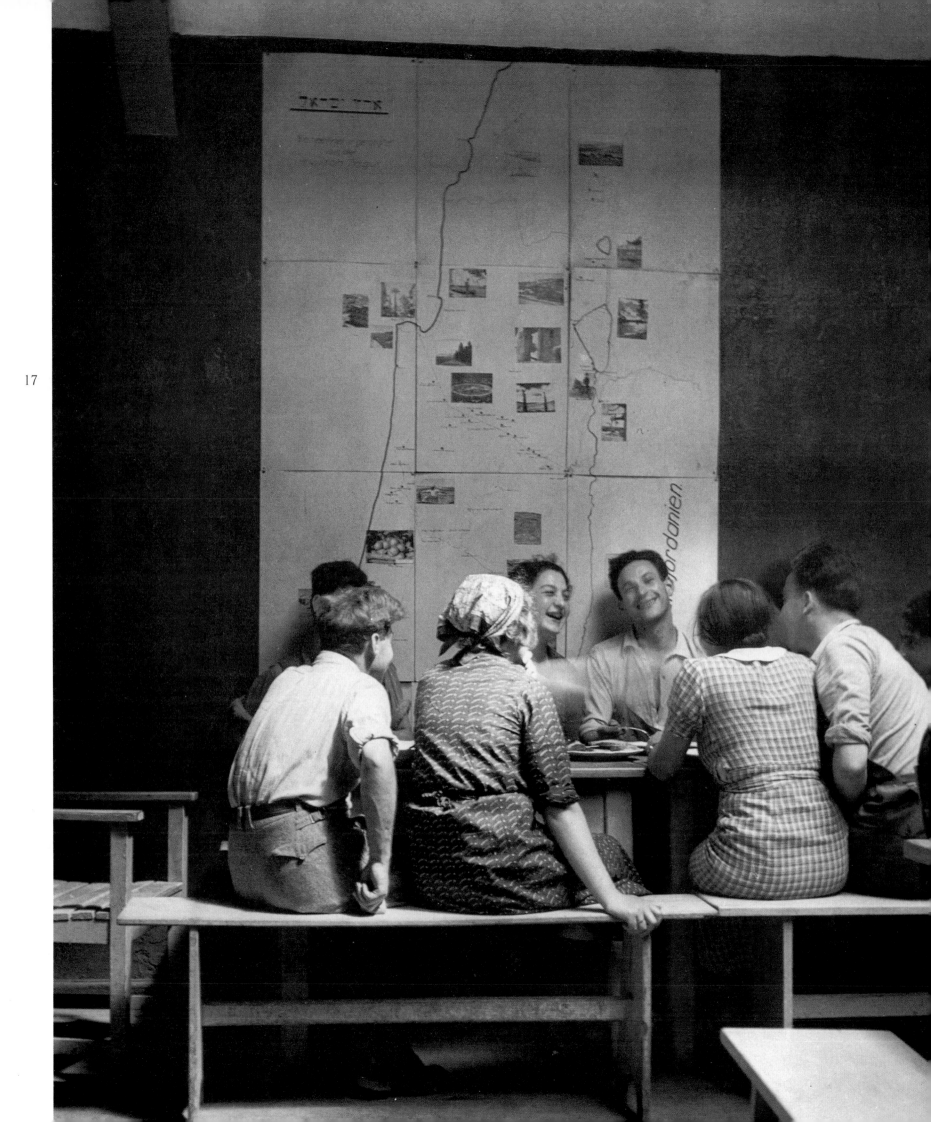

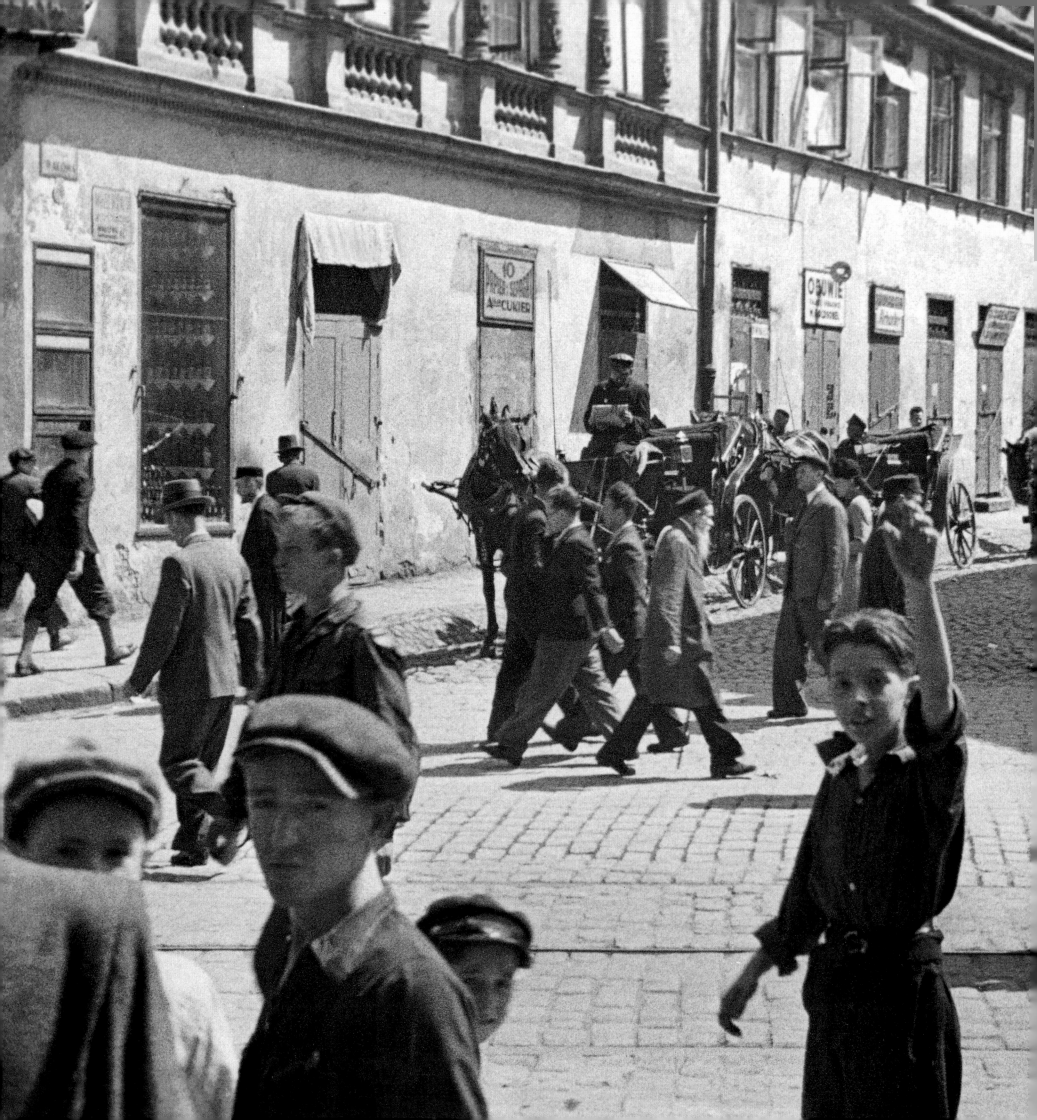

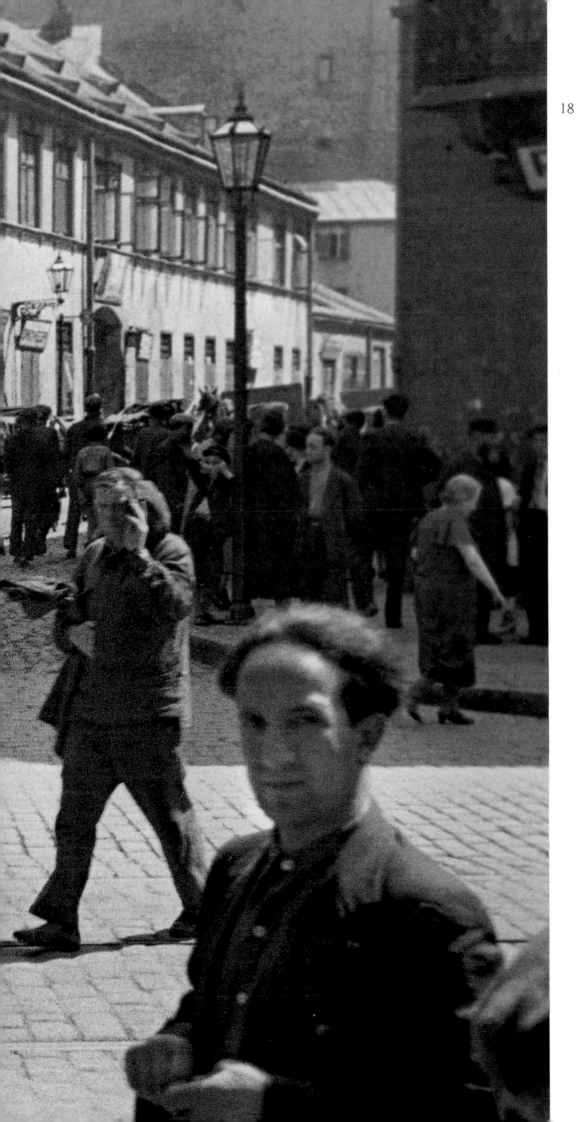

18: In the Jewish quarter of Warsaw, 1937.
It is the Sabbath, and the stores are closed

19: This child had to stay indoors during the winter. There was no money to buy her shoes. Uzhgorod, 1937
20: After twenty years with one firm, he has been fired because he is a Jew. The boycott committee demanded it. Warsaw, 1937

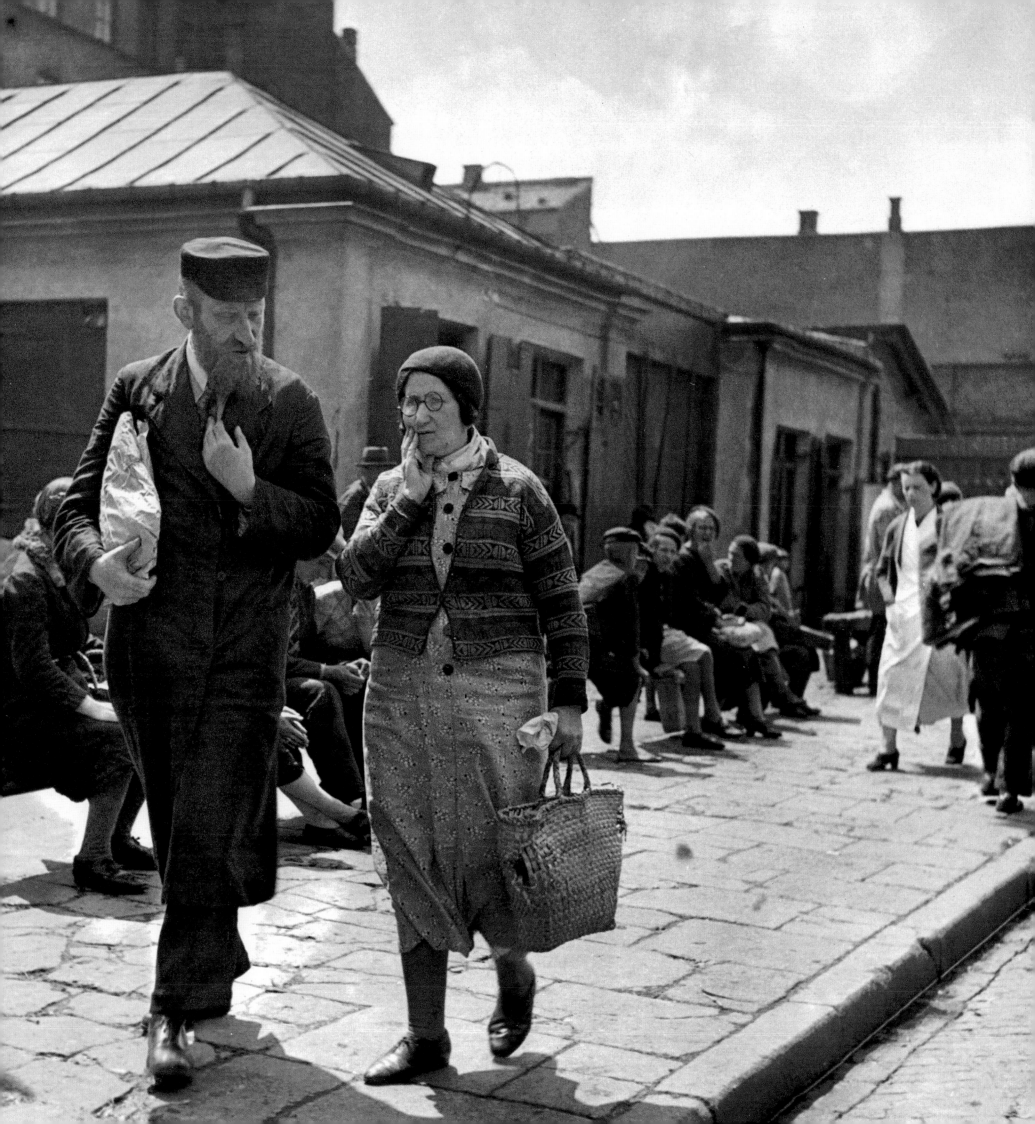

21: Because of the boycott of Jewish merchants, this storekeeper
could not pay his rent, and so the landlord locked him out. Lodz, 1938
22: A shopping street in the Nalewki, the heart of the Jewish quarter of Warsaw, 1938

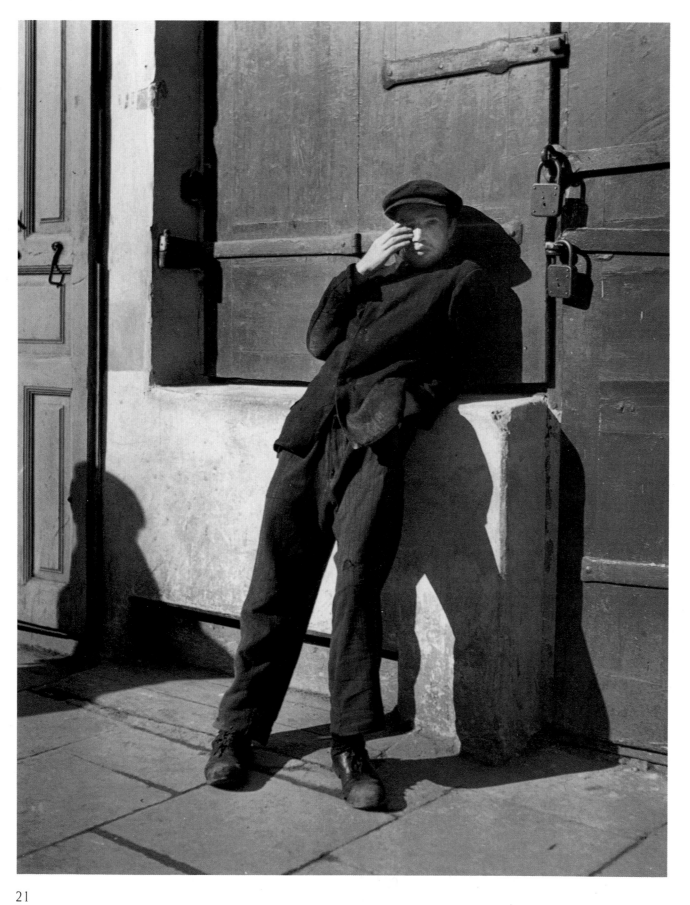

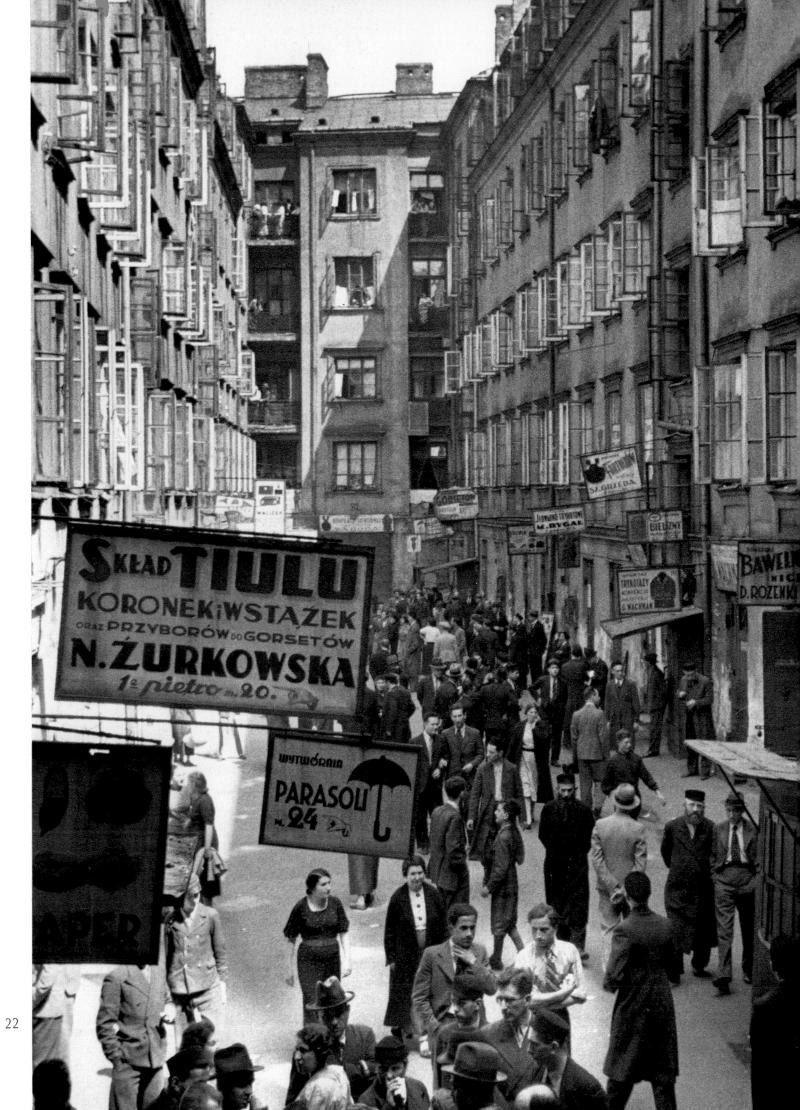

22

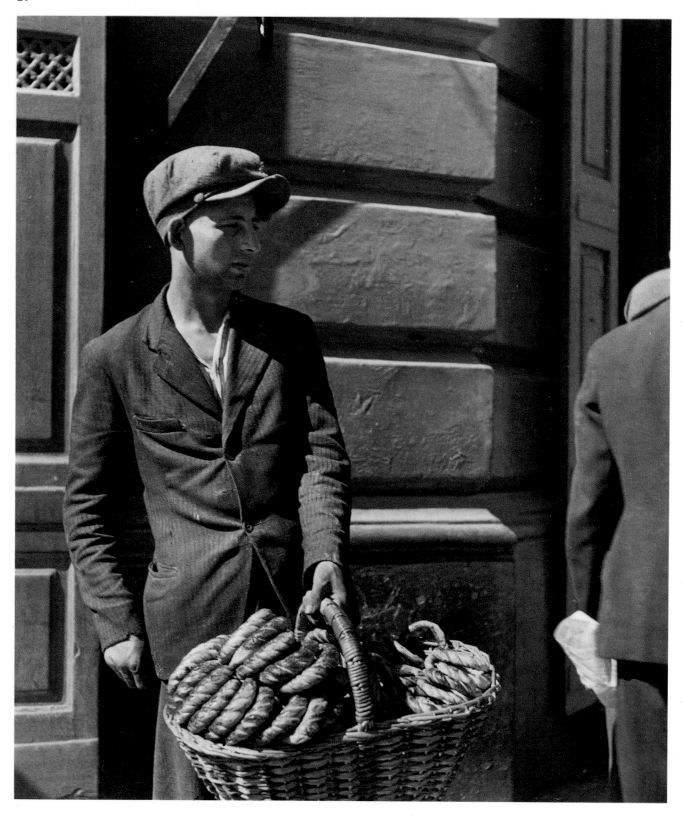

23: Peddling bagels on a street that is off-limits to Jews. Warsaw, 1937
24: The woman told me she had sold only two pieces of candy that day. She is trying
to arrange her wares more attractively. Warsaw, 1937

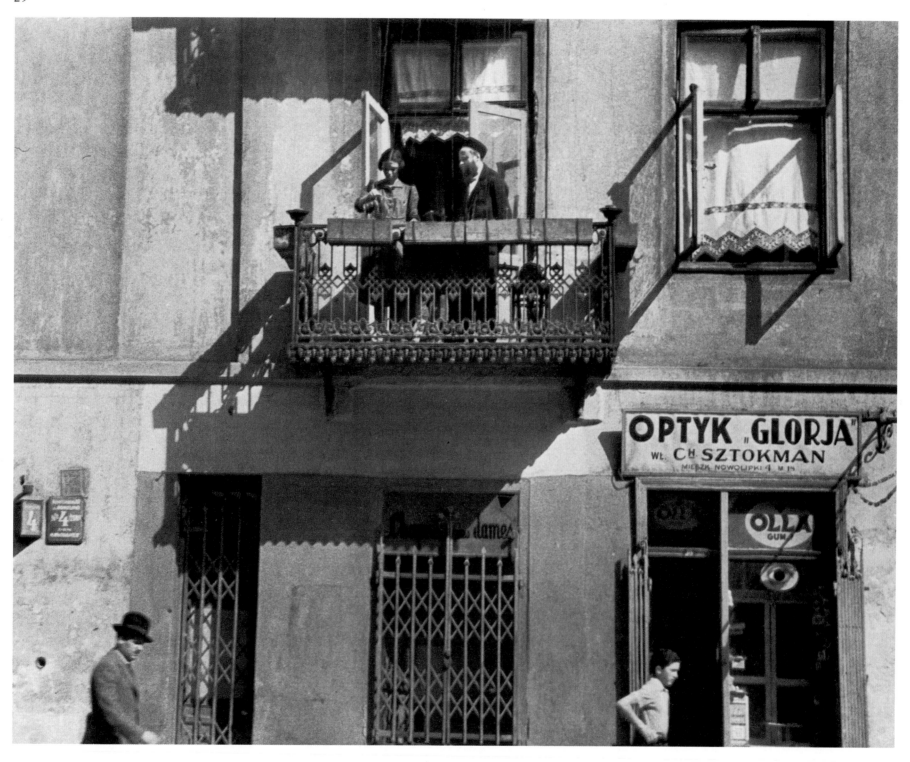

25: Father and daughter on their balcony. A middle-class street in Warsaw, 1936
26: A shopkeeper, forced out of business by the boycott, passing by his old store. The new, non-Jewish merchant is having it renovated. Lask, a town near Lodz, 1937

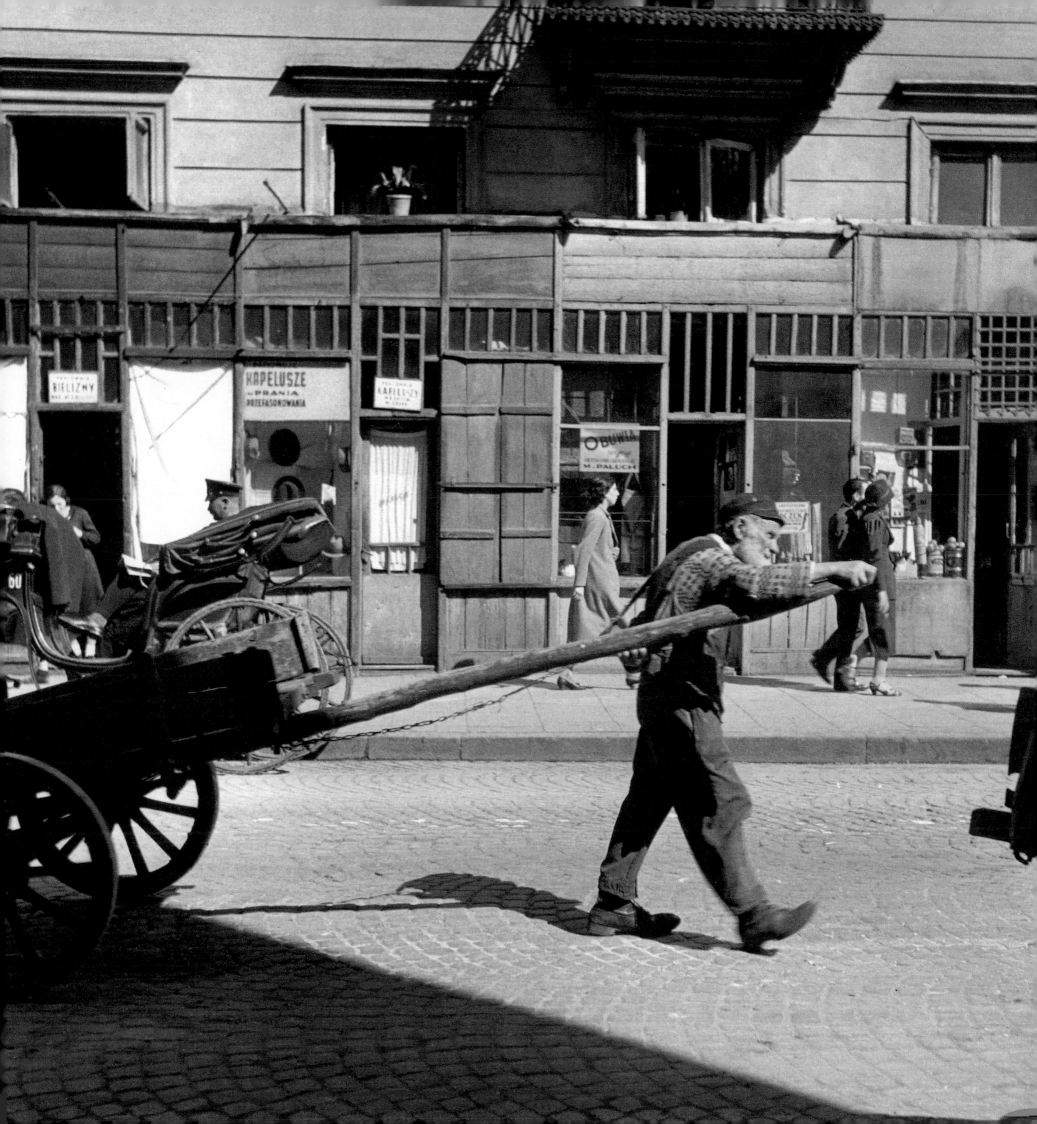

27: A member of an artel of Jewish porters. Warsaw, 1937.
The artels were cooperative ventures. When the group could not find collective work, each member went out to find business on his own. All earnings were contributed to the cooperative; a third was paid to the municipal authorities, and the rest was shared equally
28: Licenses for members of the artel of Jewish porters. Warsaw, 1937.
Tragarz is the Polish word for "porter"

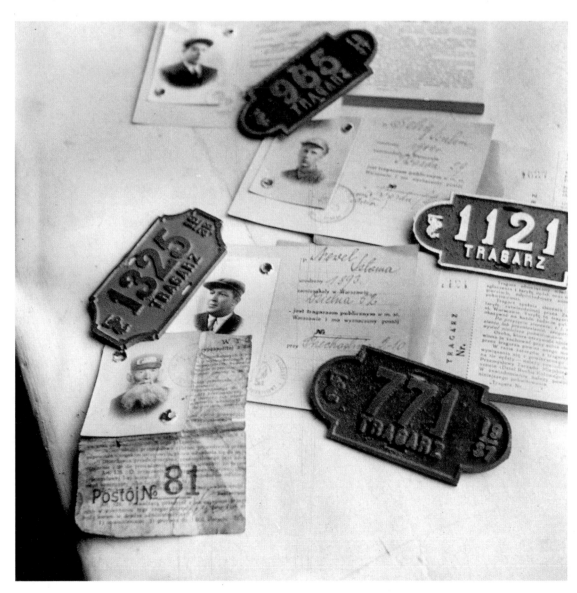

27 28

29: The meager meal of a porter's family. His name was Nat Gutman. Warsaw, 1938
30: Nat Gutman's wife. Warsaw, 1938

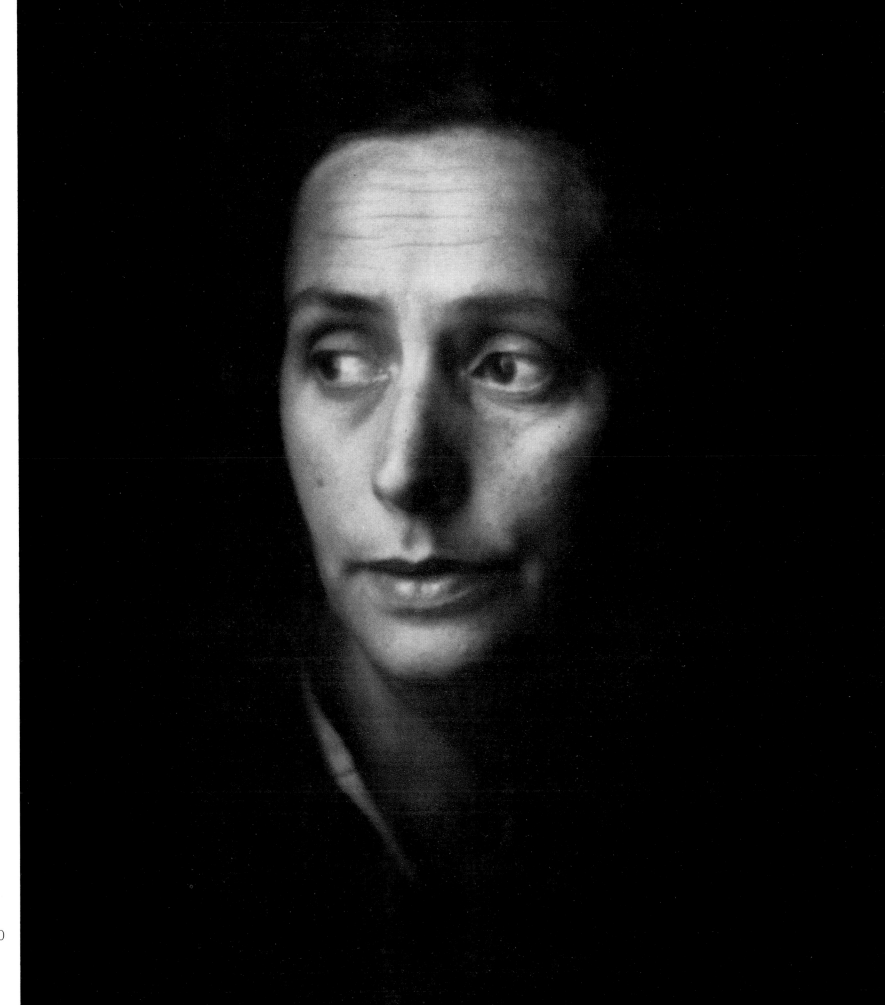

31: Nat Gutman's wife and son. The boy has a toothache. Warsaw, 1938
32: In Leopoldstadt, the Jewish district of Vienna, 1936

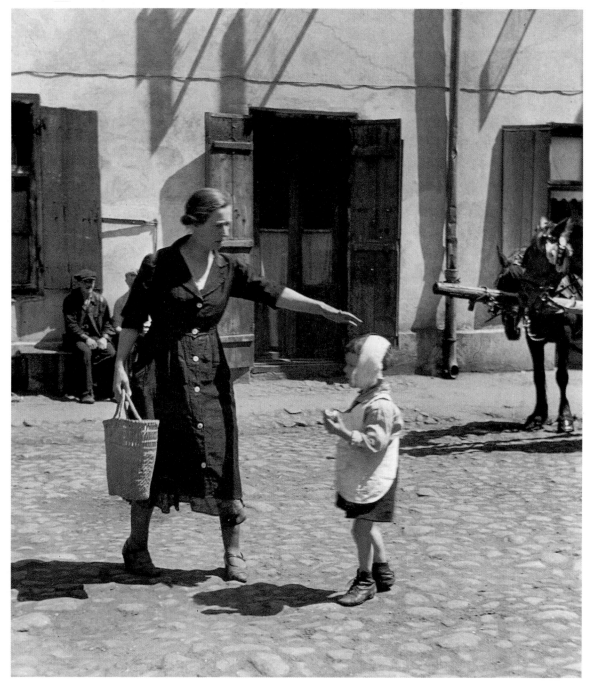

31

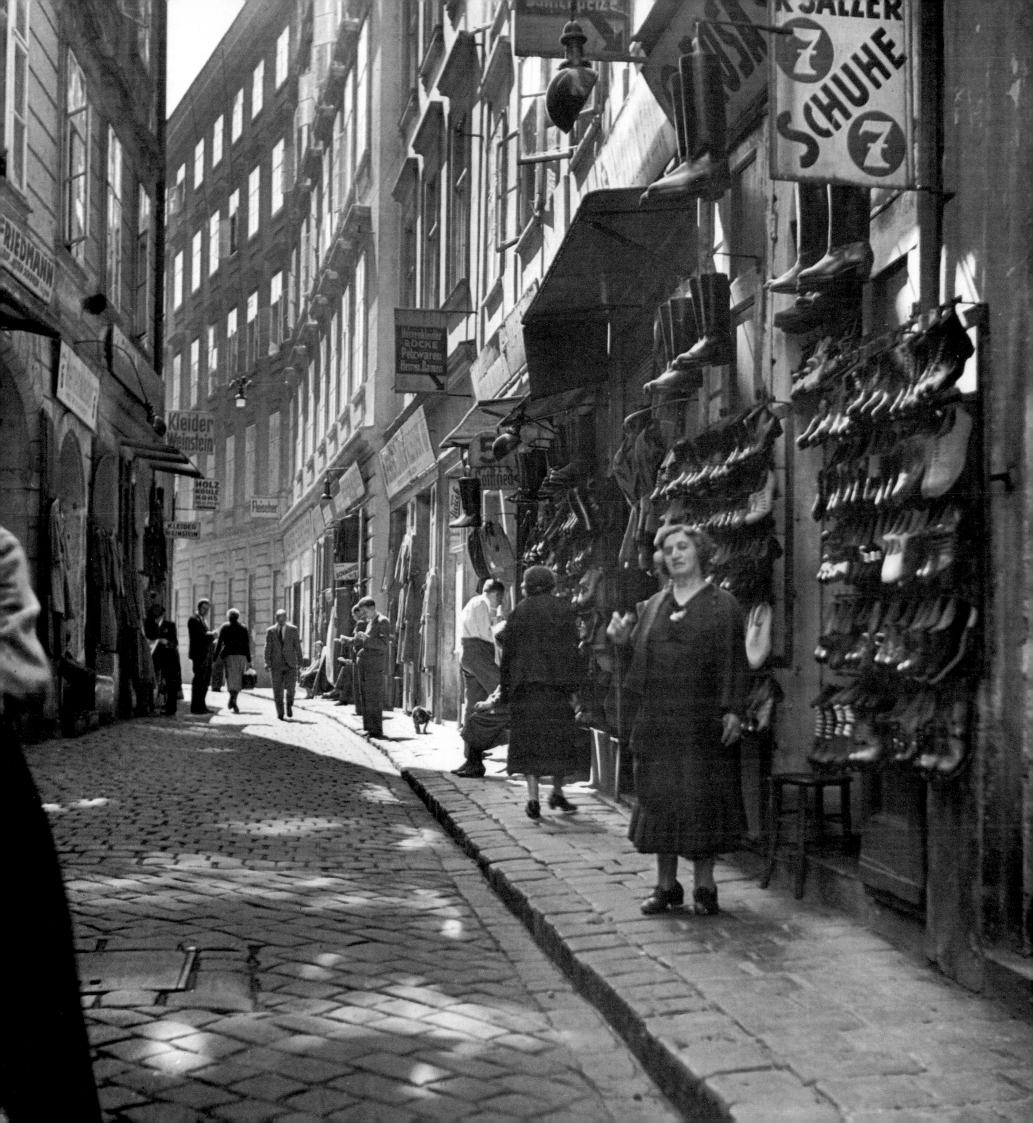

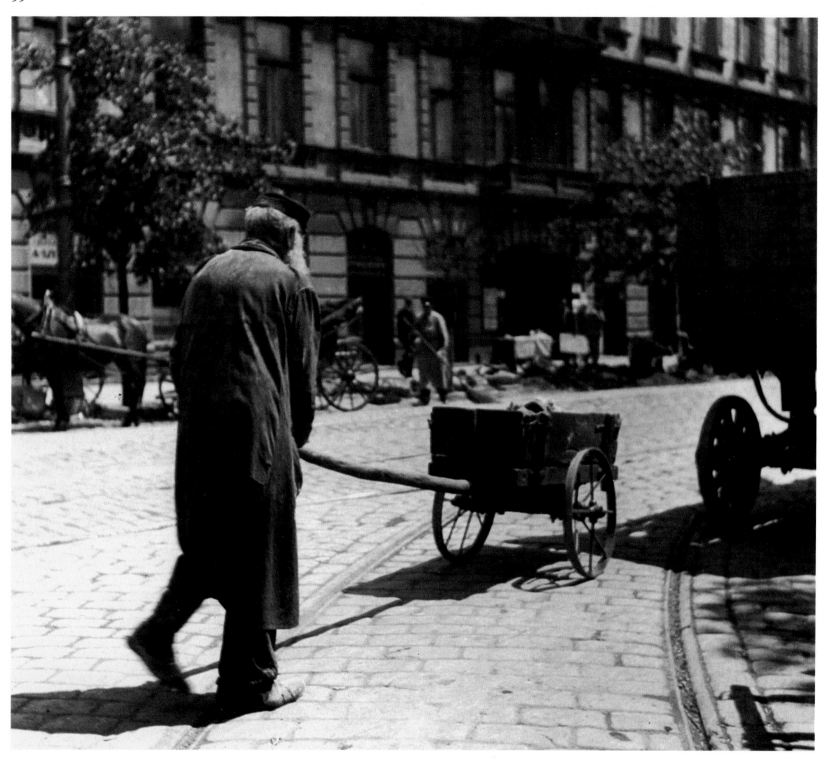

33: The oldest member of the artel, delivering a heavy load. Warsaw, 1938
34: This man had lost his legs in a Russian pogrom thirty years before. Warsaw, 1937

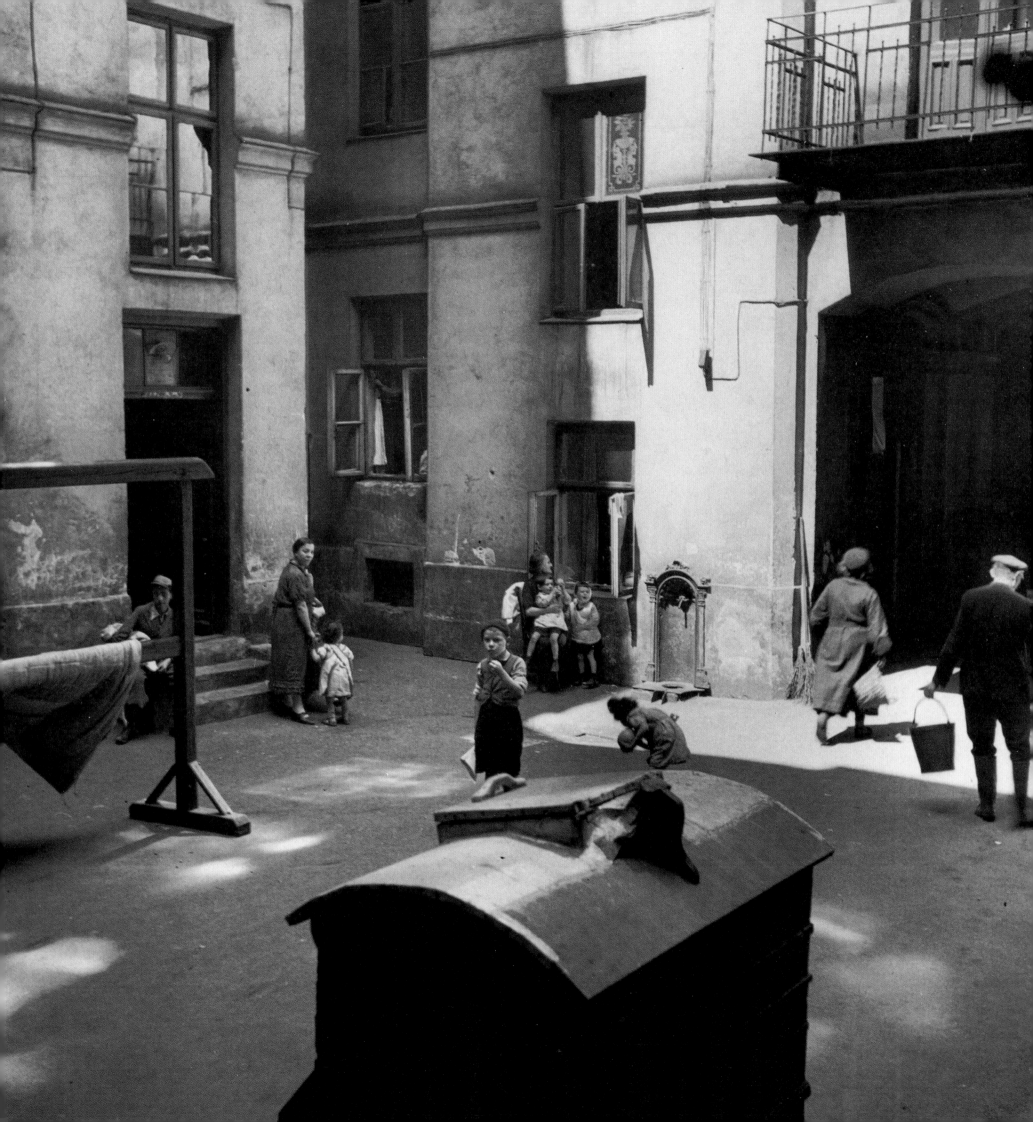

35: A courtyard in a middle-class neighborhood of Warsaw, 1935
36: This Jewish girl does not have a license for her bicycle. Warsaw, 1937

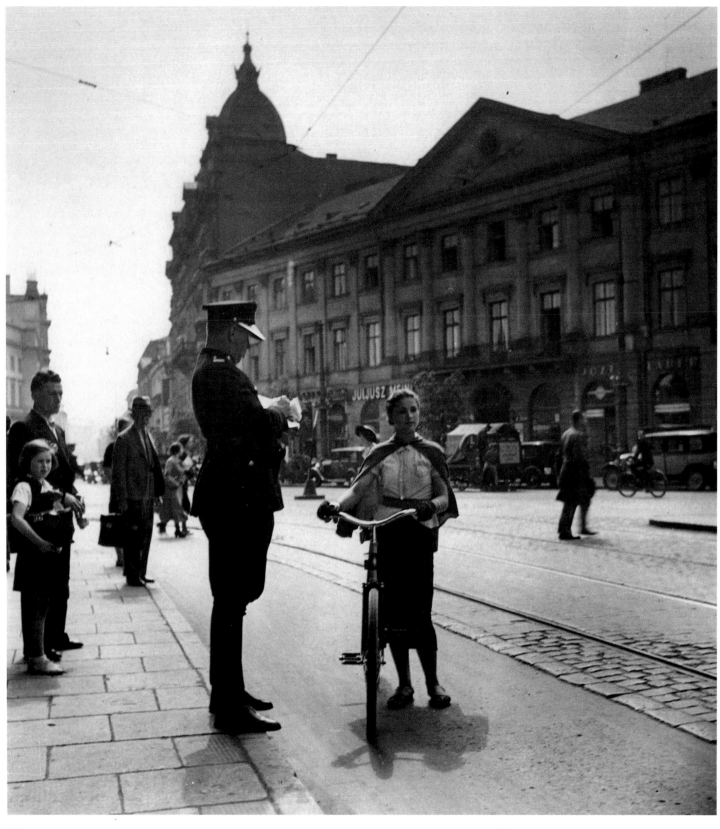

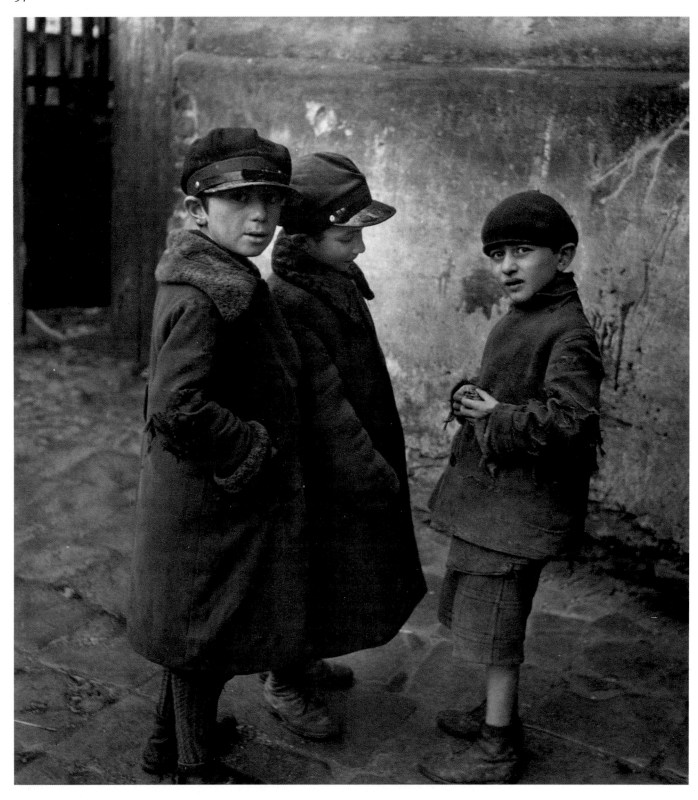

37: Jewish boys, suspicious of strangers. Mukachevo, 1937
38: Nat Gutman, the porter. Warsaw, 1938

39: Children seeking light and air outside their basement home. Warsaw, 1938
40: In one of the twenty-six compartments of the basement, a grandmother cares for
her grandchildren while their parents look for work. Warsaw, 1938

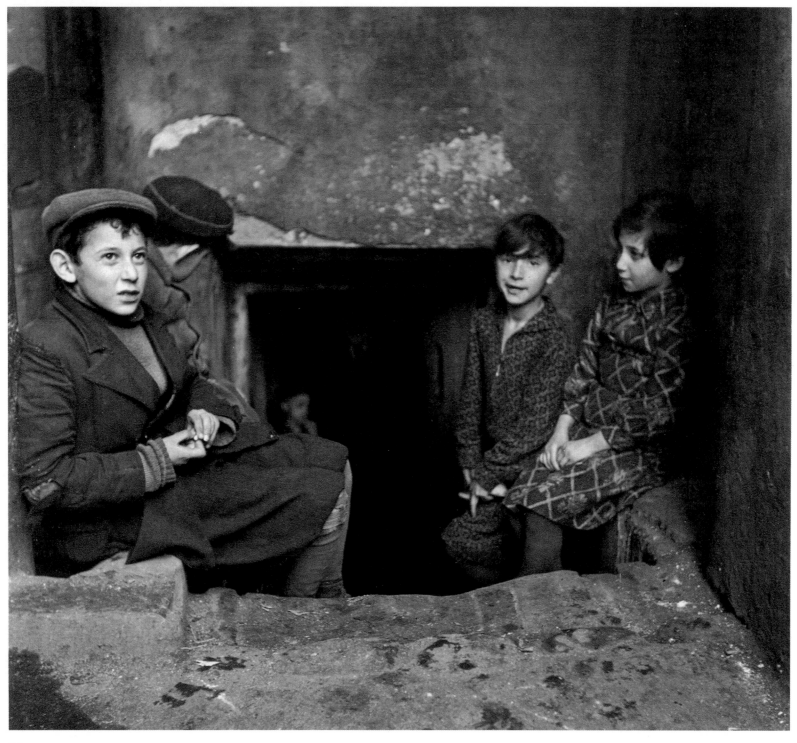

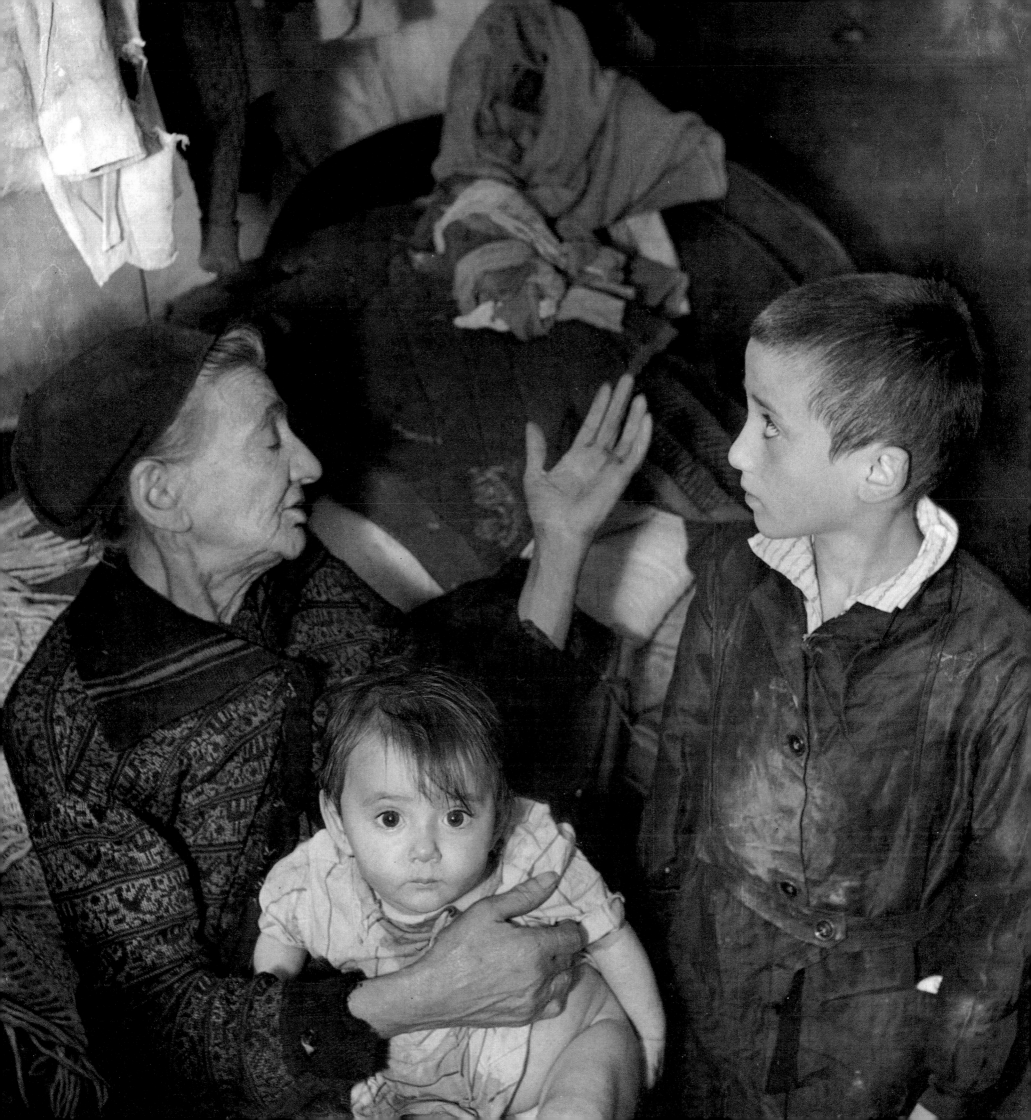

41: Basement lodgings and workshop. Nine people slept in two beds. Warsaw, 1939
42: Since the basement had no heat, Sara had to stay in bed all winter. Her father painted the flowers for her, the only flowers of her childhood. Warsaw, 1939

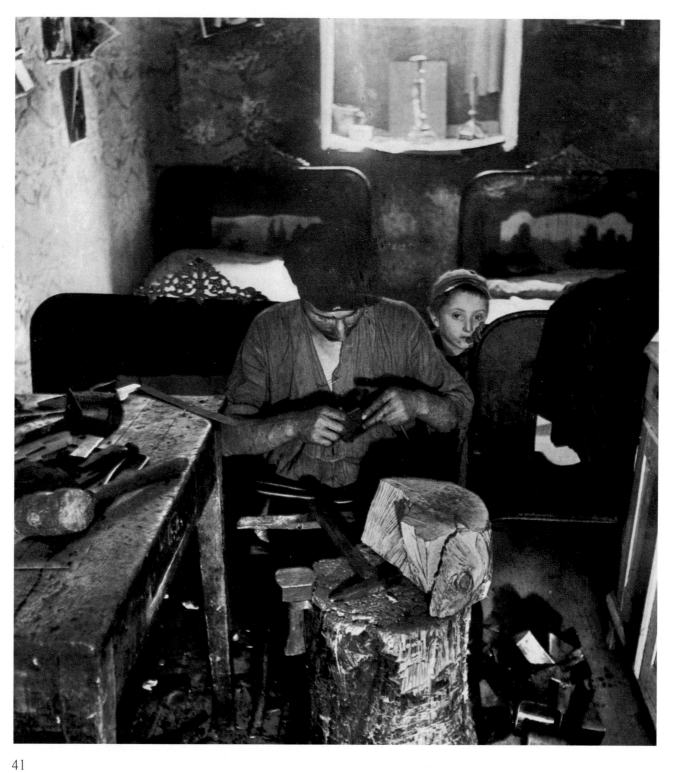

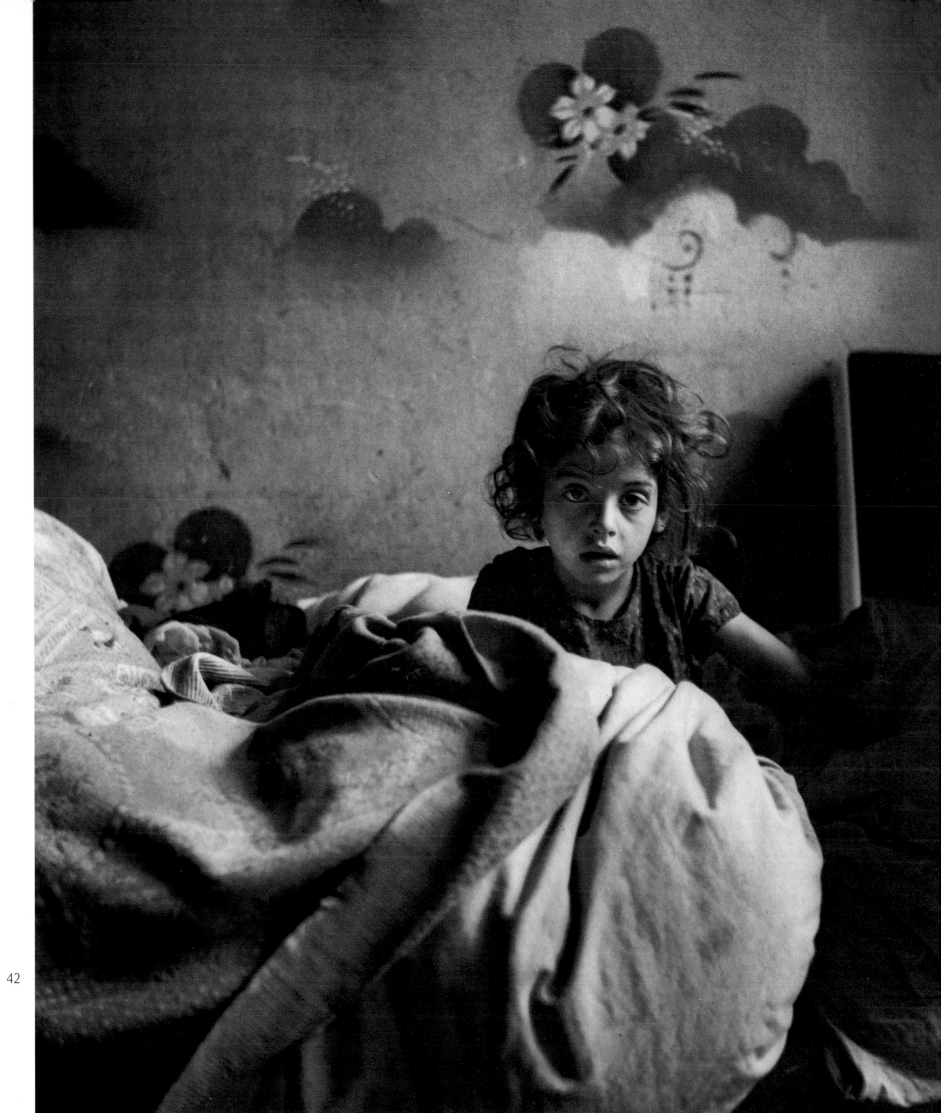

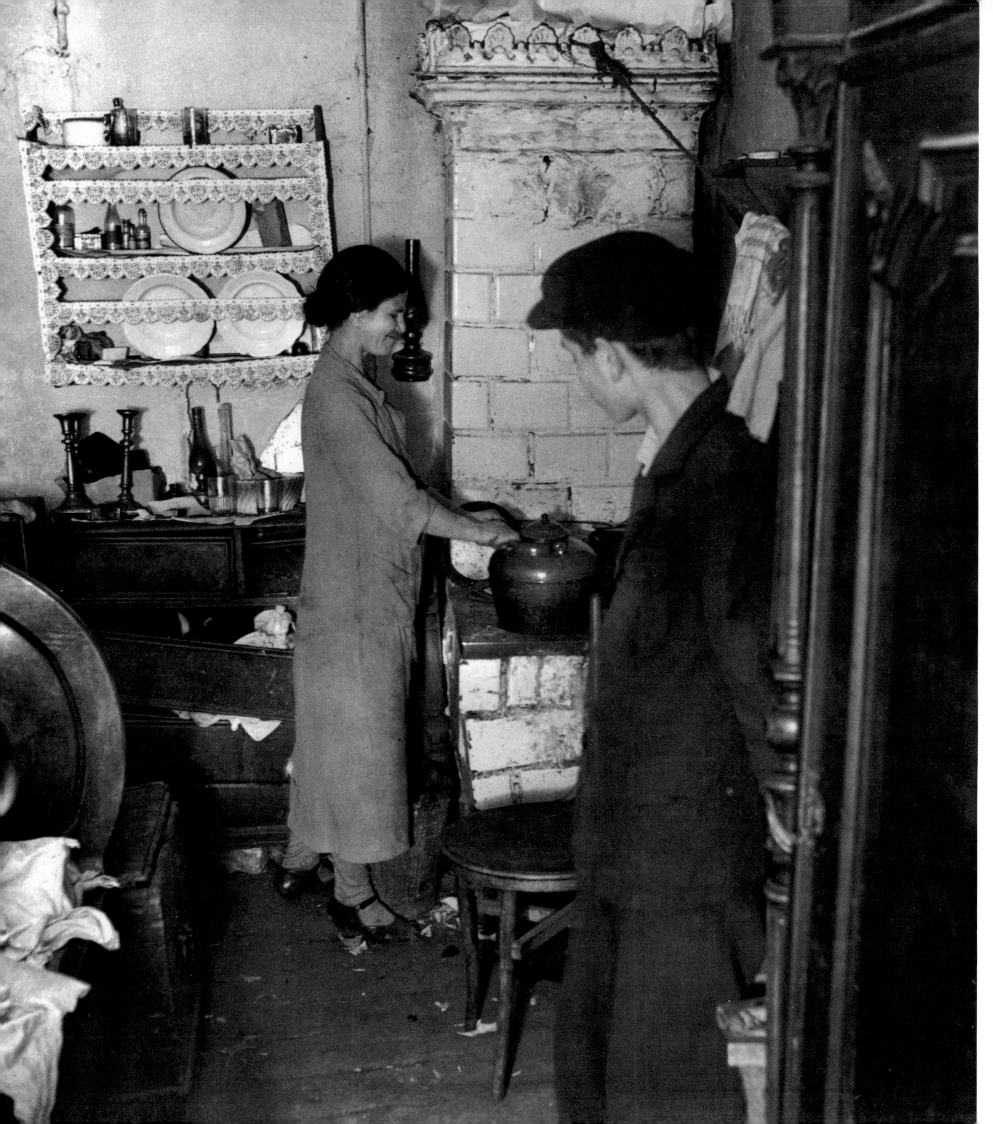

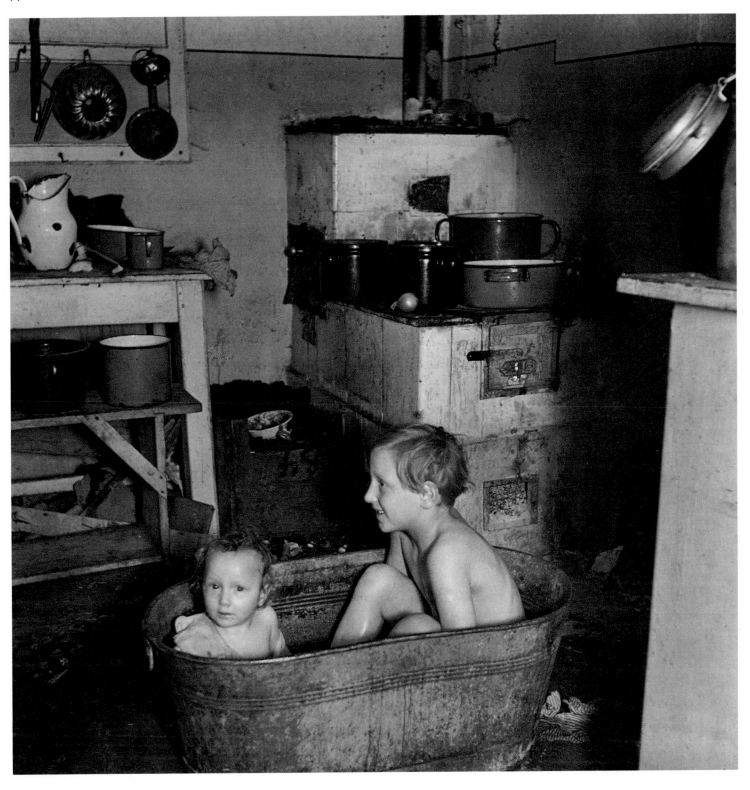

43: The corner kitchen of a one-room apartment. The stove also provided heat. Warsaw, 1936
44: The luxury of a bath in water heated on the coal stove. Warsaw, 1936

45: A one-room apartment shared by two families. Warsaw, 1938
46: Hungry child. Warsaw, 1938

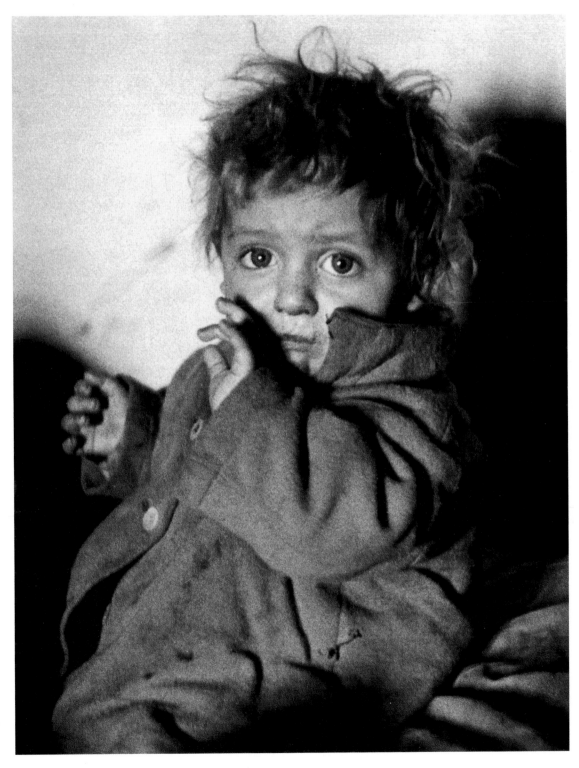

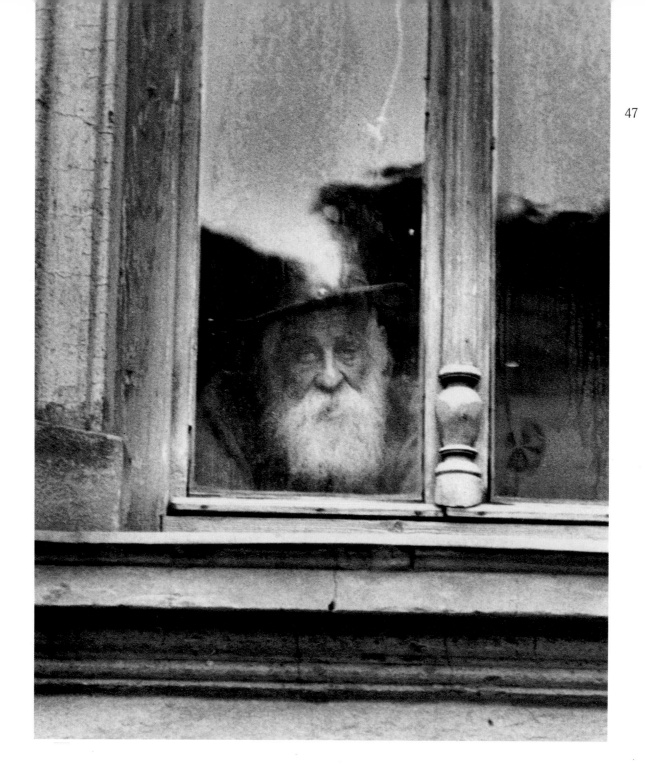

47: Uzhgorod, 1937
48: The youngest member of a porters' artel, looking for work. Warsaw, 1938

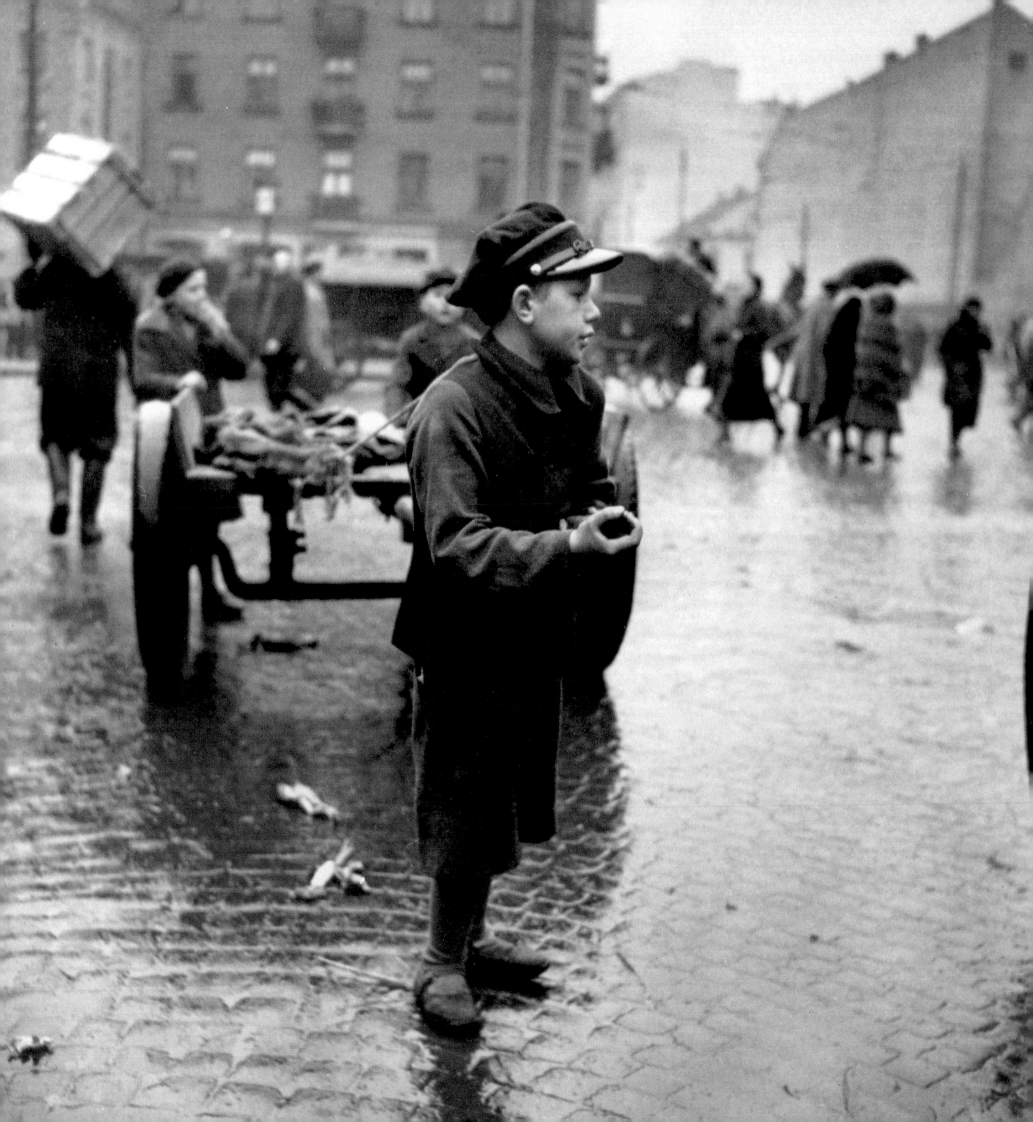

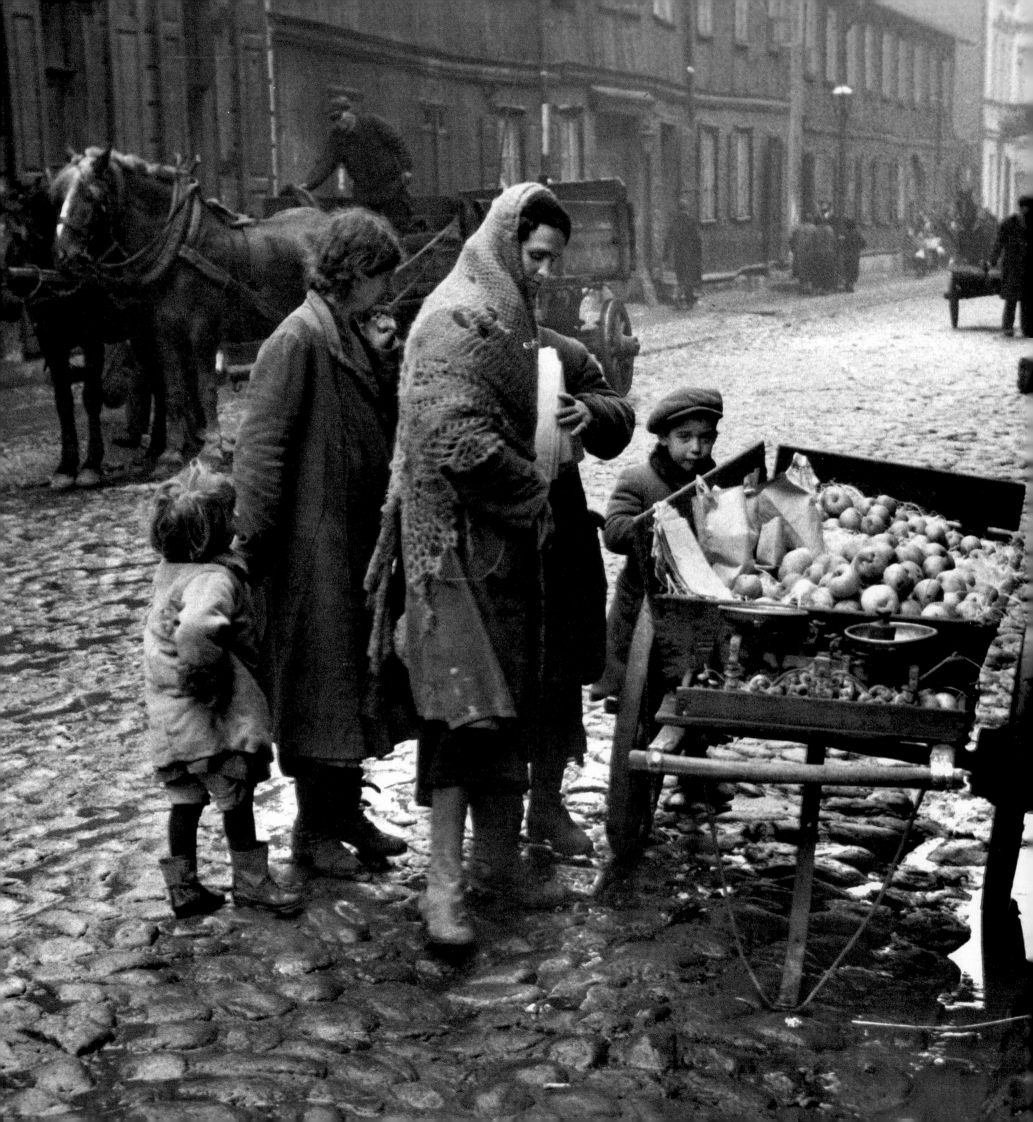

49: Apples for sale on the Gesia Ulica, one of the main streets in the Jewish quarter of Warsaw, 1937
50: The boycott changed peddlers into beggars. Warsaw, 1937

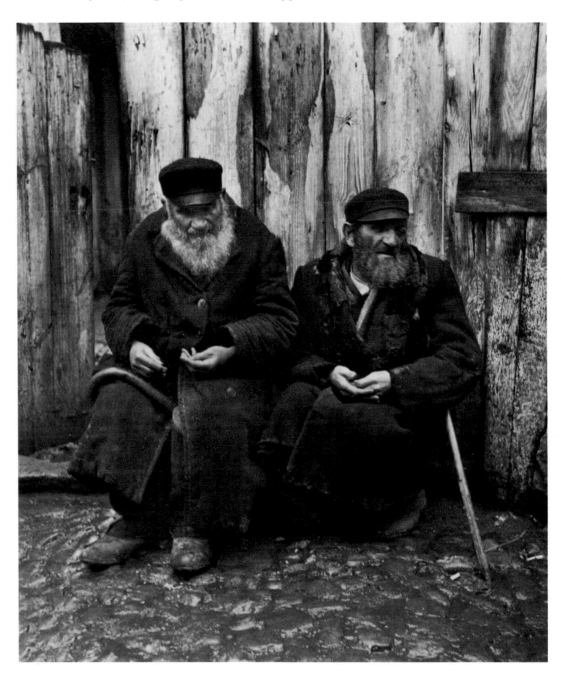

49 50

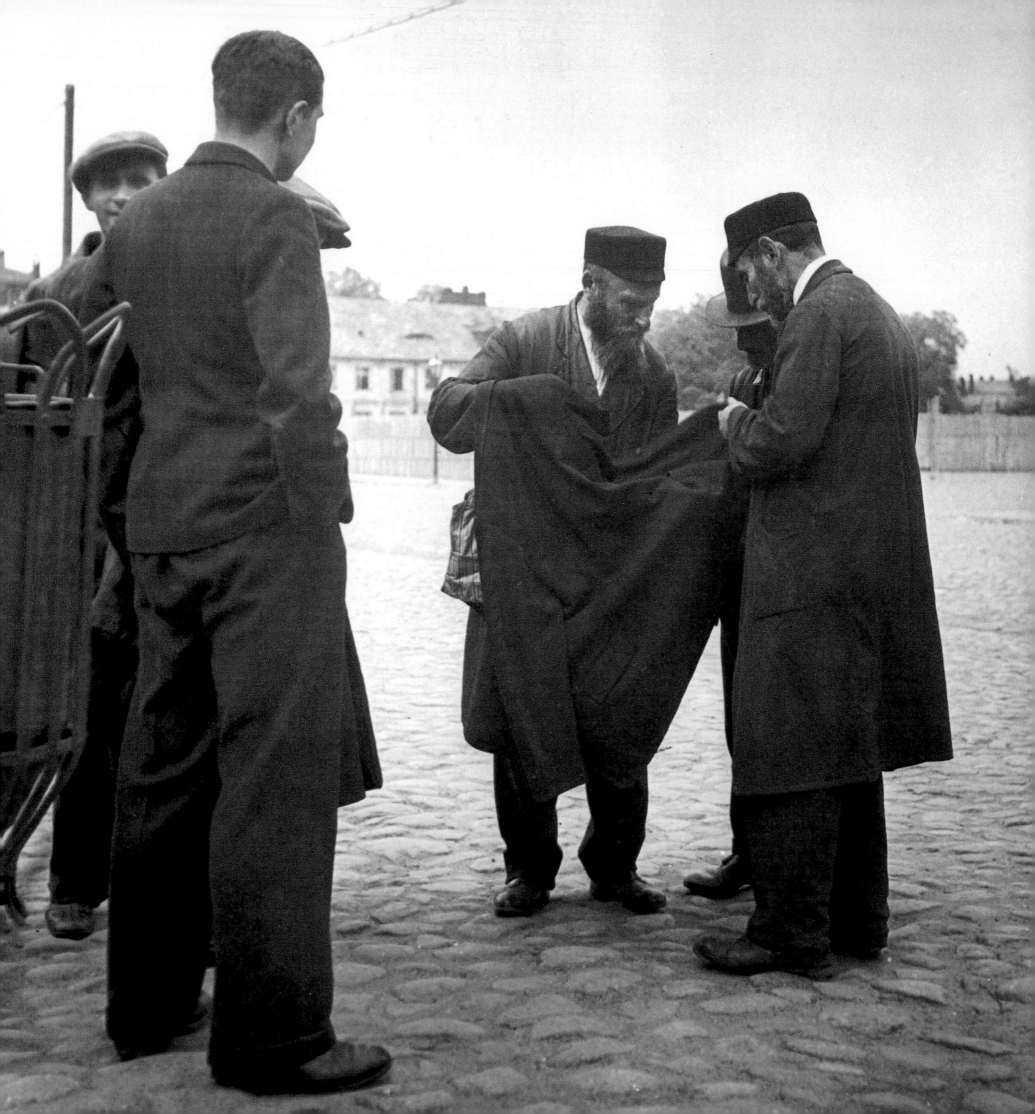

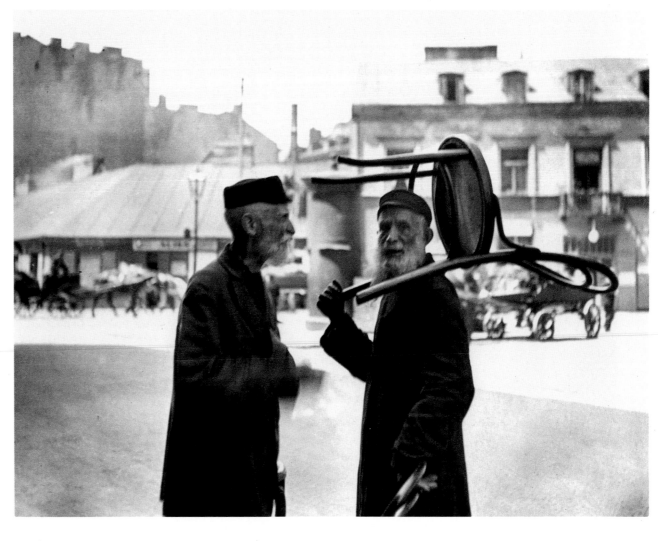

51: A used coat is offered for sale. Warsaw, 1936
52: Selling one of his chairs. Warsaw, 1936

53: In Baluty, a poor Jewish district of Lodz, 1937
54: In Grodzisk, a town near Warsaw, 1937

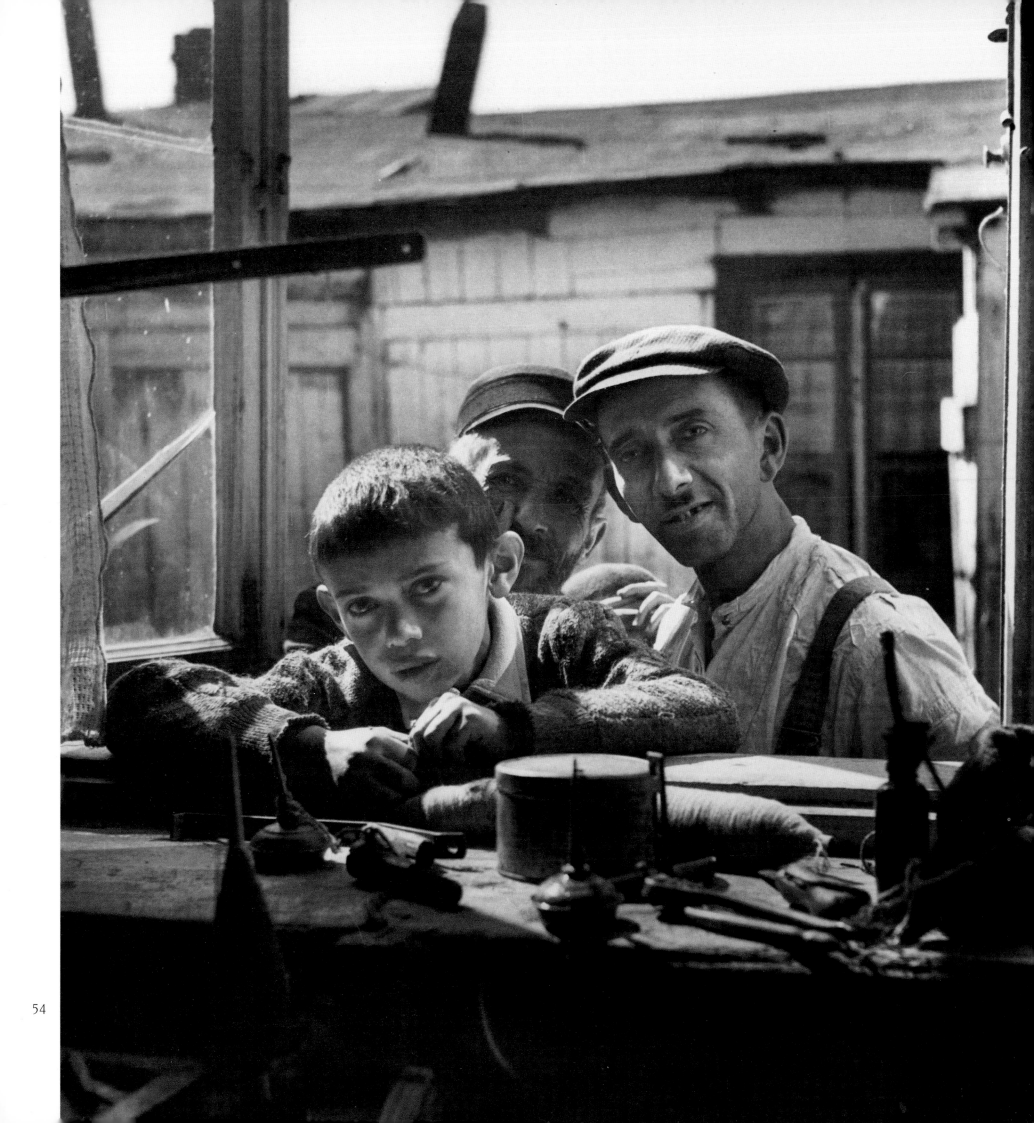

55 and 56: City children at a summer camp sponsored by the TOZ (Jewish Health Society).
The children were taught to put their shoes in a circle and remember the place. Slonim, 1936

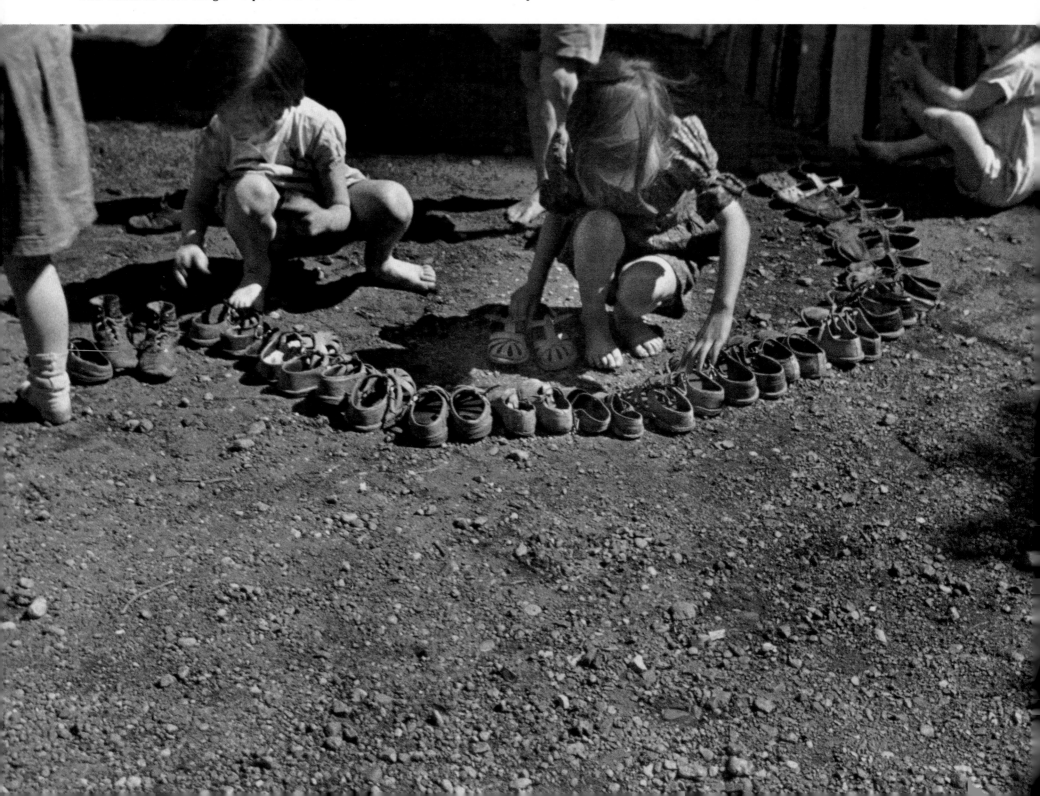

56

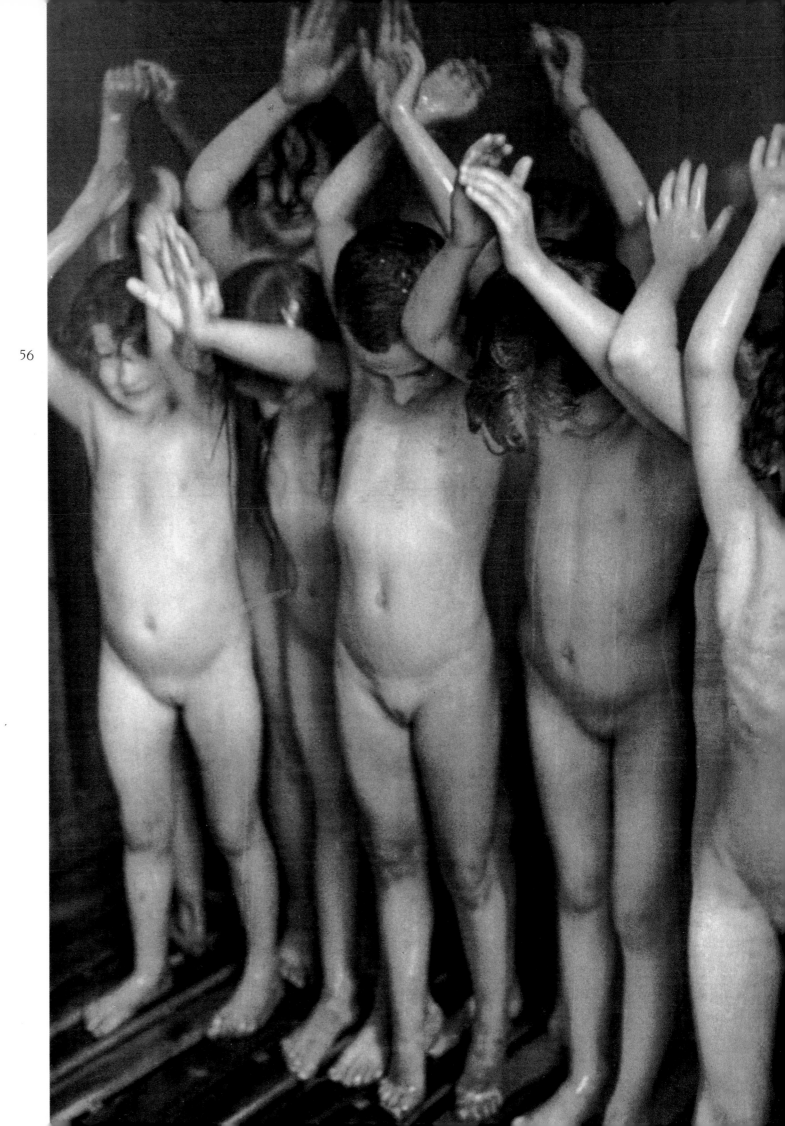

57: The teacher had asked, "What is the biggest city in the world?" I would have helped the girl, but I didn't know the answer either. Warsaw, 1937
58: One man is on the way home. The other man has no home; the bag contains all his possessions. Warsaw, 1938

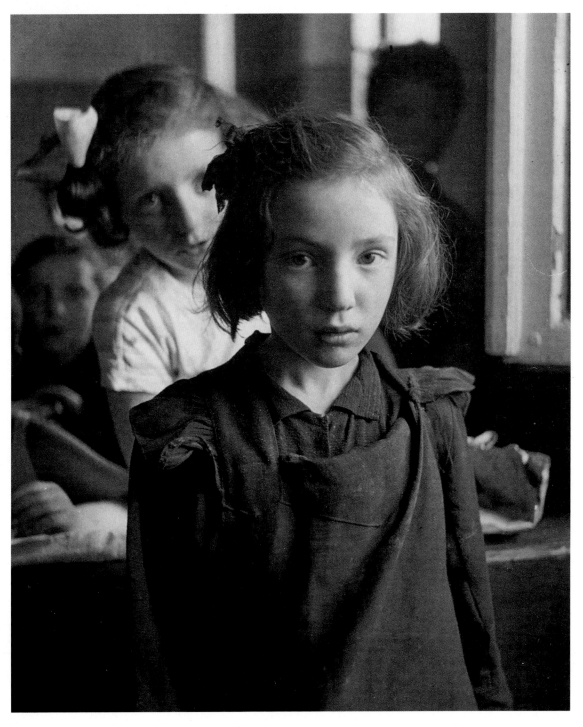

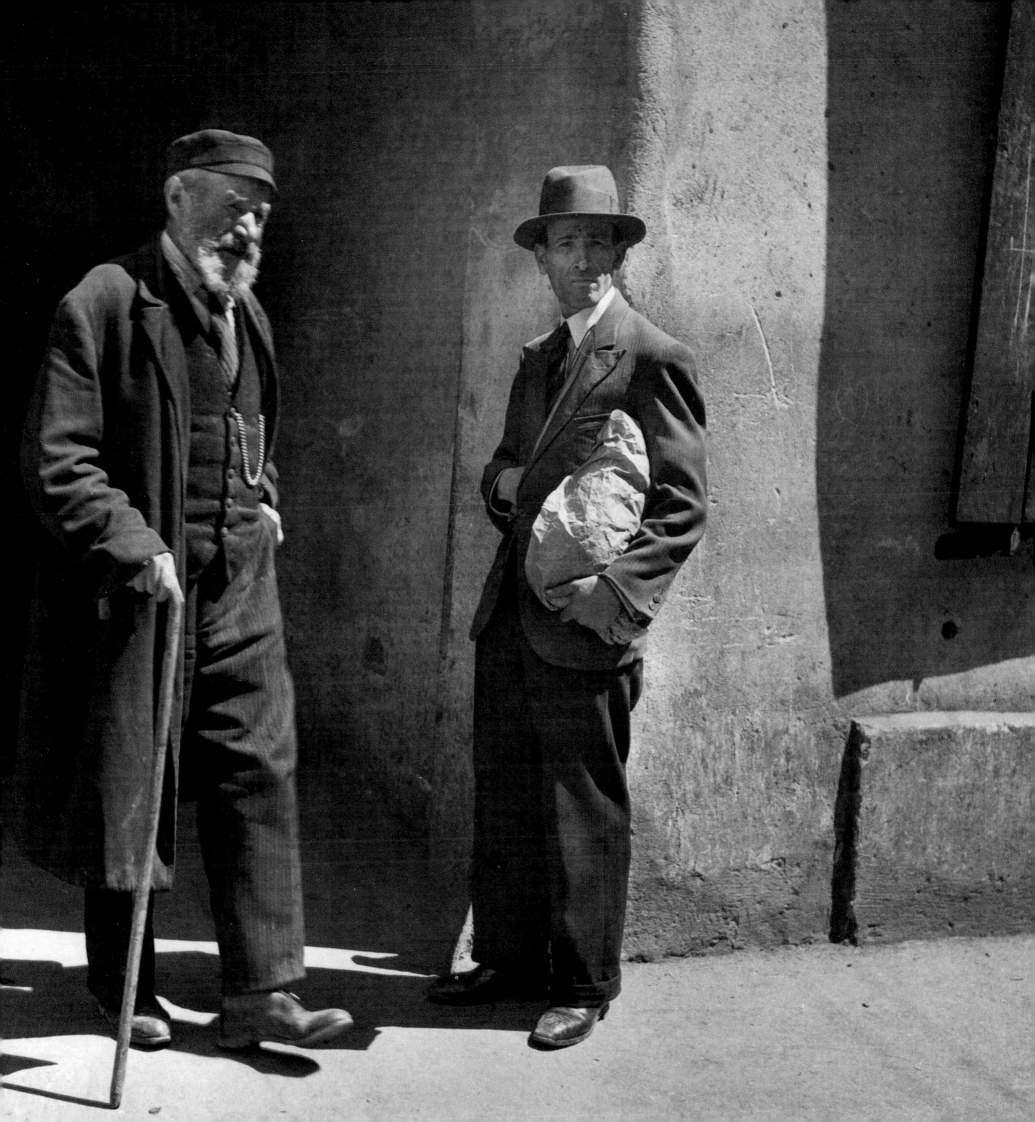

59: Collecting contributions for the repair of a hundred-year-old synagogue. Warsaw, 1938
60: Street vendors. Warsaw, 1938

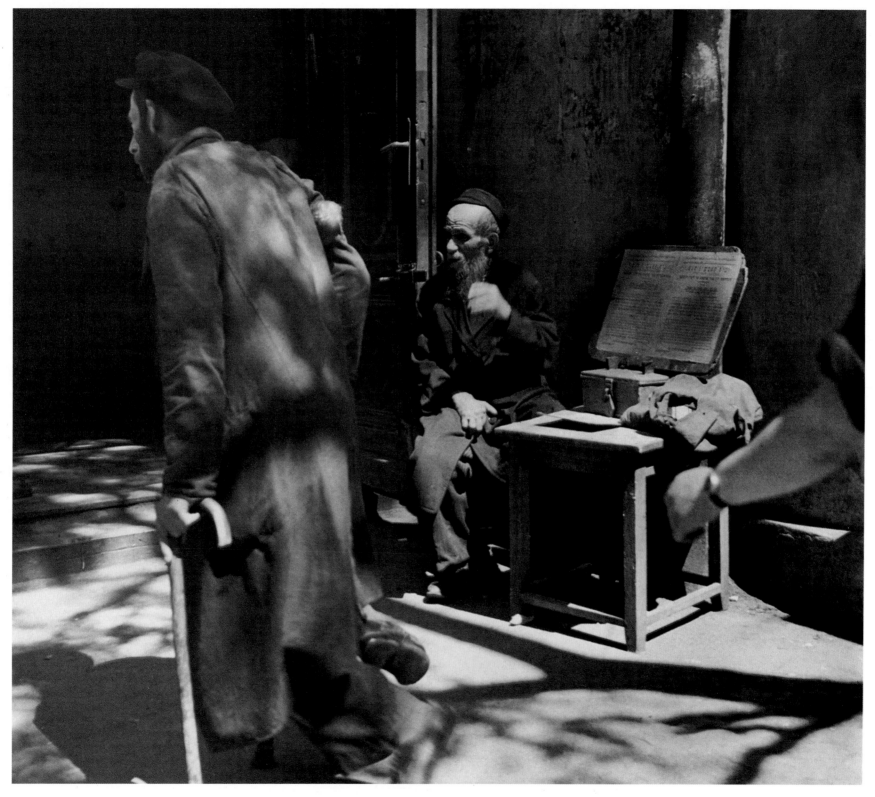

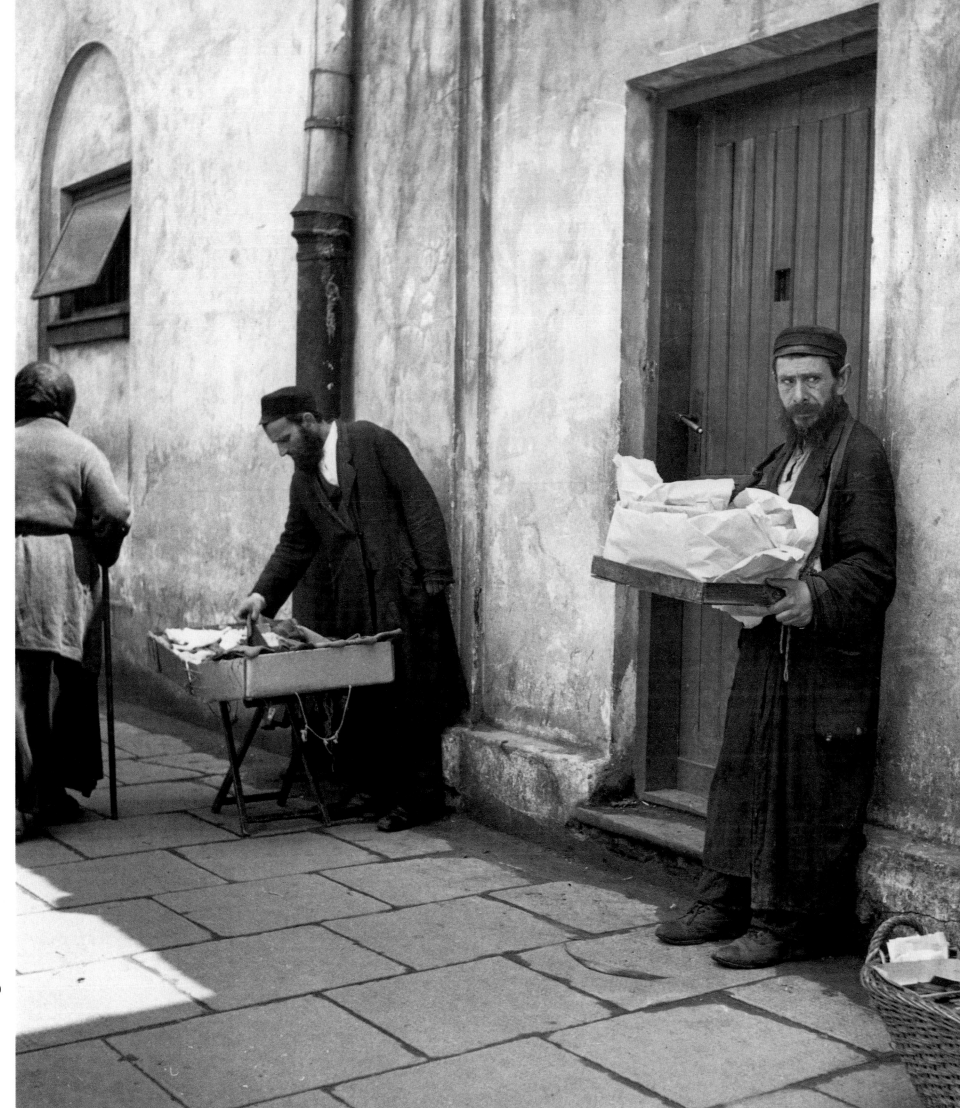

61 and 62: Members of a porters' artel. Warsaw, 1938

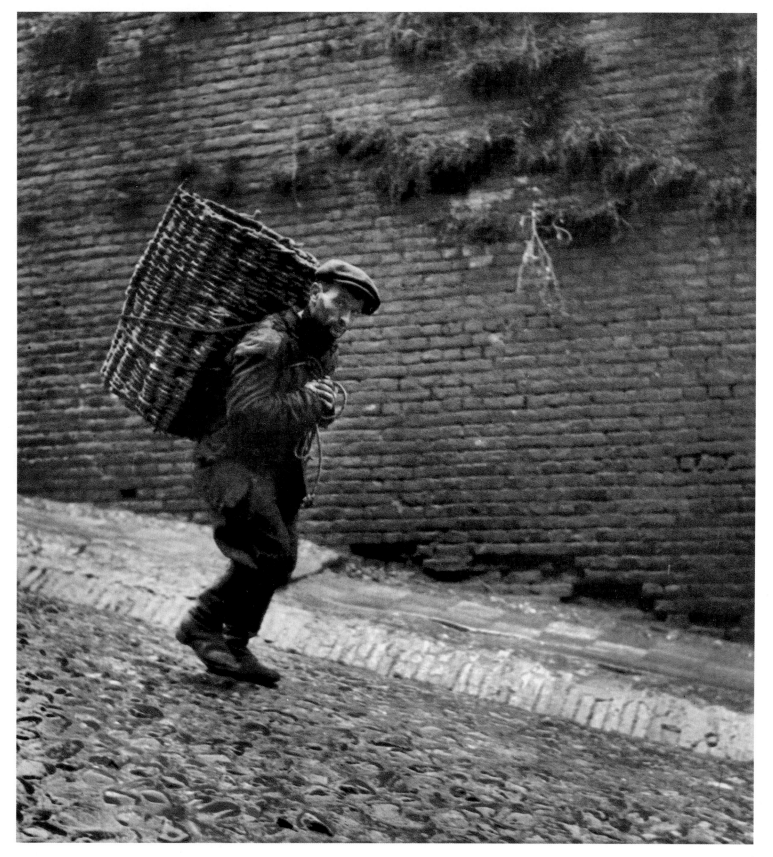

61

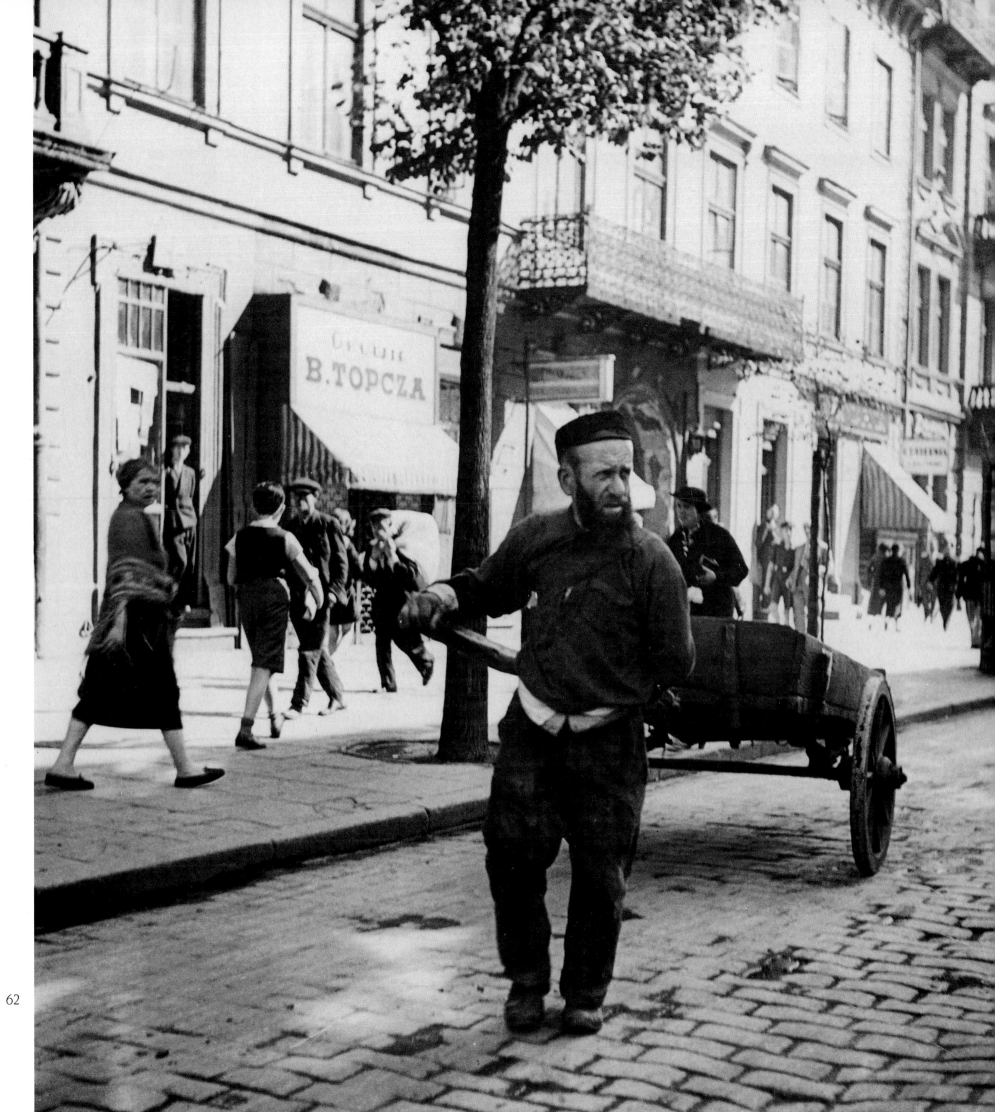

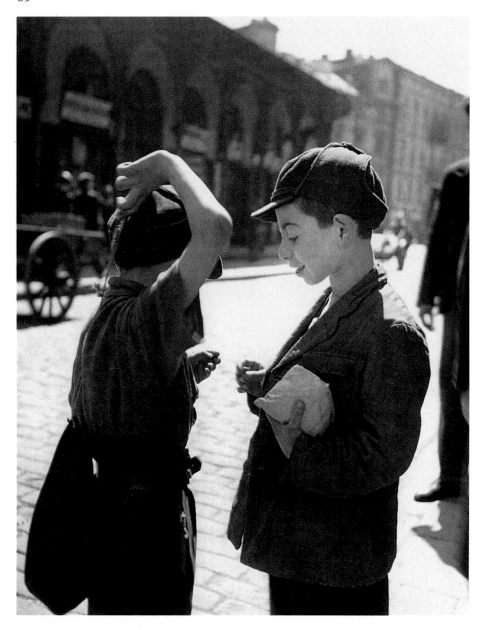

63: Two boys compare Purim gifts. Warsaw, 1936
64: A yeshiva boy negotiating for an "ess tog," an eating day. The man
agreed to provide him with dinner on Thursdays. Warsaw, 1936

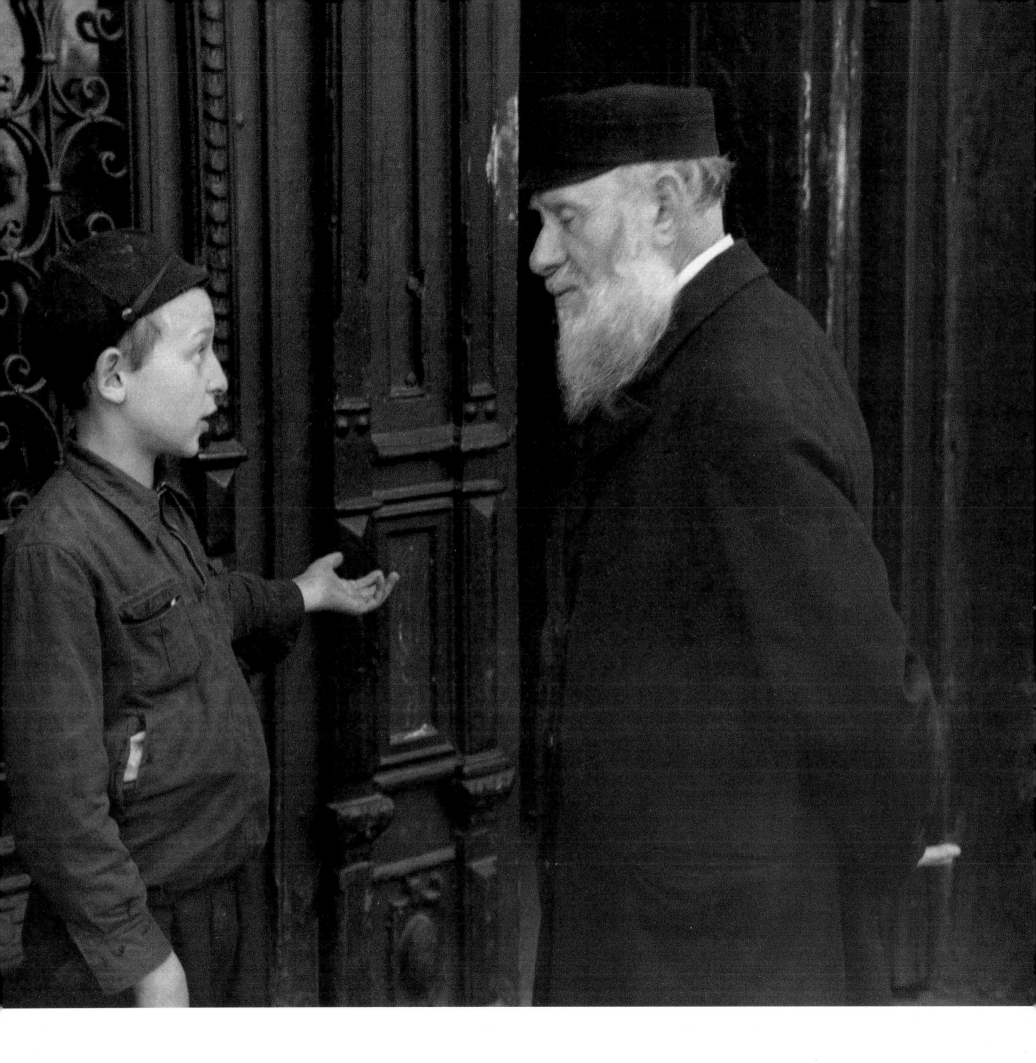

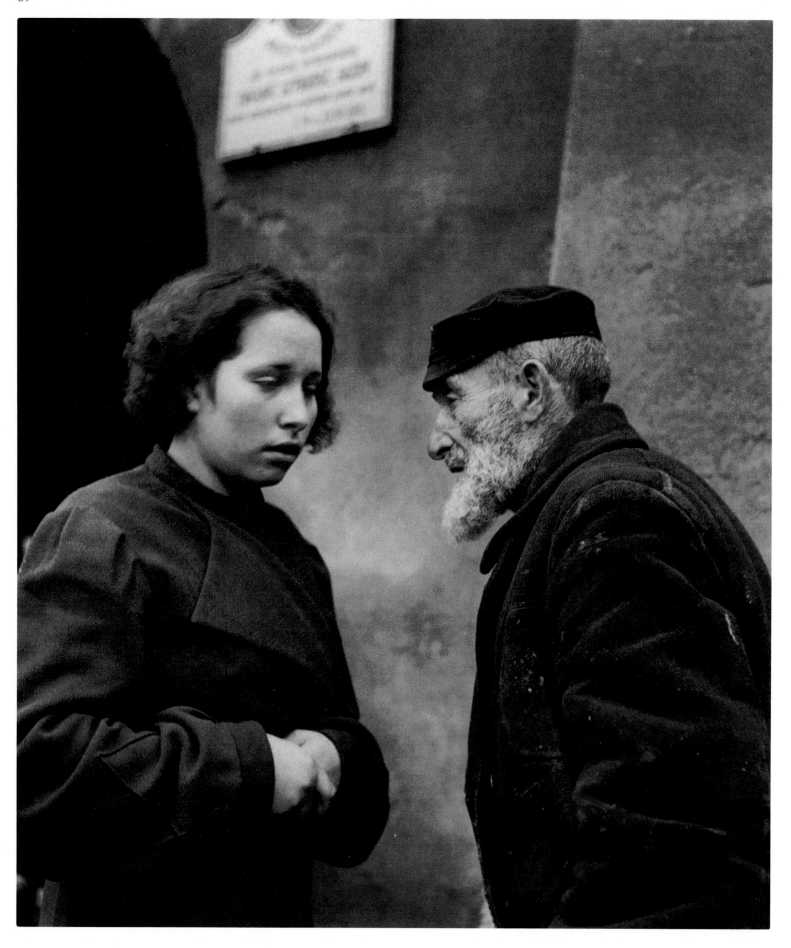

65: Granddaughter and grandfather. Warsaw, 1938
66: A family of bagel peddlers. Warsaw, 1938

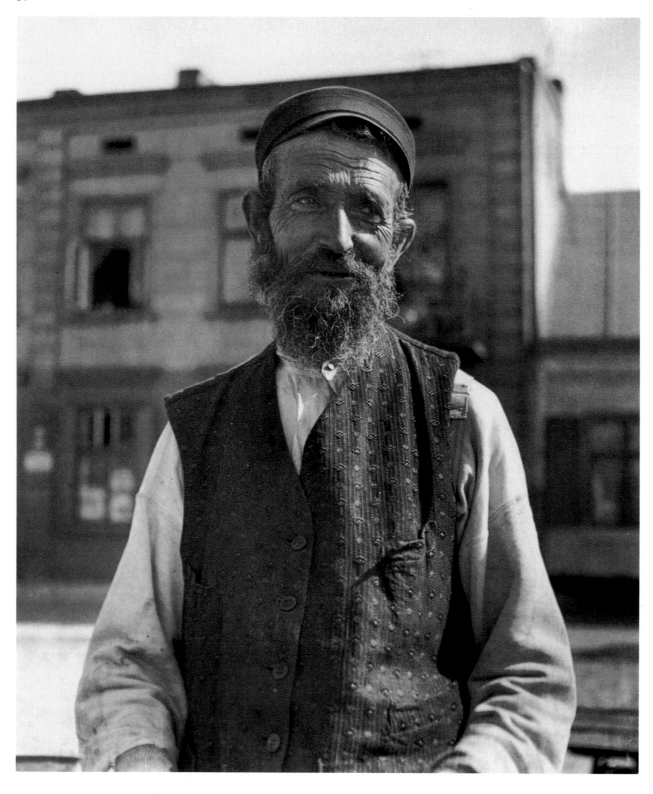

67: My coachman. Slonim, 1937
68: At the Karcelak, the open-air market in Warsaw, 1937

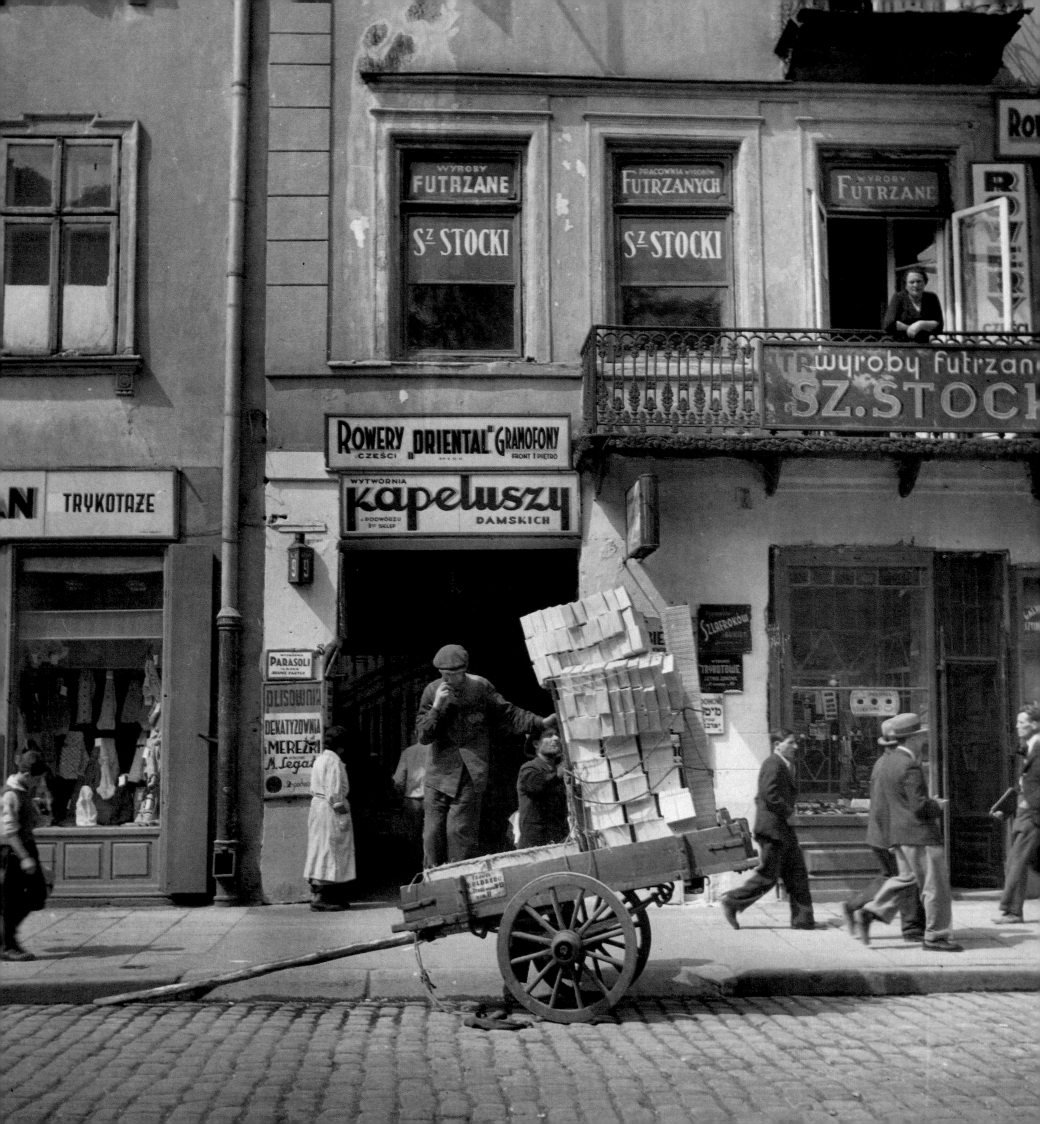

69: In place of a horse, this porter had to harness himself to his cart. Warsaw, 1937
70: A porter at rest. Warsaw, 1937

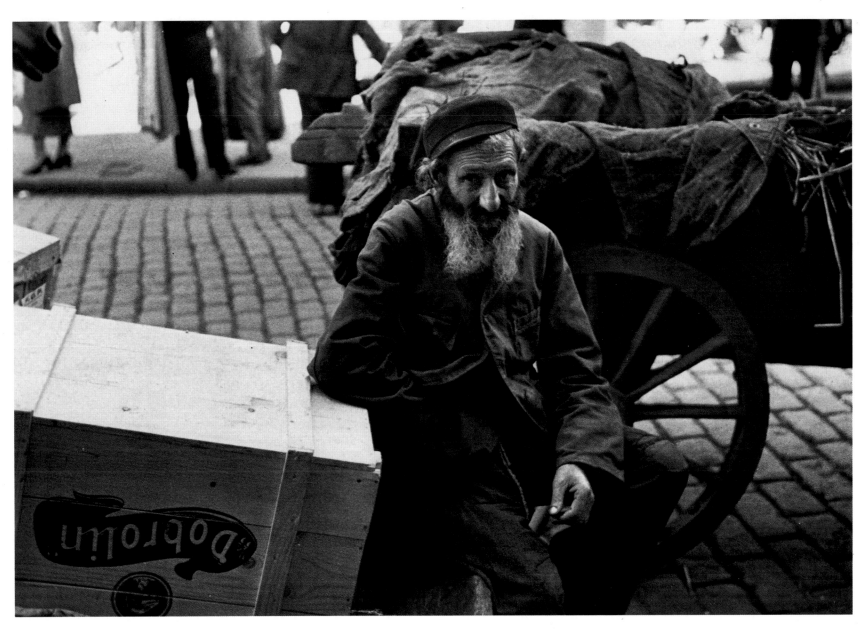

71: A lemonade peddler. Warsaw, 1936
72: A porter asleep on top of his carrying box. He is holding on to his most valuable possession: his shoes. Warsaw, 1936

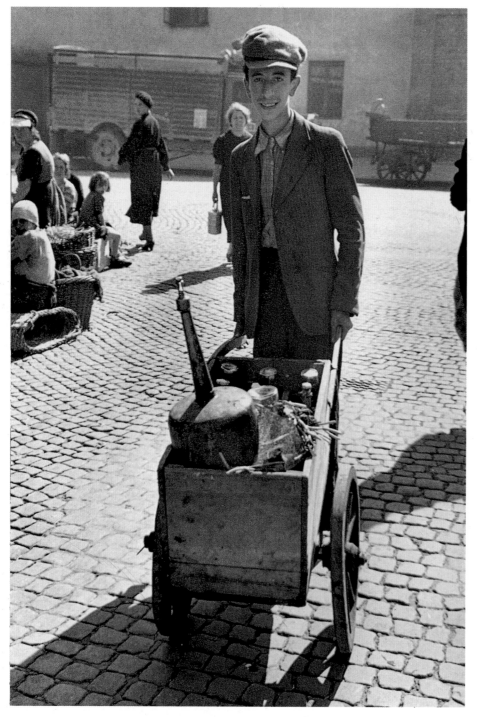

71

72

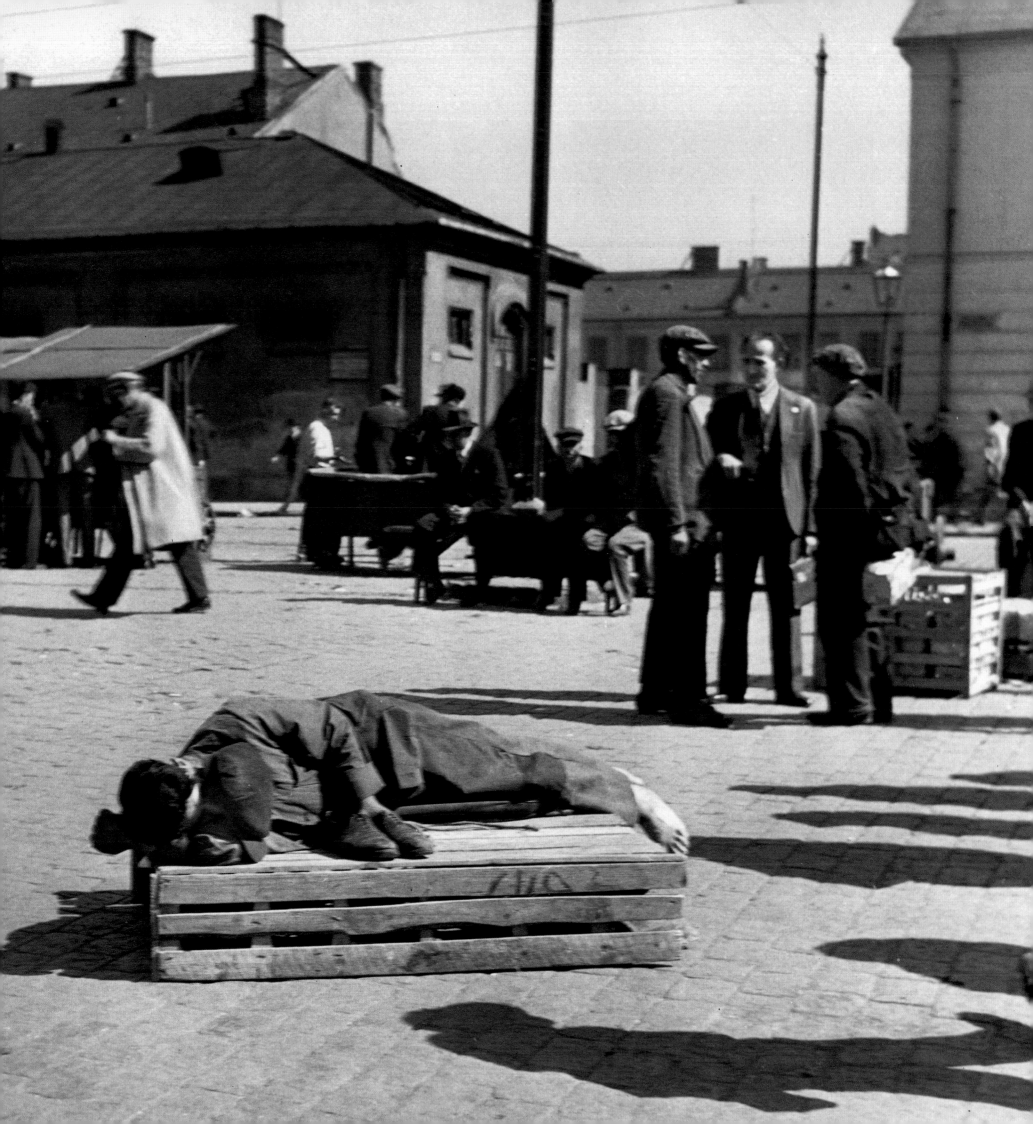

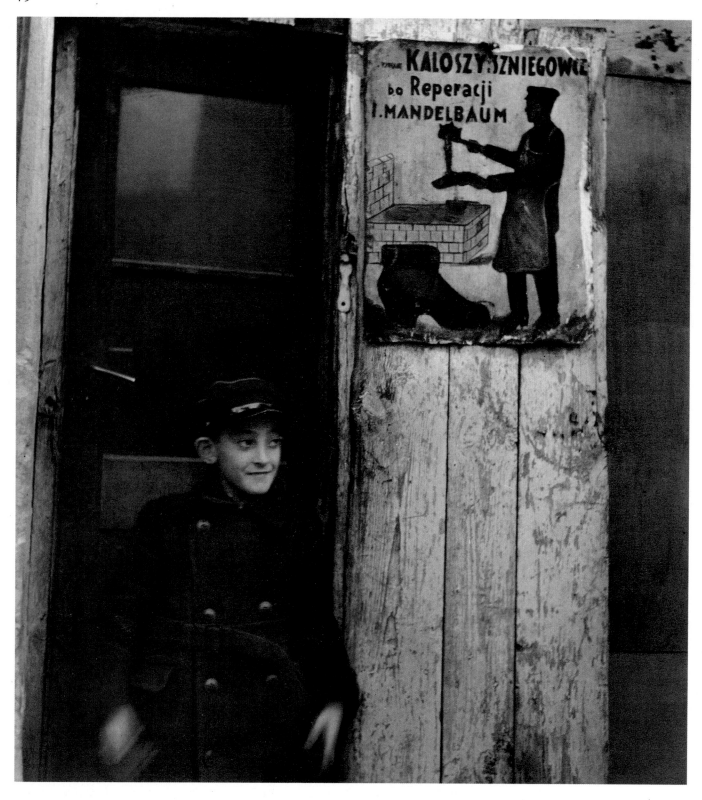

73: In the doorway of his home. Mukachevo, 1938
74: Another storekeeper locked out of his store because of the boycott. Mukachevo, 1938

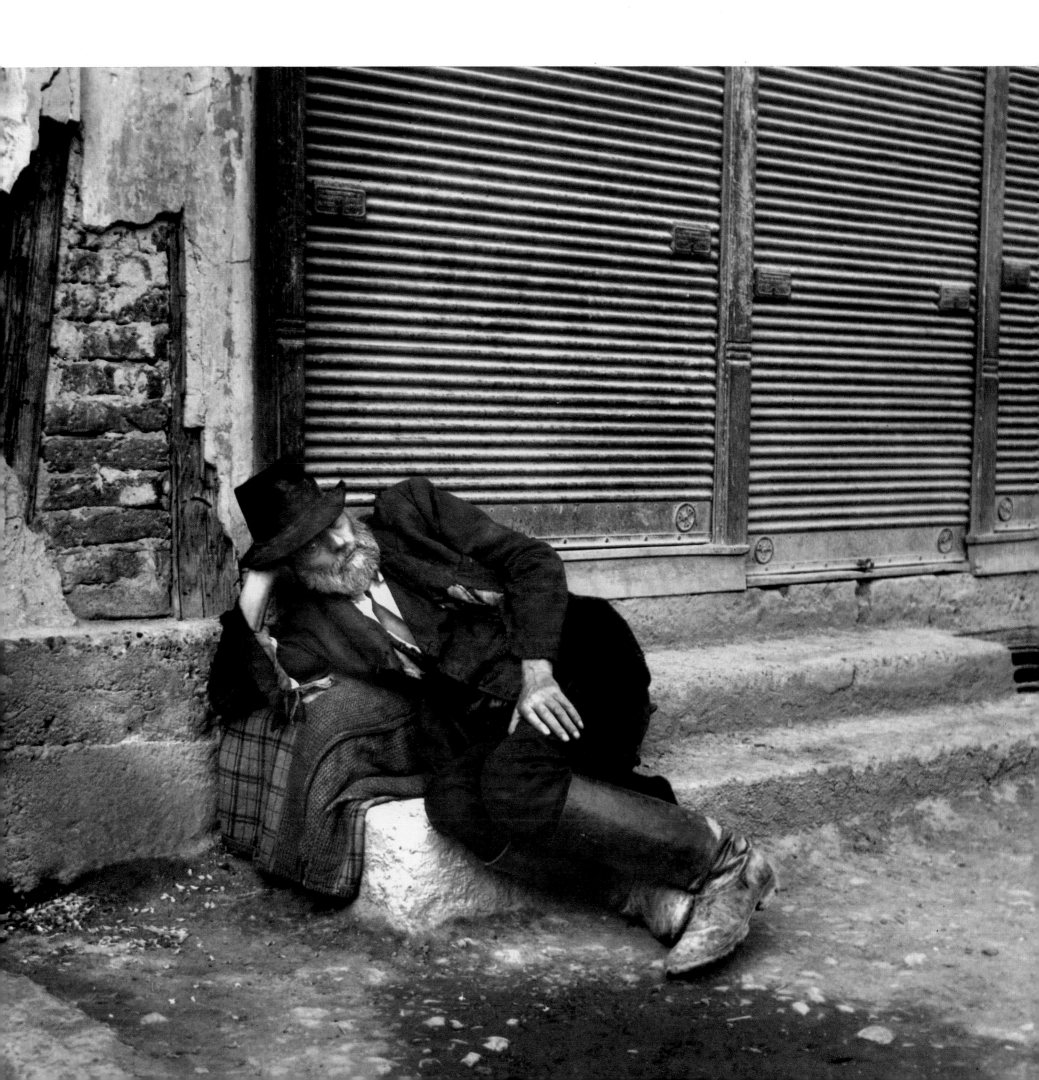

75: Studying cabala in a basement in Kazimierz, the old ghetto of Cracow, 1936
76: An elder of a village in Carpathian Ruthenia, 1938

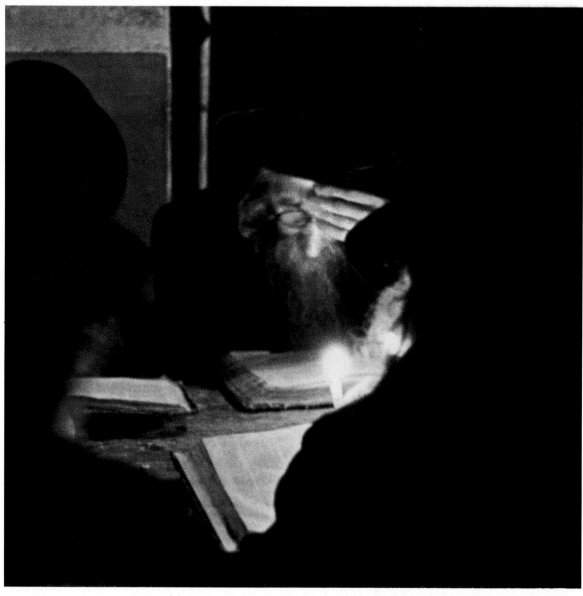

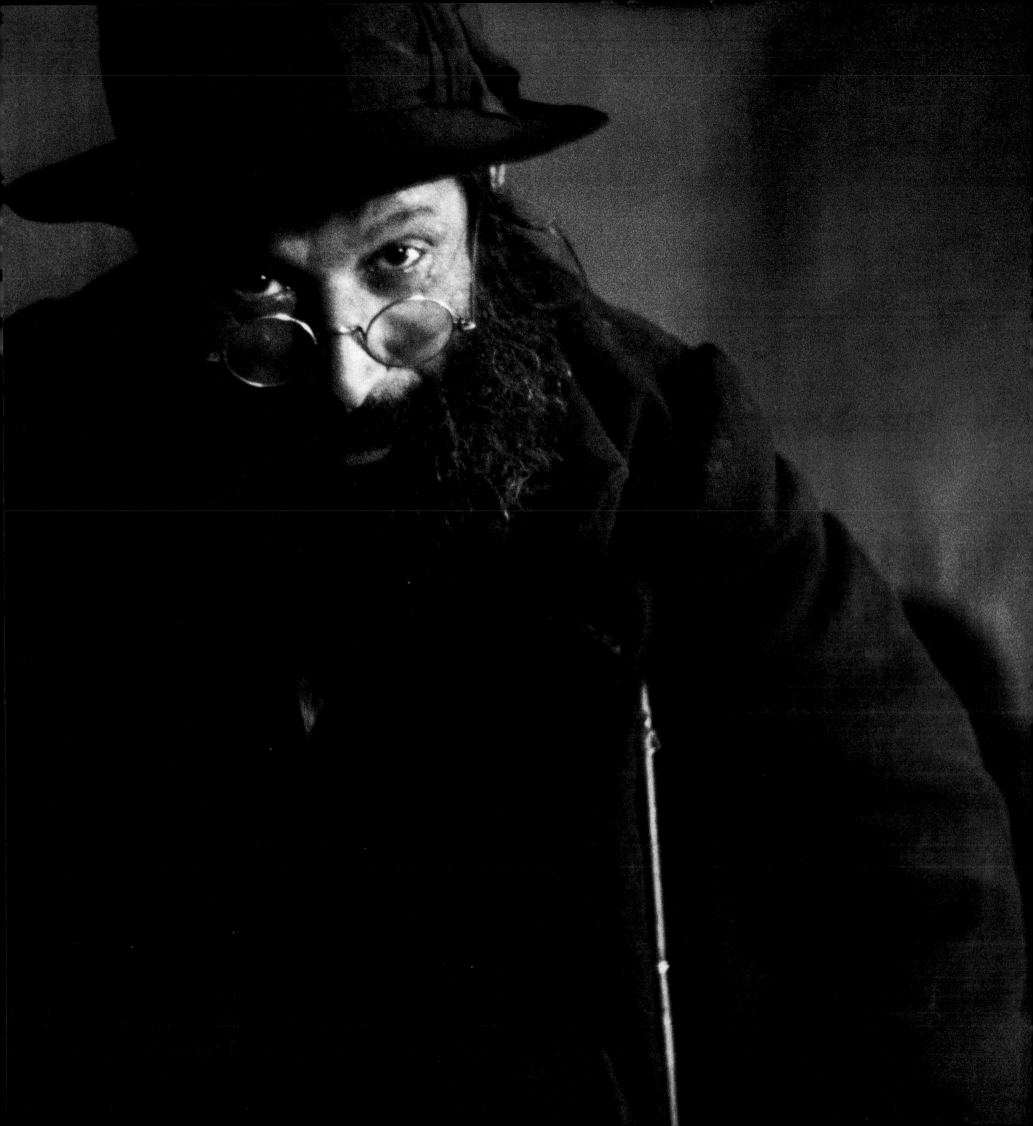

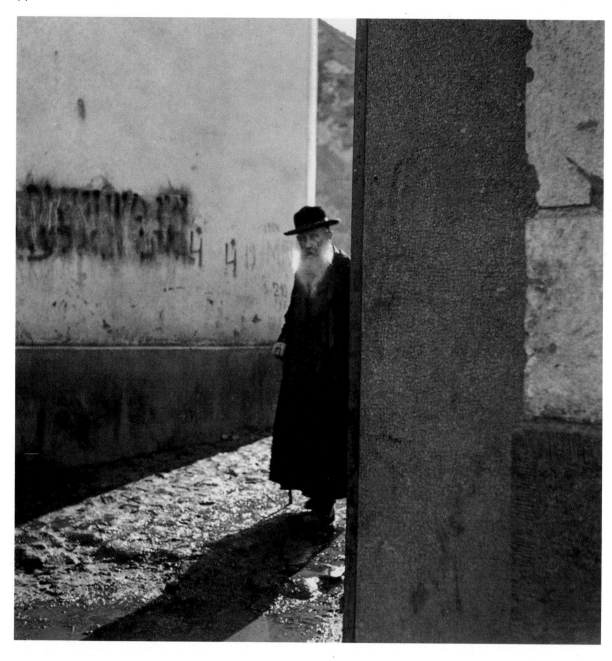

77: Mukachevo, 1938
78: Rabbi Baruch Rabinowitz in discussion with his students. Mukachevo, 1938

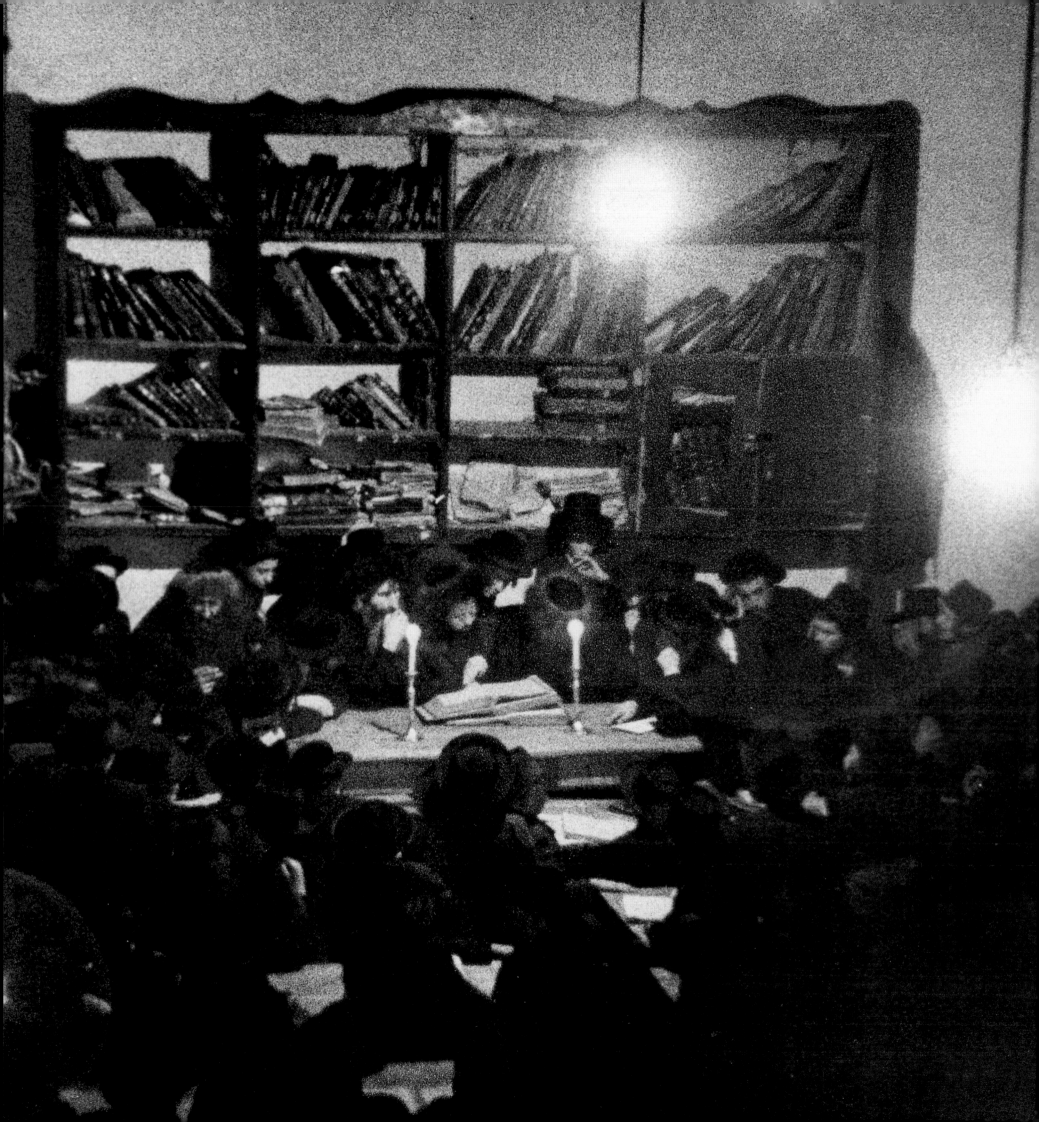

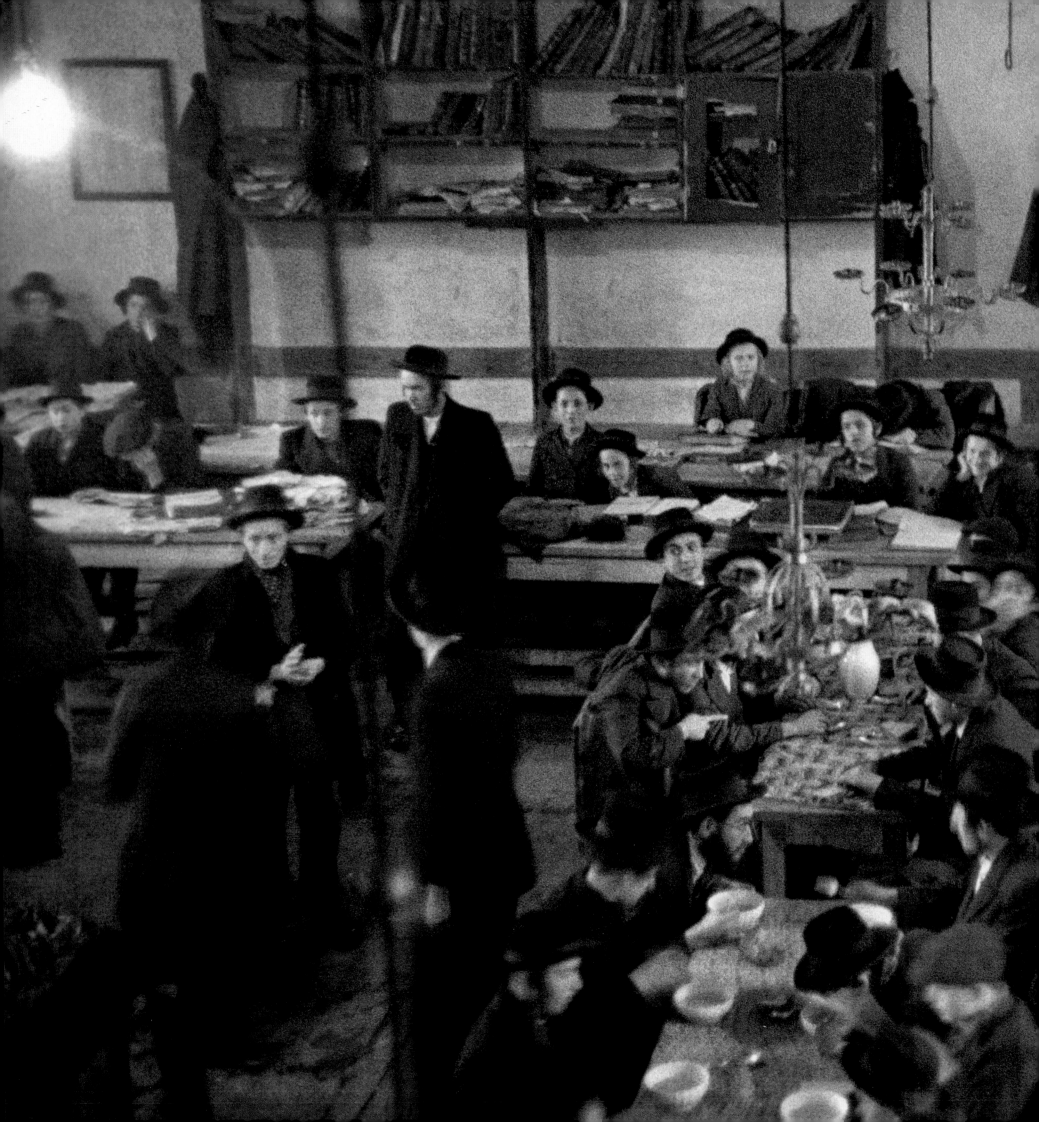

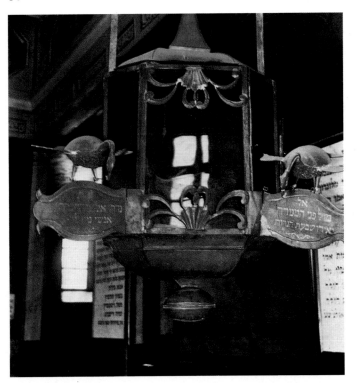

79: The study room in the mansion of Rabbi
Rabinowitz was transformed into a dining room
at mealtime. Mukachevo, 1938
80: A synagogue lamp. Lask, 1937

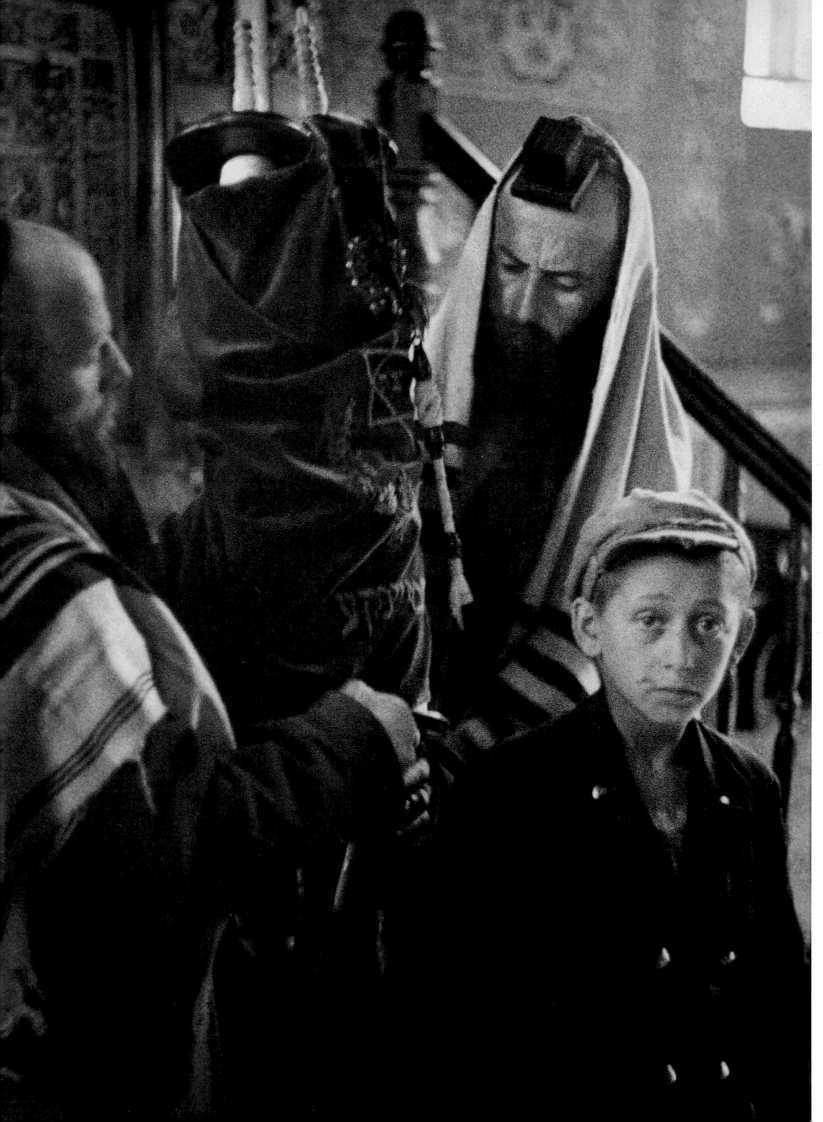

81: Thursday services. Lask, 1937
82: Morning prayers. Lask, 1937

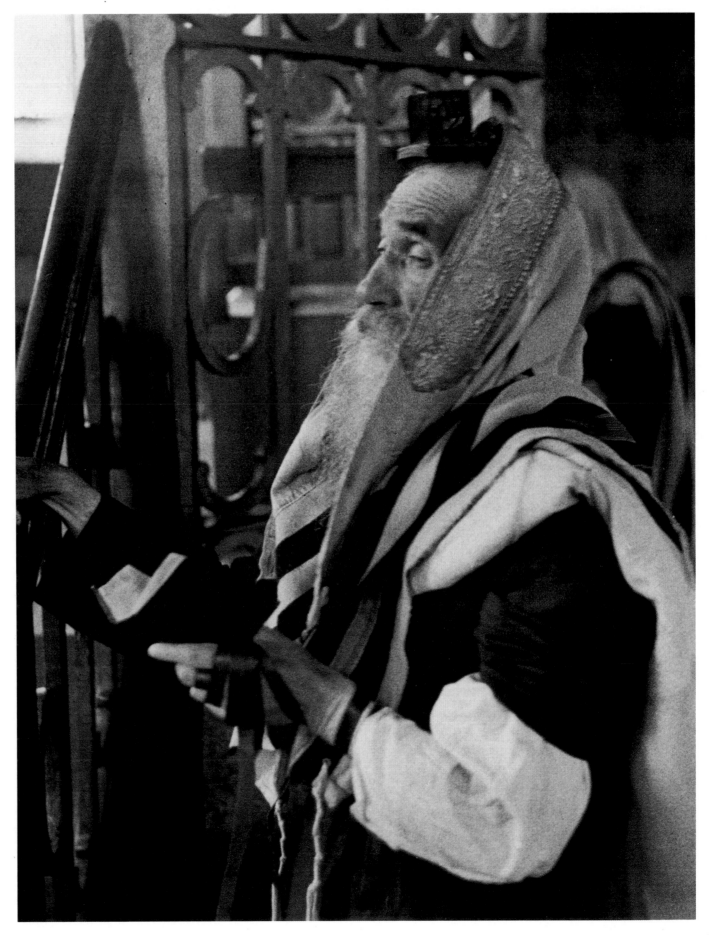

82

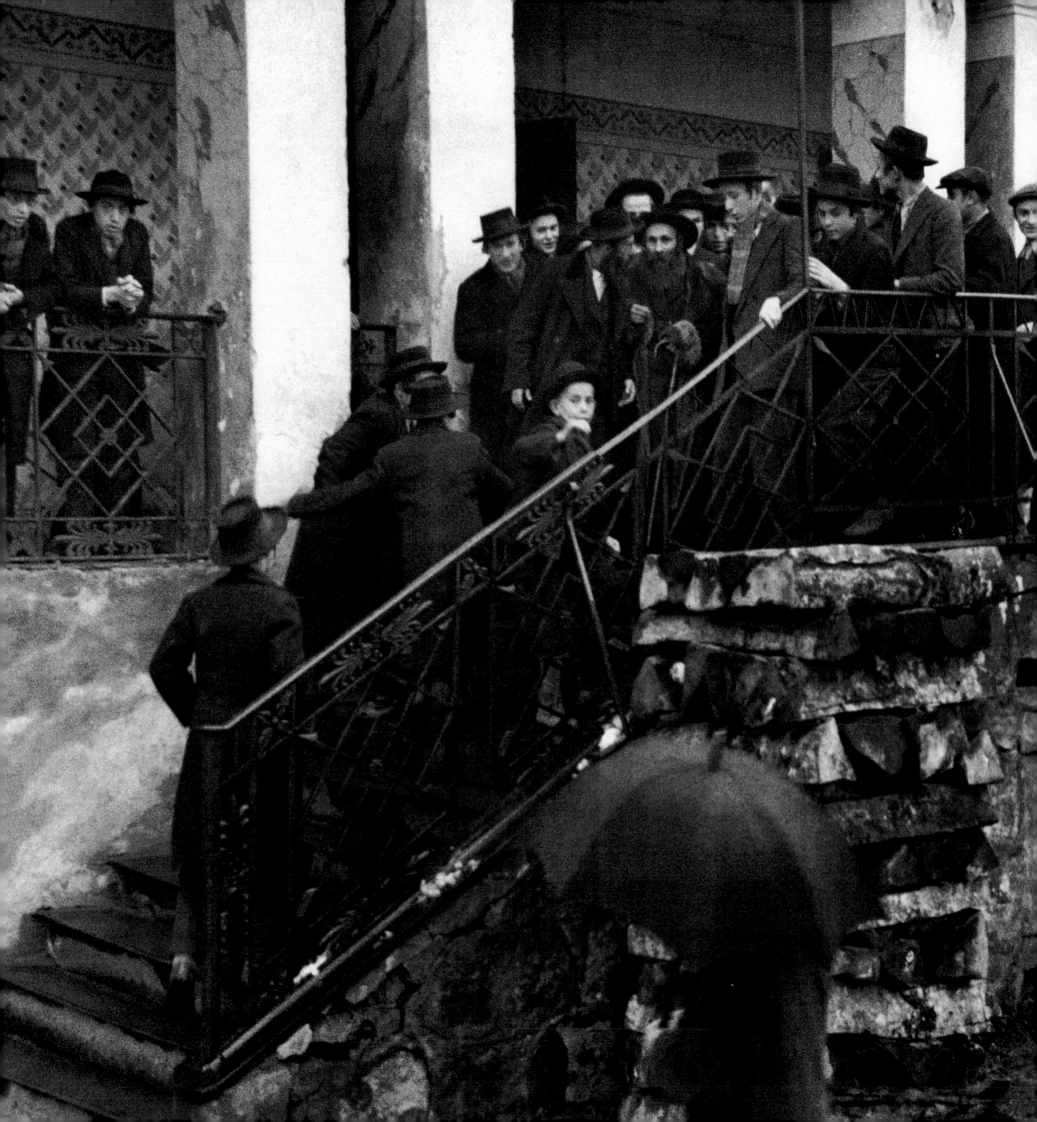

83: Rabbi Chuna Halberstam *(with a cane)* leaving the mansion of Rabbi Rabinowitz. Mukachevo, 1938
84: Rabbi Rabinowitz *(right)* in discussion with Rabbi Nuta Shloime Shlissel, chief justice of the bet din (the rabbinical court) of Mukachevo, 1938

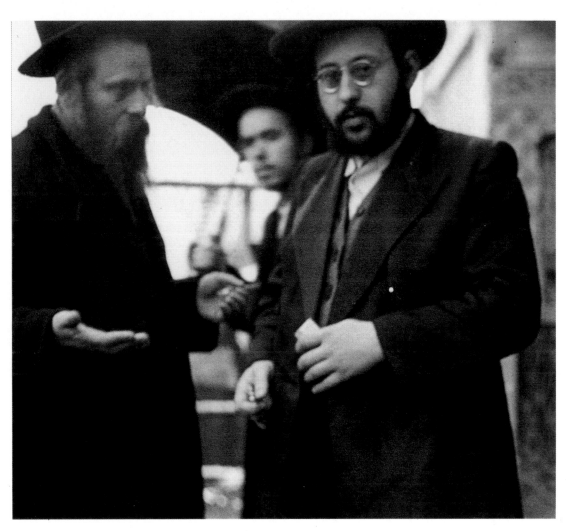

83 84

85: Rabbi Yechiel Chaim Wagschal, assistant to Rabbi Rabinowitz. Mukachevo, 1938
86: A rabbi and the leader of the choir on the way home after morning prayers. Mukachevo, 1938

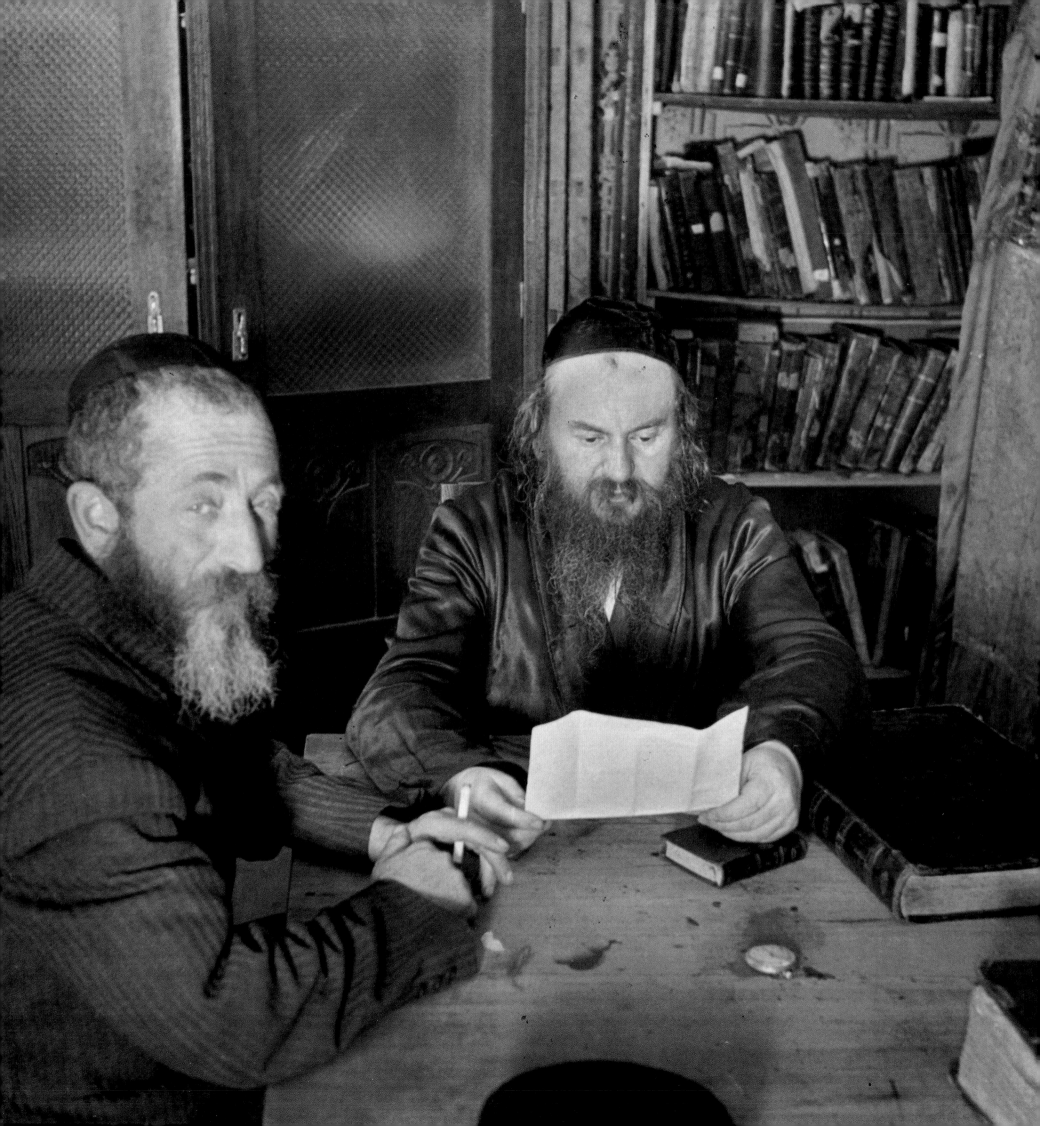

87: Rabbi Leibel Eisenberg *(reading)* and his shammes. Lask, 1936
88: Yeshiva student. Slonim, 1937

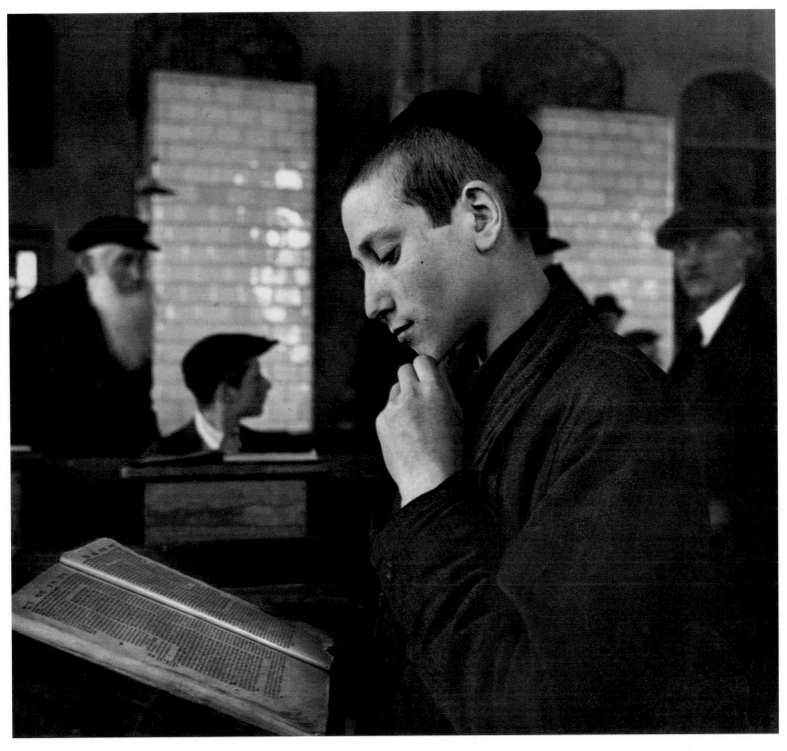

89 and 90: Old men of Pabianice, a city near Lodz, 1937
91: Yeshiva students in a discussion of the Talmud. Warsaw, 1936

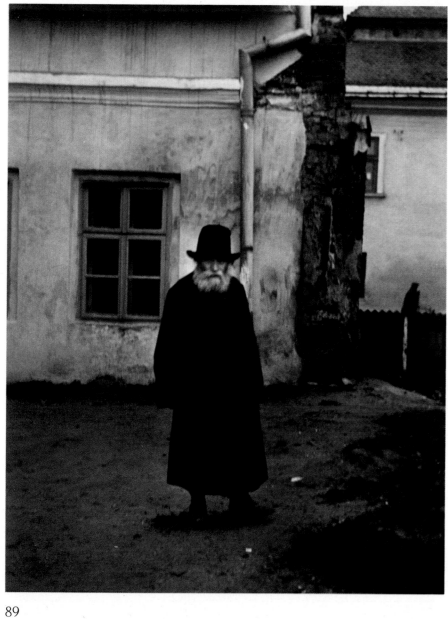

89

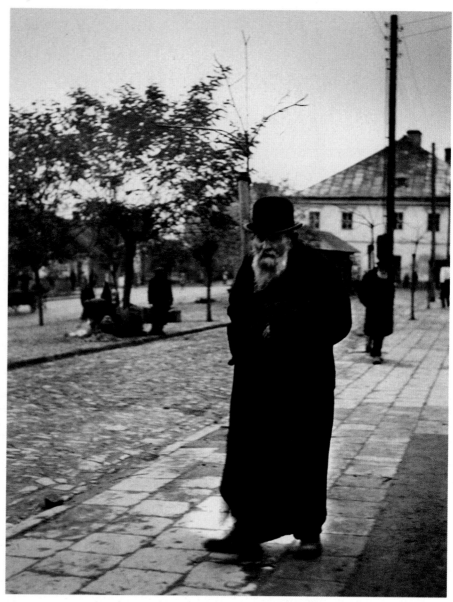

90

91

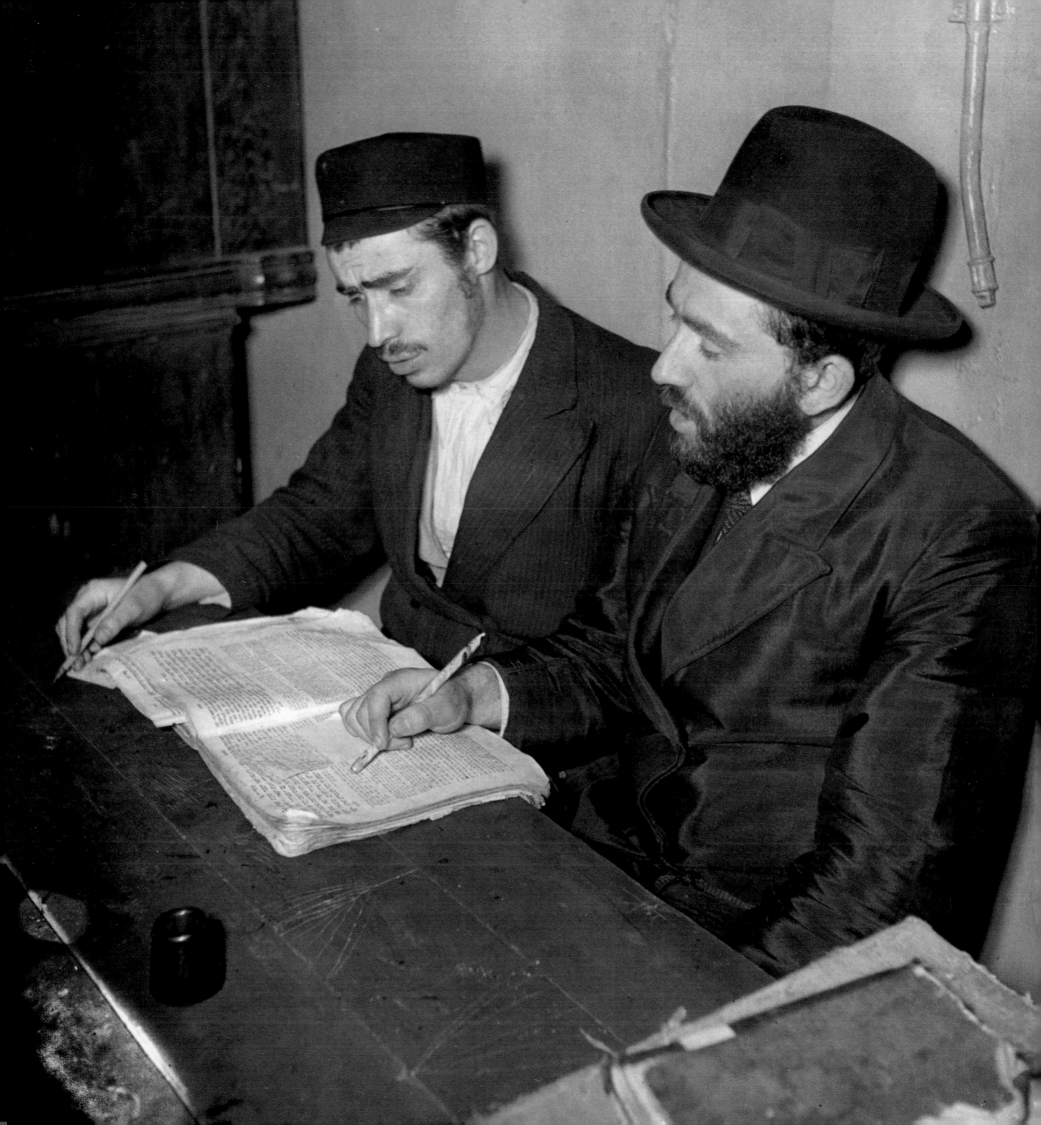

92: Yeshiva friends. The families of these students live far from Mukachevo. 1937
93: Worshippers leaving the synagogue. Mukachevo, 1937

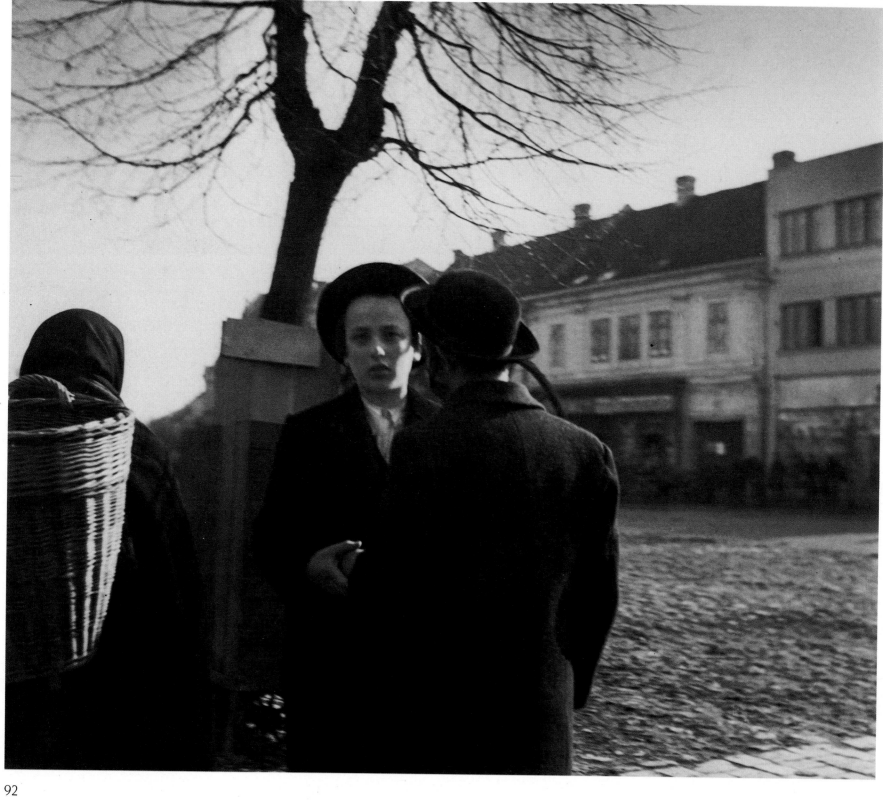

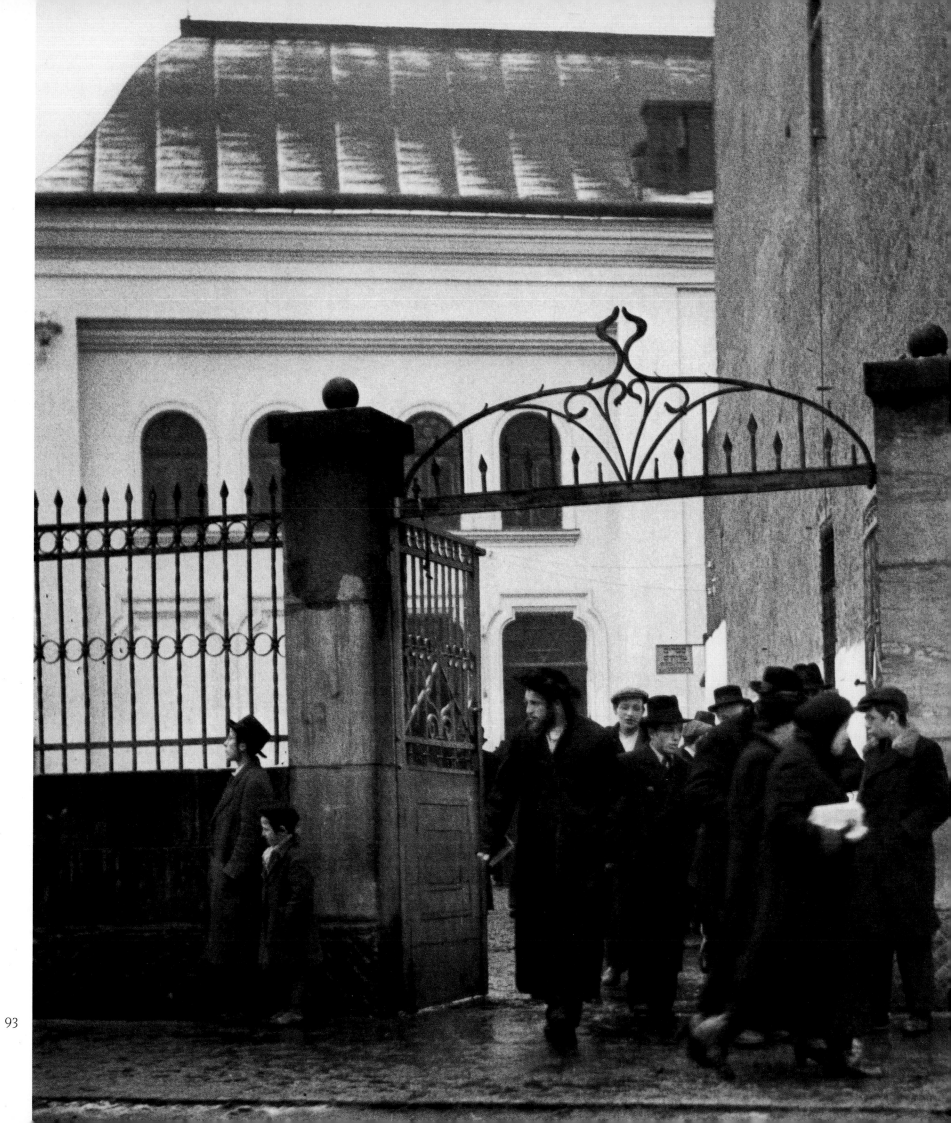

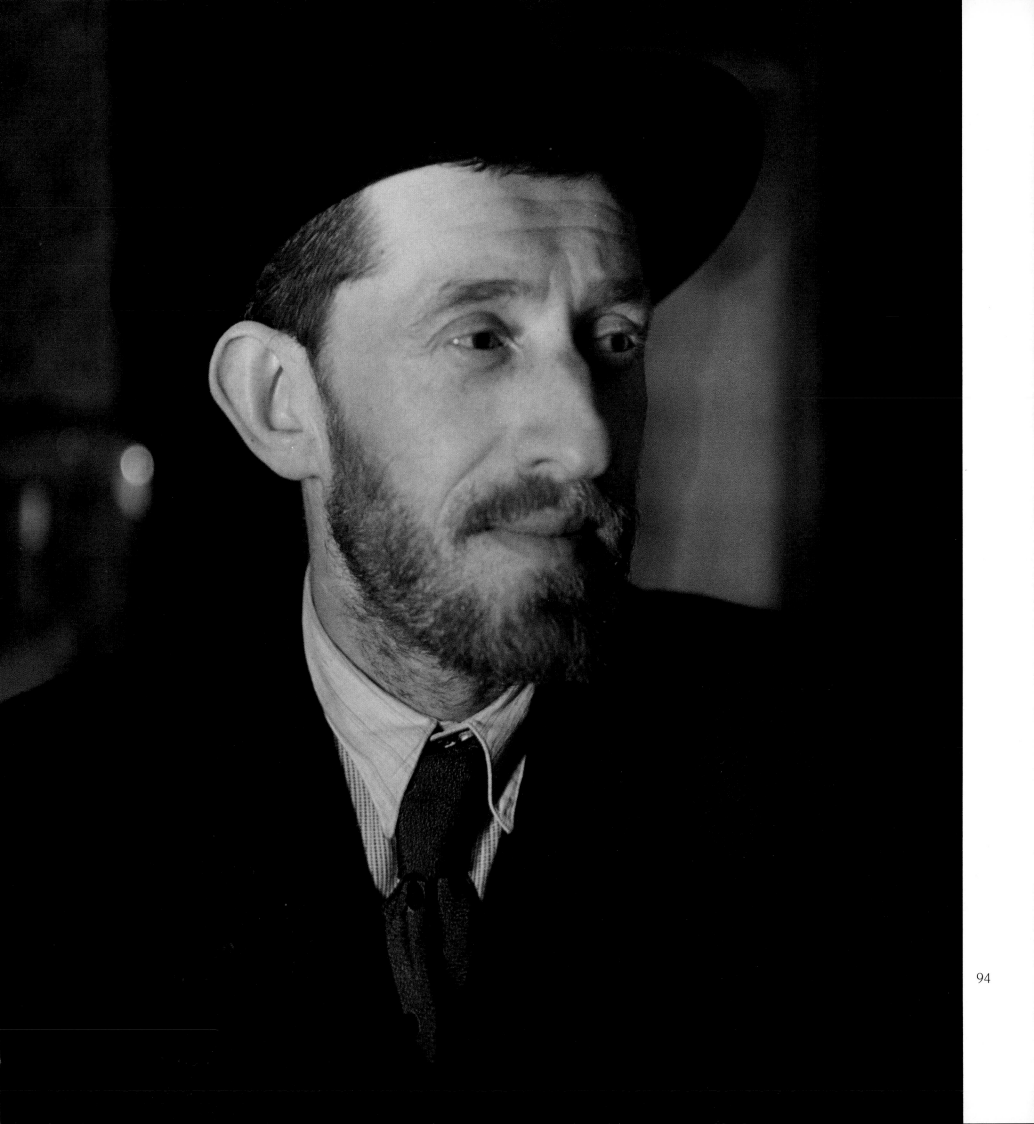

94: Henryk Schwartz, a traveling salesman. Mukachevo, 1936.
He miraculously survived a death camp and today lives in Israel
95: Lured by the sun, but studying the Talmud. Mukachevo, 1938

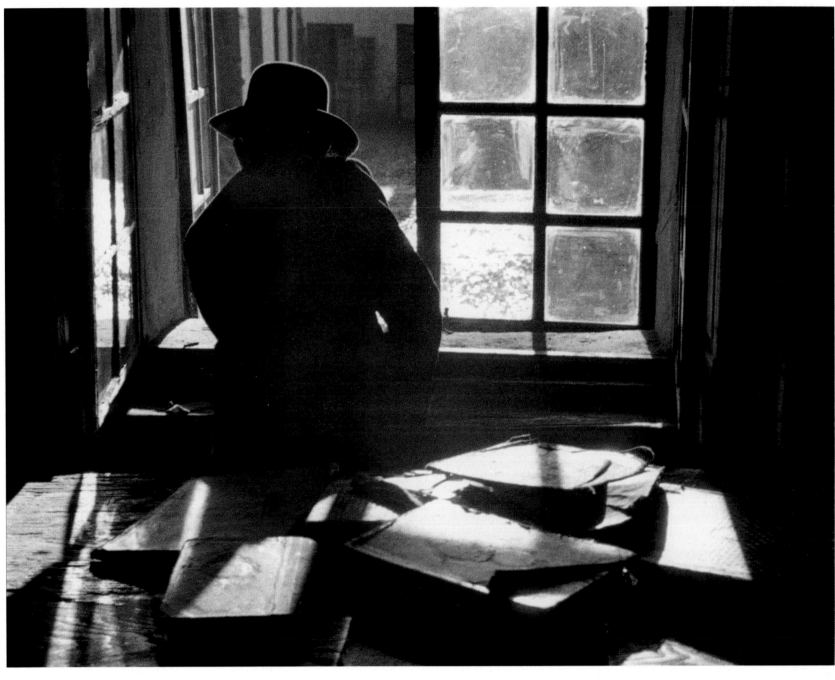

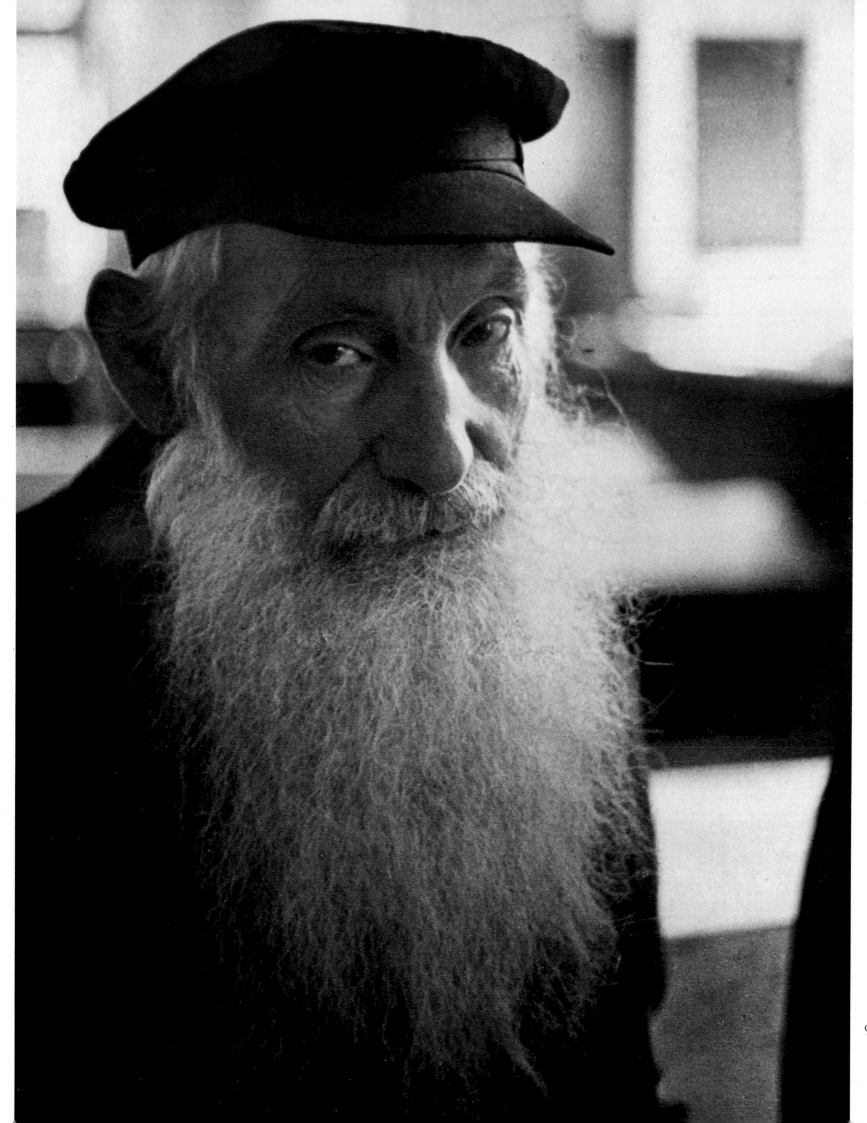

96: An old man. Slonim, 1937
97: A shoemaker. Warsaw, 1937

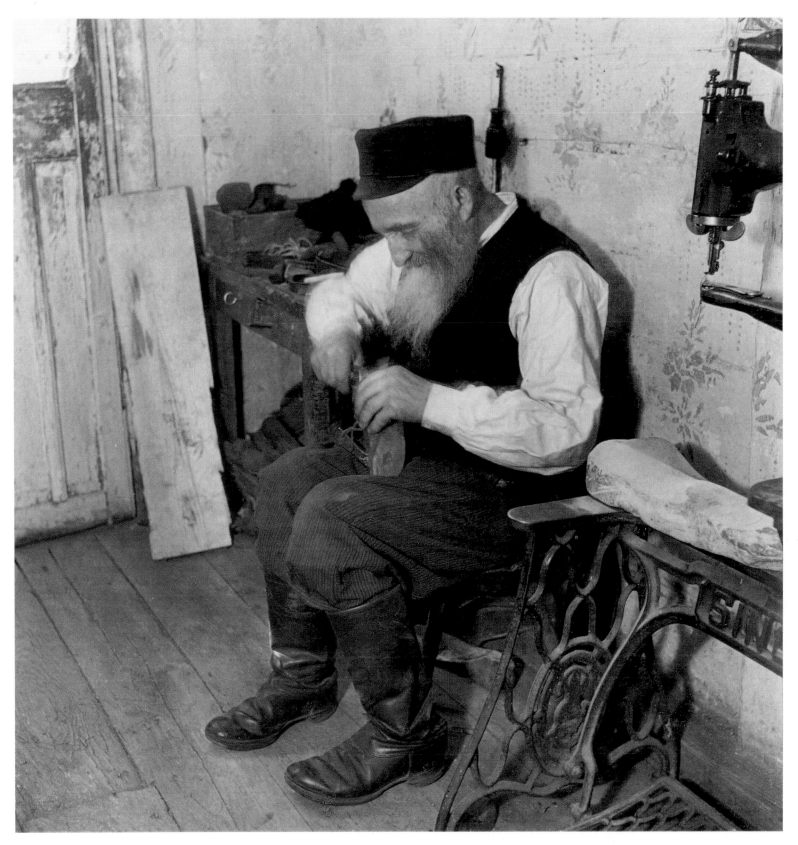

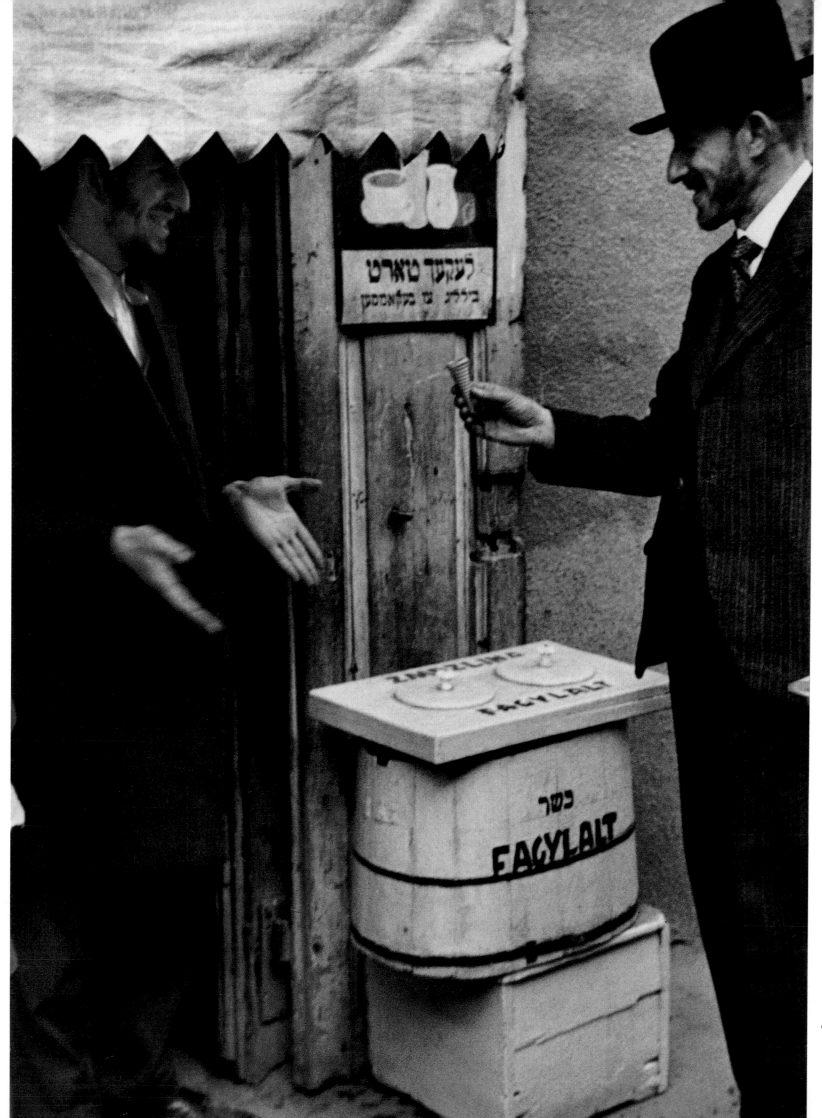

98: The ice cream was good. A little more would be even better. Mukachevo, 1936
99: Trying on caps at the market. Mukachevo, 1938

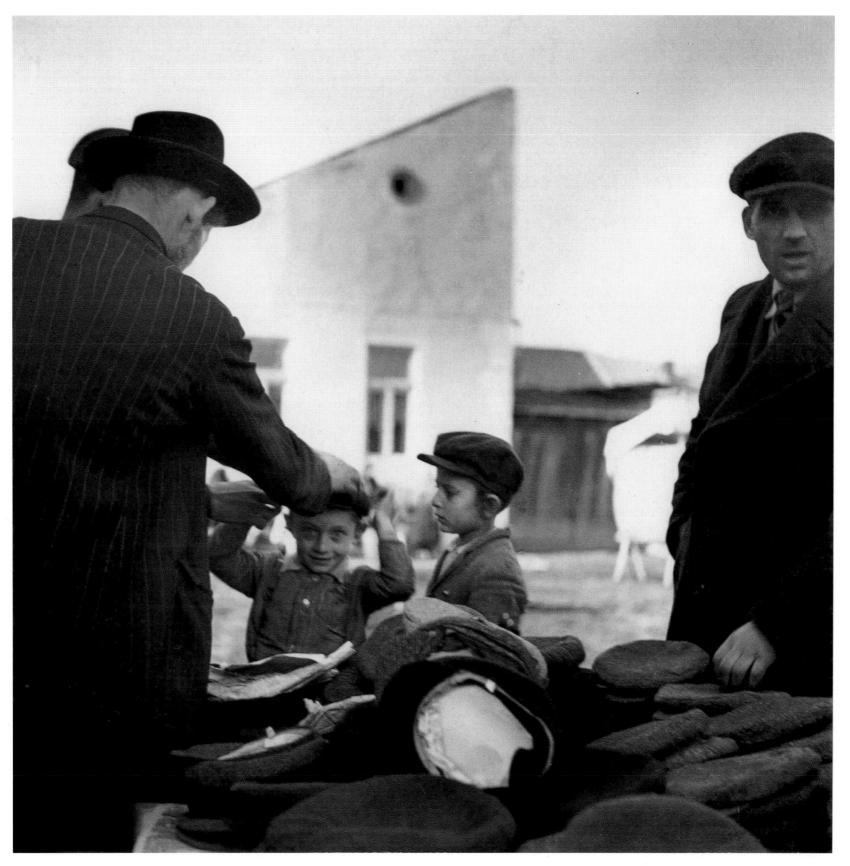

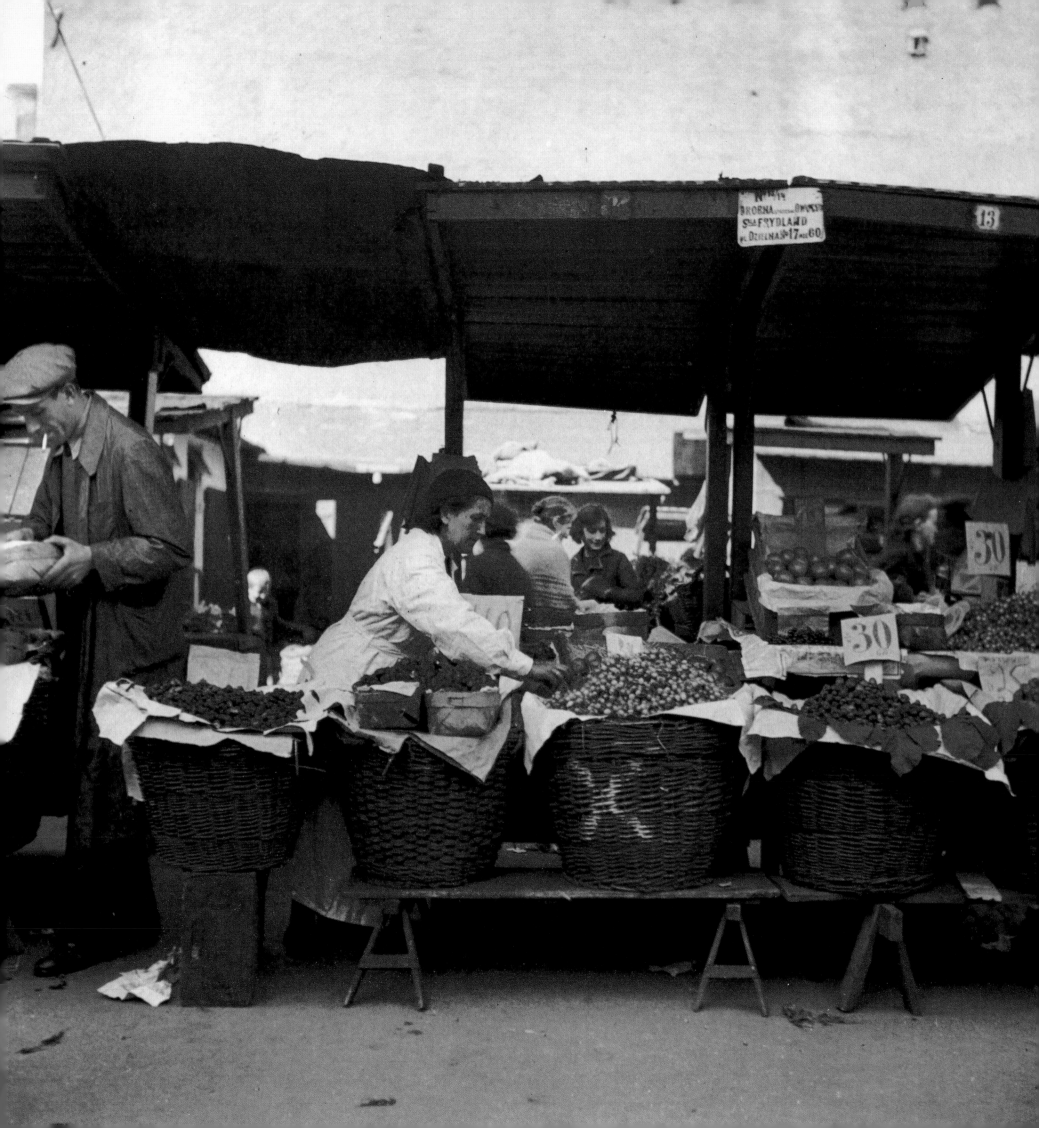

100: A fruit stand. Warsaw, 1937
101: Hoping for a loan from the credit union. Warsaw, 1938

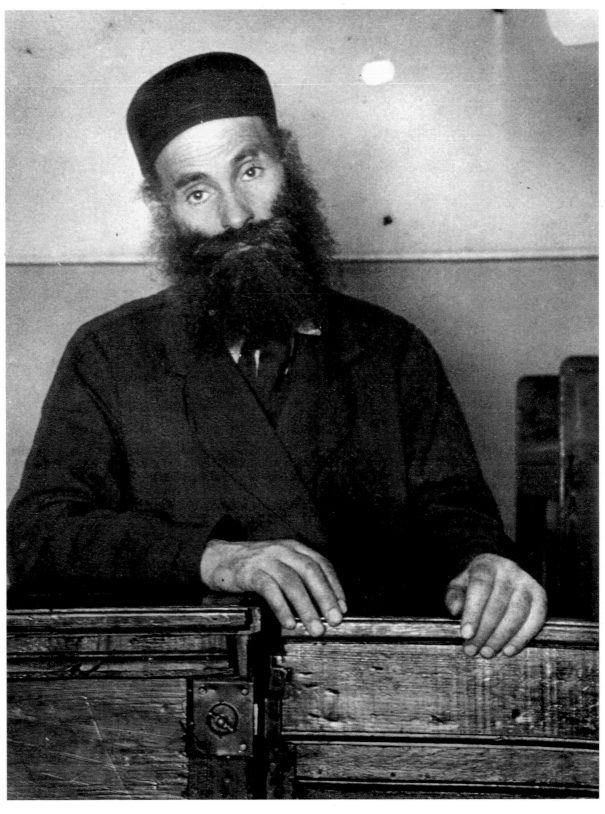

101

102 and 103: A community kitchen for the poor. Prague, 1937

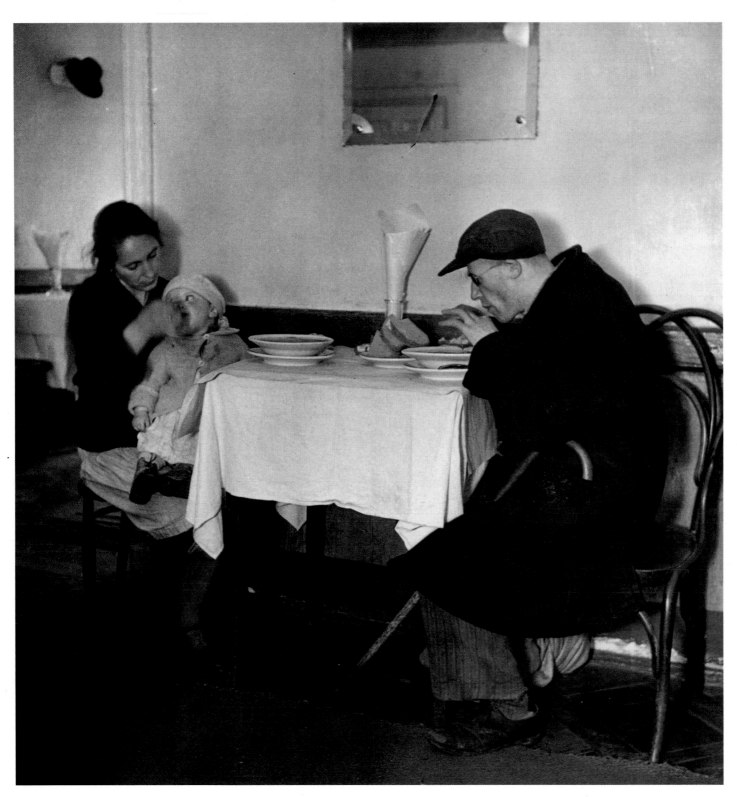

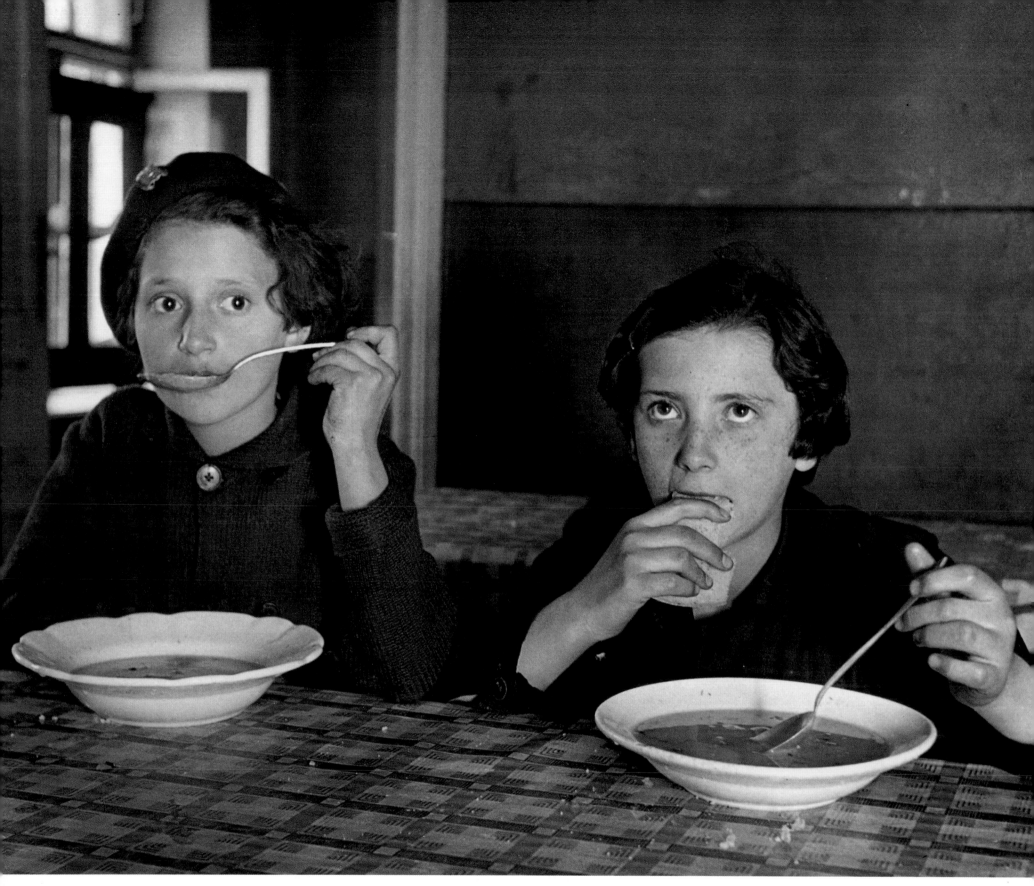

104: Students in front of the Talmud Torah, a school of religious study. Mukachevo, 1937

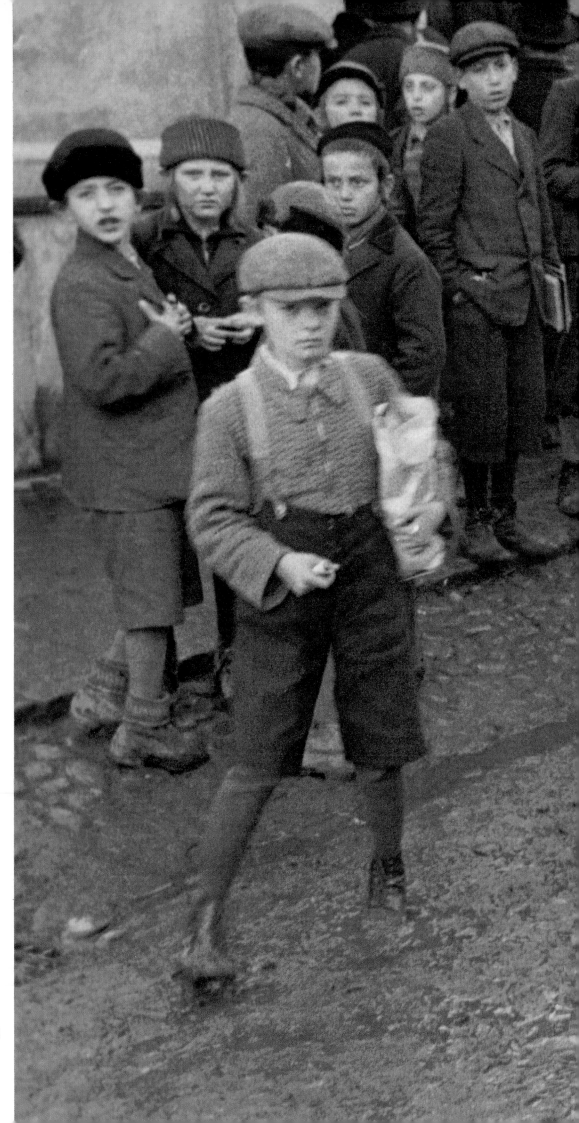

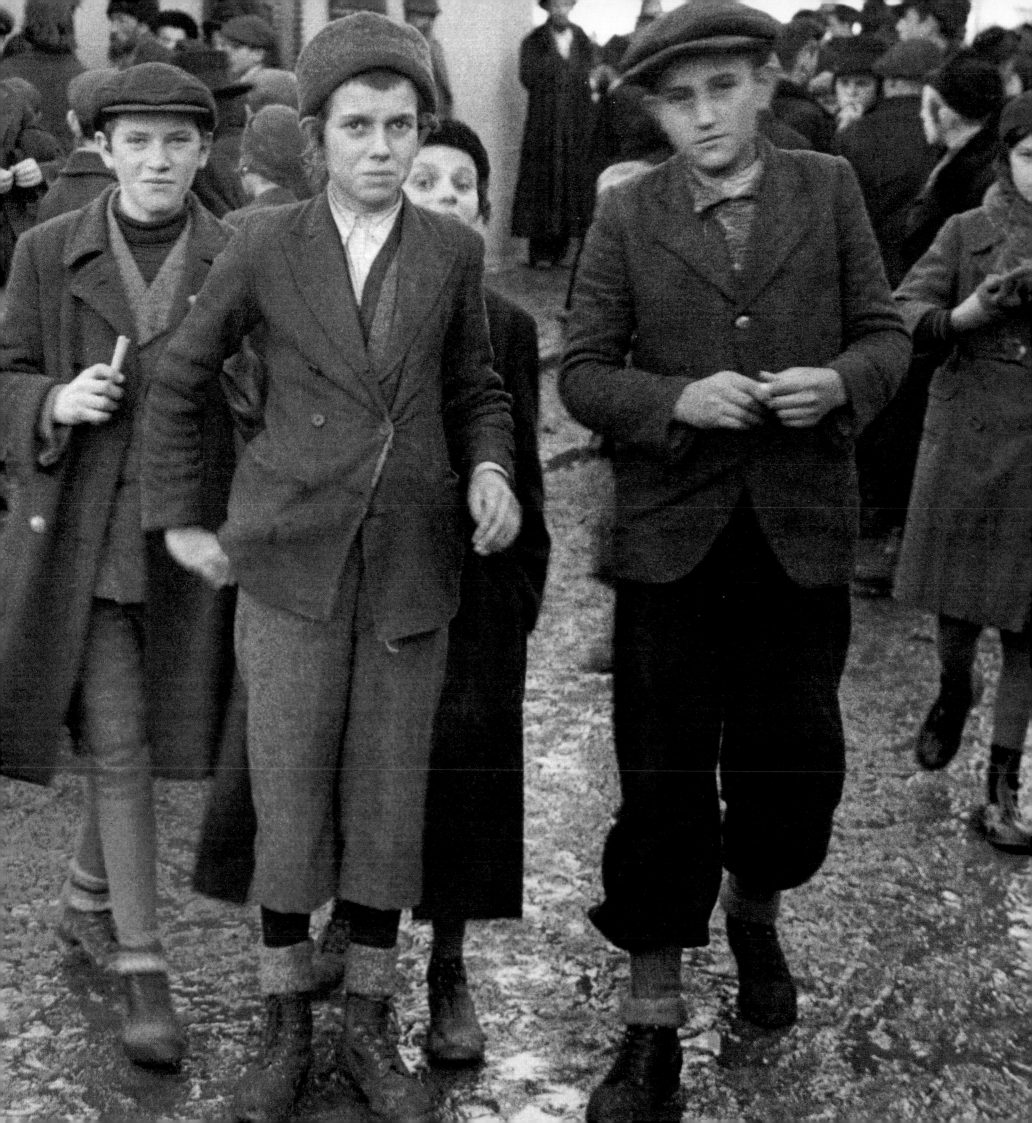

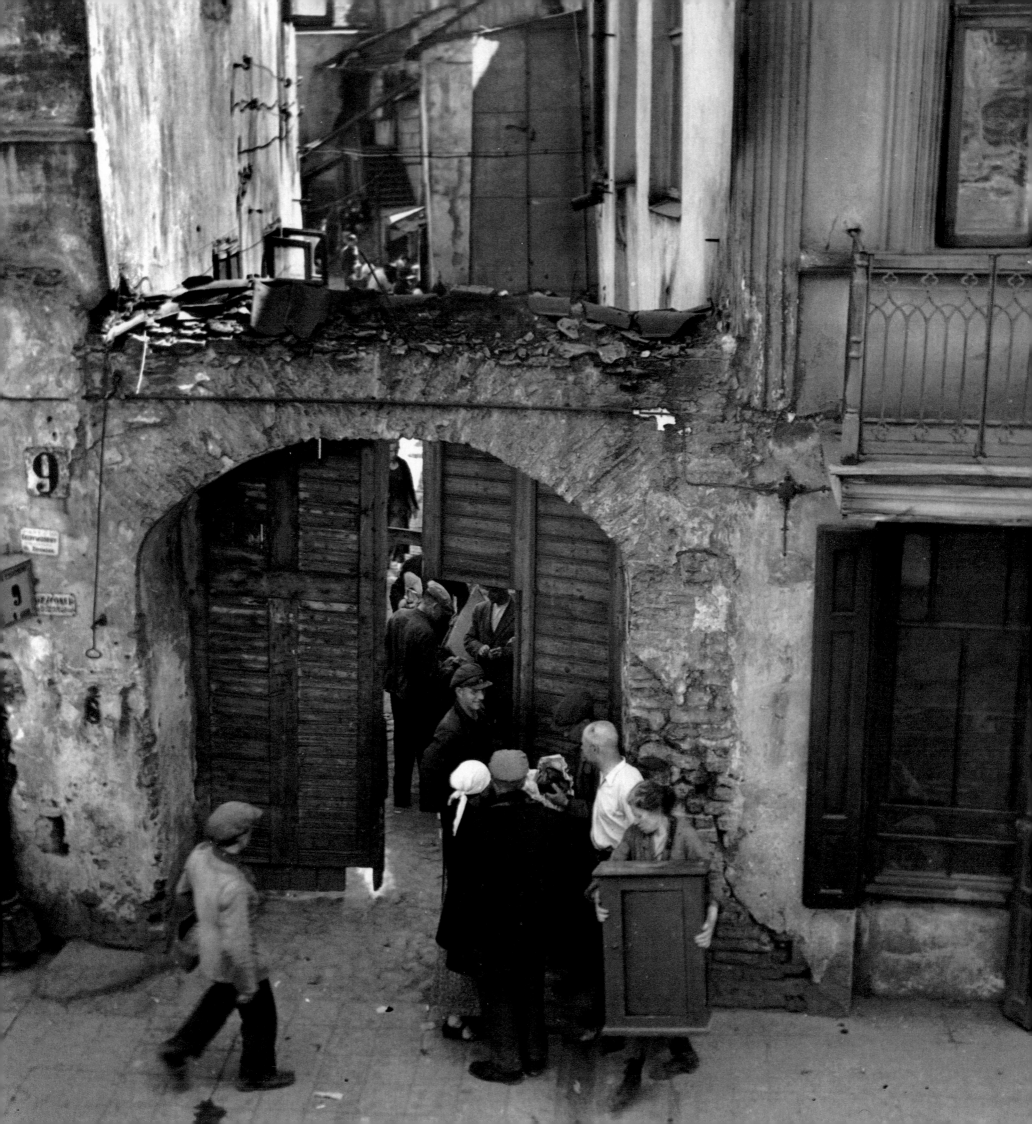

105: Street scene. Vilna, 1937
106: City boys. Mukachevo, 1937

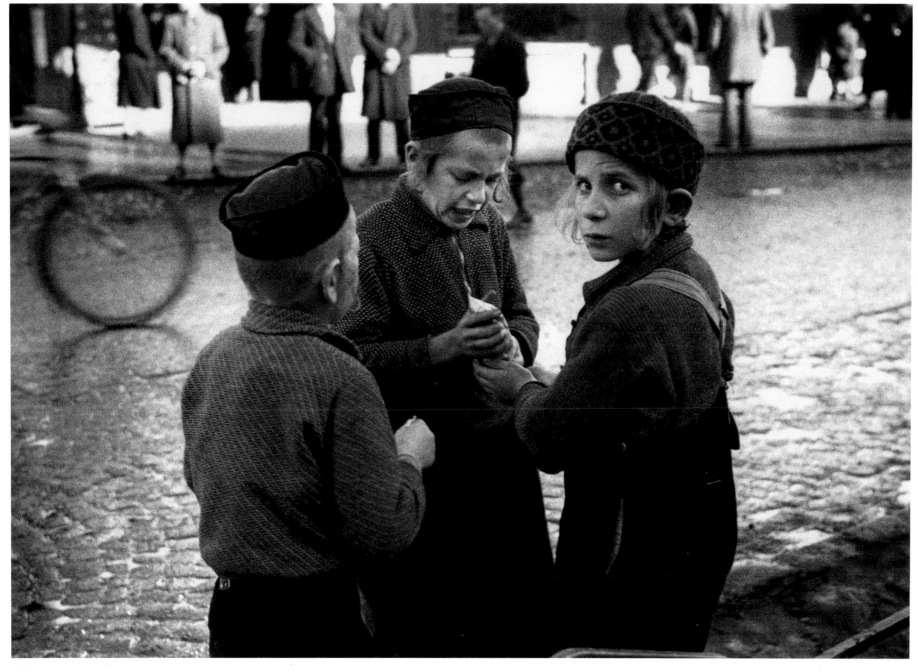

113: The stairway entrance to the court of Rabbi Meir Ben Gedaliah (1558-1616). Lublin, 1938
114: Sharing sorrows. Lodz, 1937

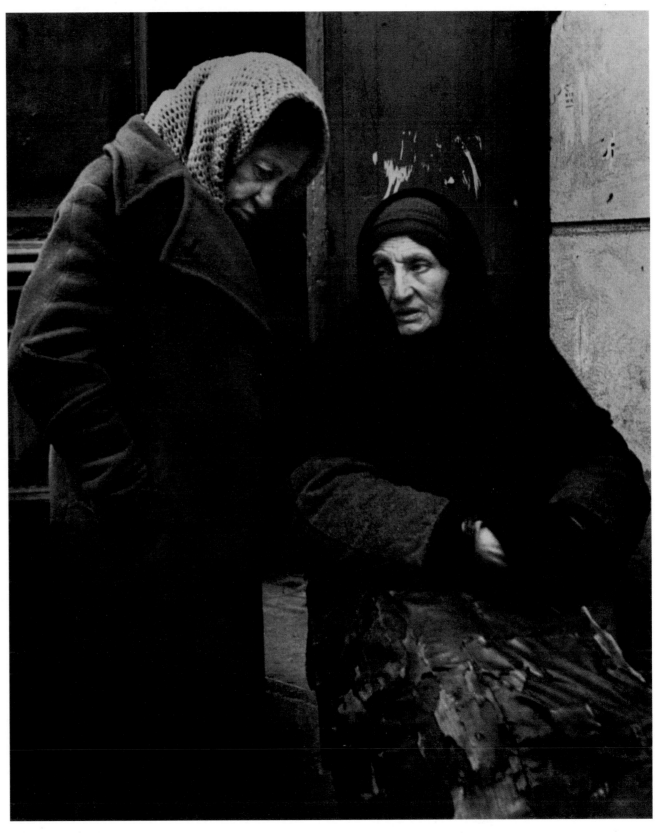

115: The private entrance to the study of Elijah, the Gaon of Vilna (1720-1797). Vilna, 1937
116: A boy with a toothache. Next year another child will inherit the tattered schoolbook. Slonim, 1937

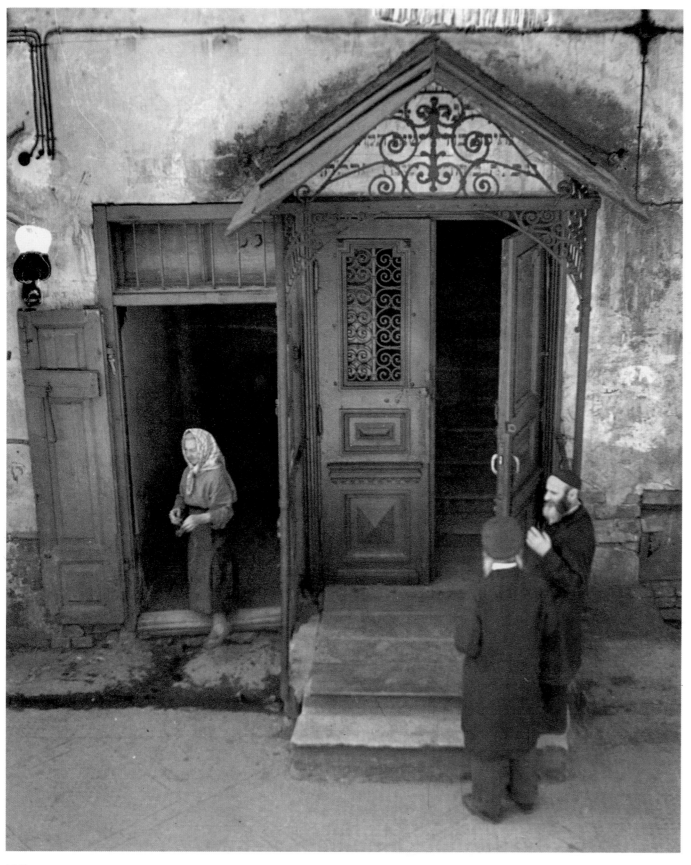

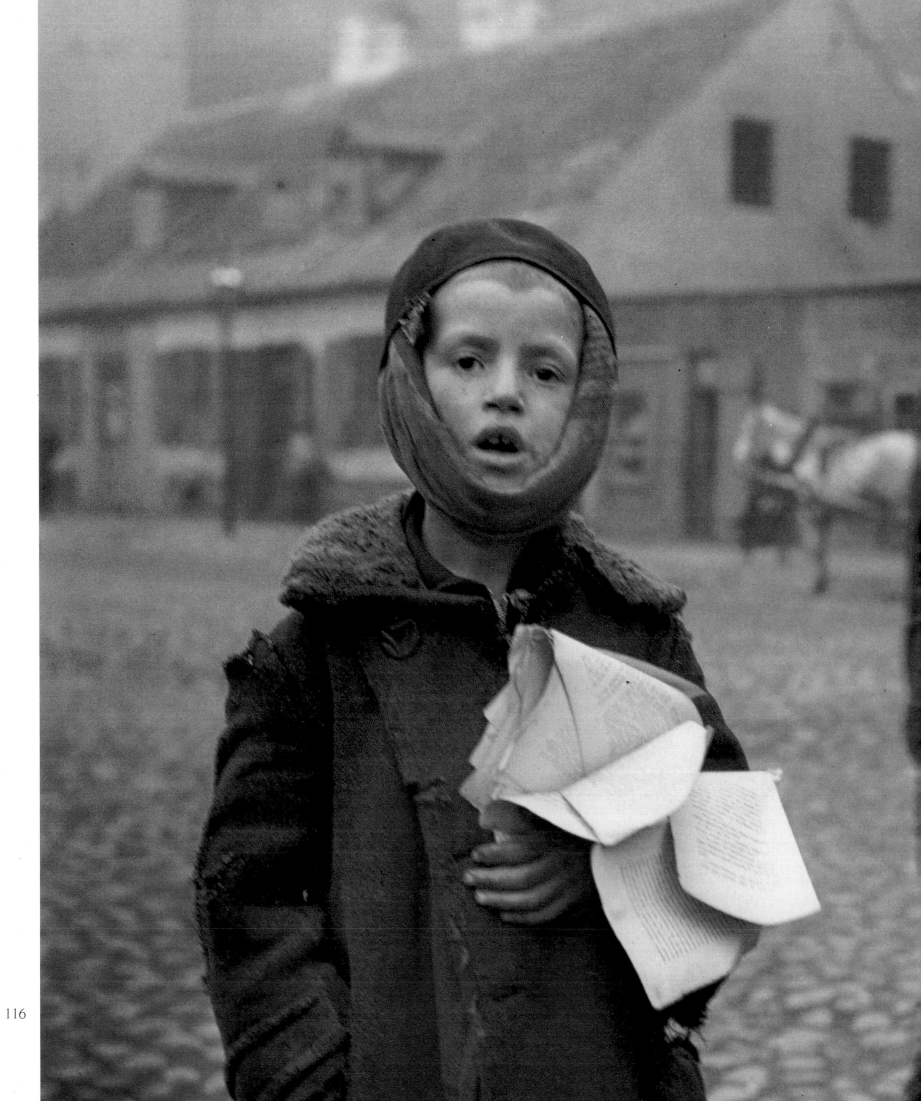

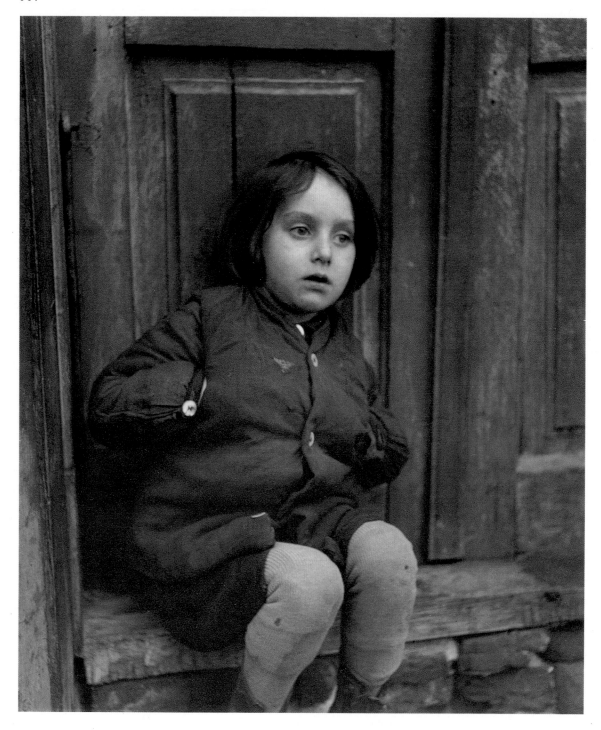

117: Her mother has gone to look for work. Warsaw, 1937
118: The old woman's husband was killed in a pogrom twenty years before.
She spoke of her daughter with pride. Lodz, 1935

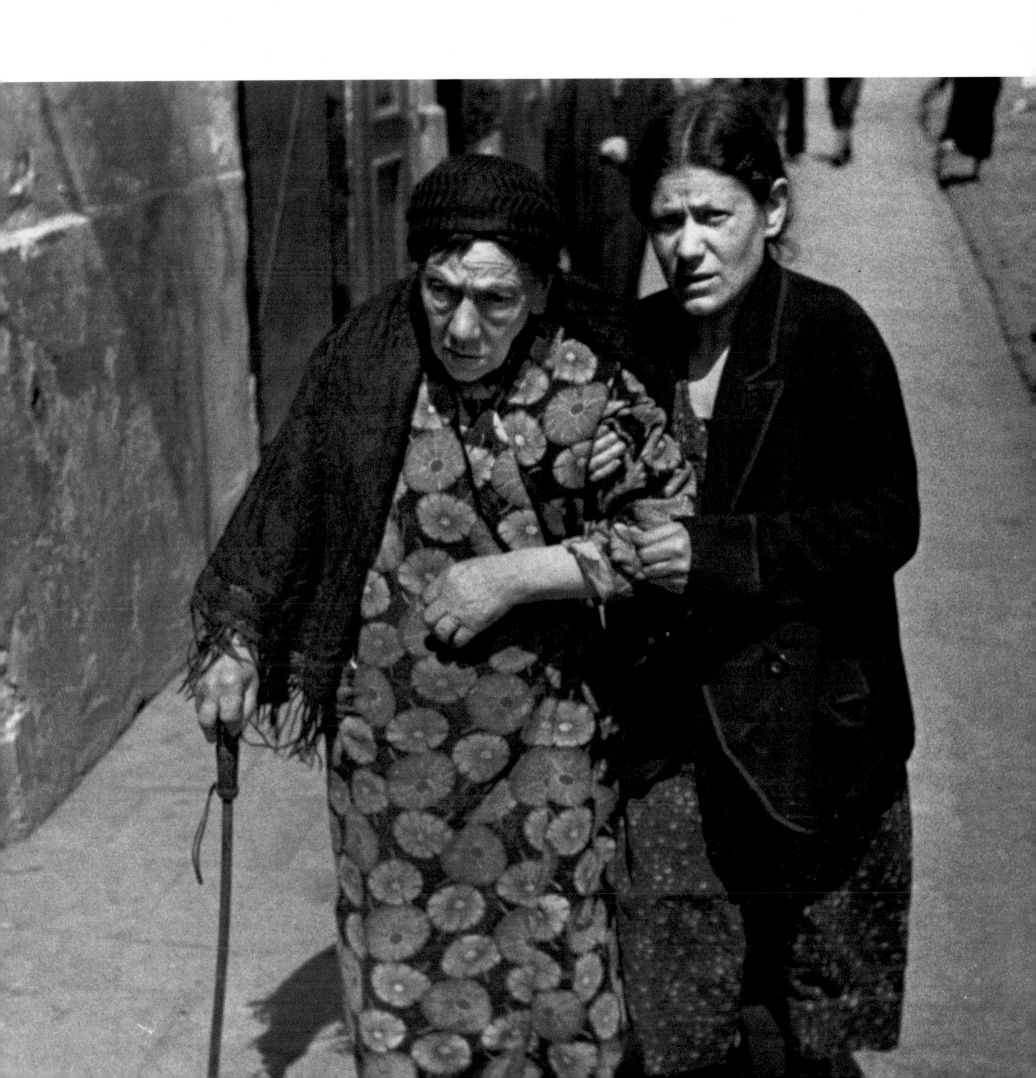

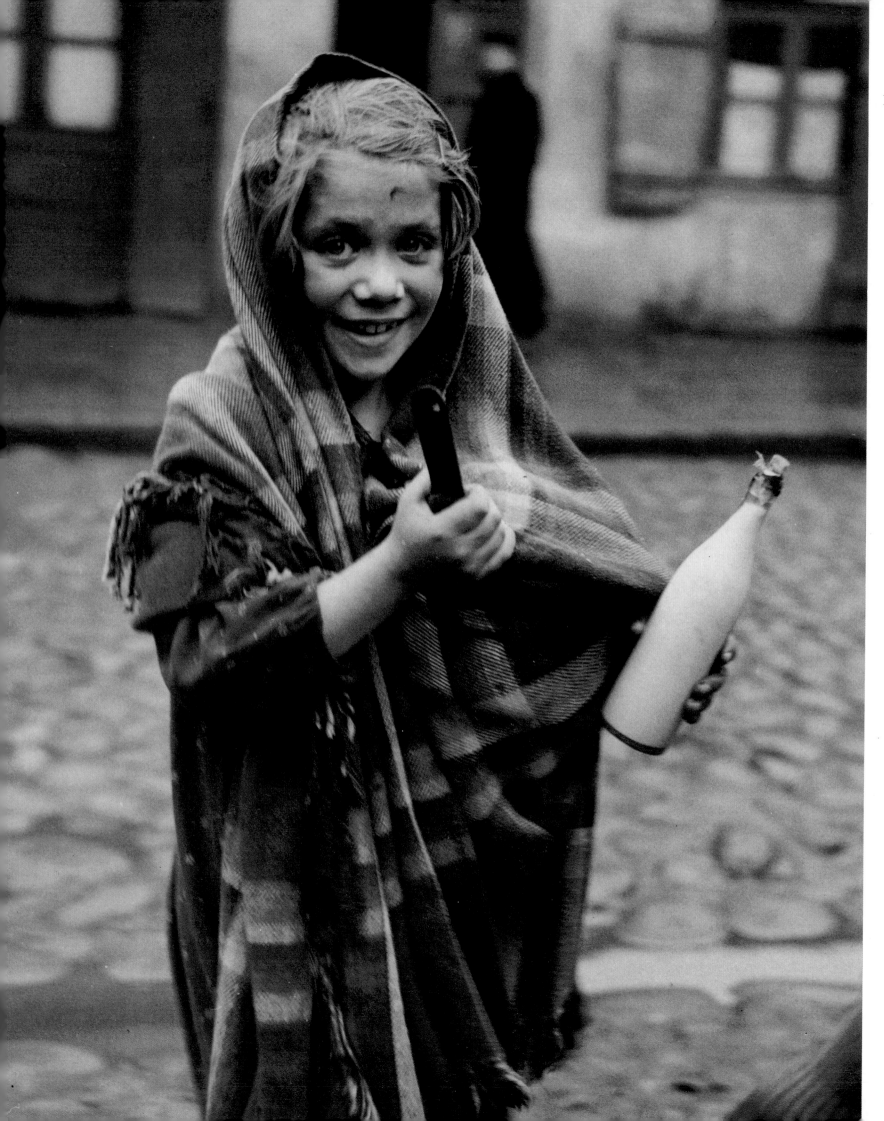

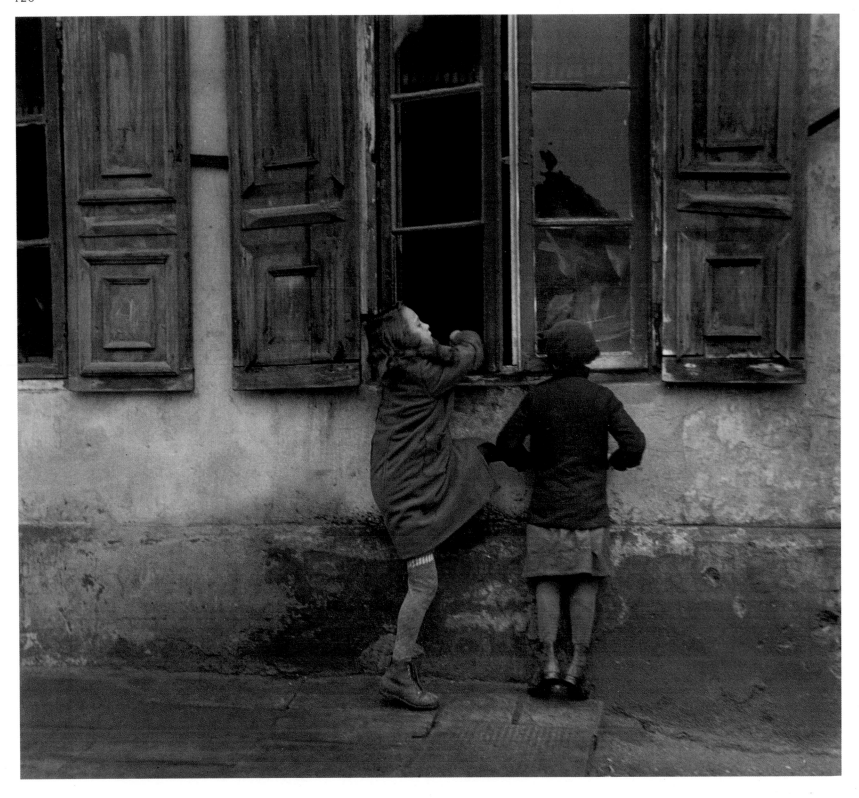

119: Selma was sent to the store for a pot of soup and a bottle of milk. Lodz, 1938
120: These girls were sent out to play, but they preferred to watch Mother at work inside. Slovakia, 1935

121: Writing a letter to his mother, who is working in Lodz. Warsaw, 1937
122: Two friends shyly approach the photographer. Lodz, 1938

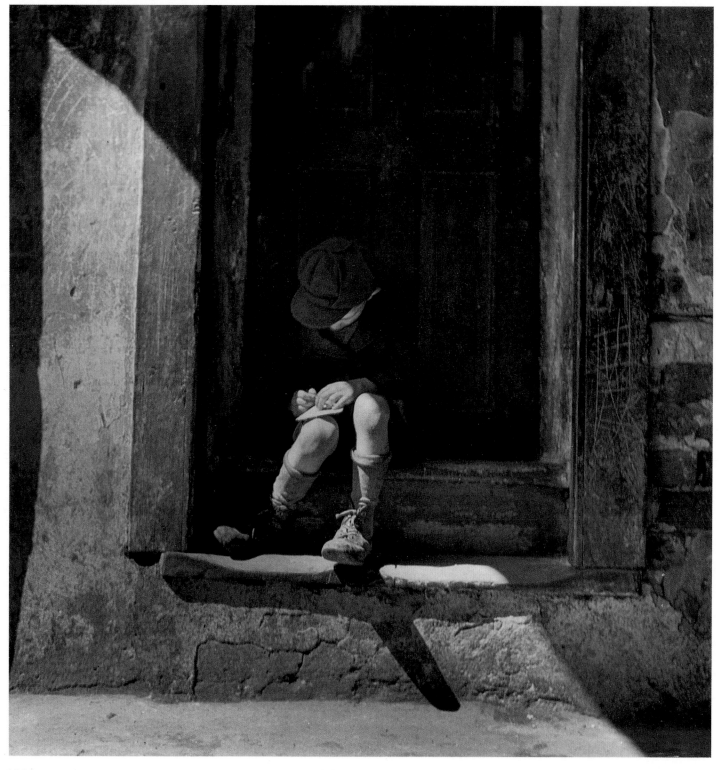

121

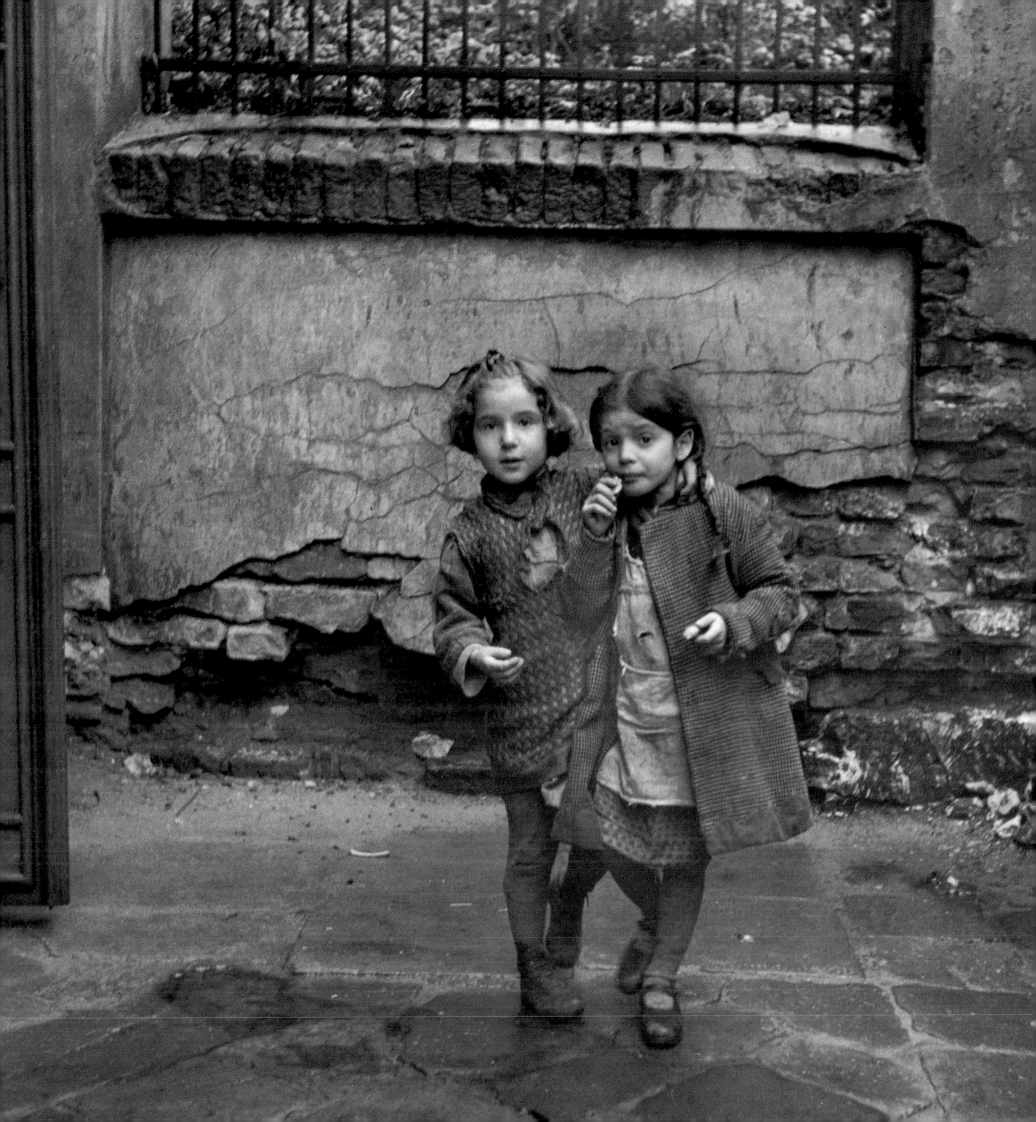

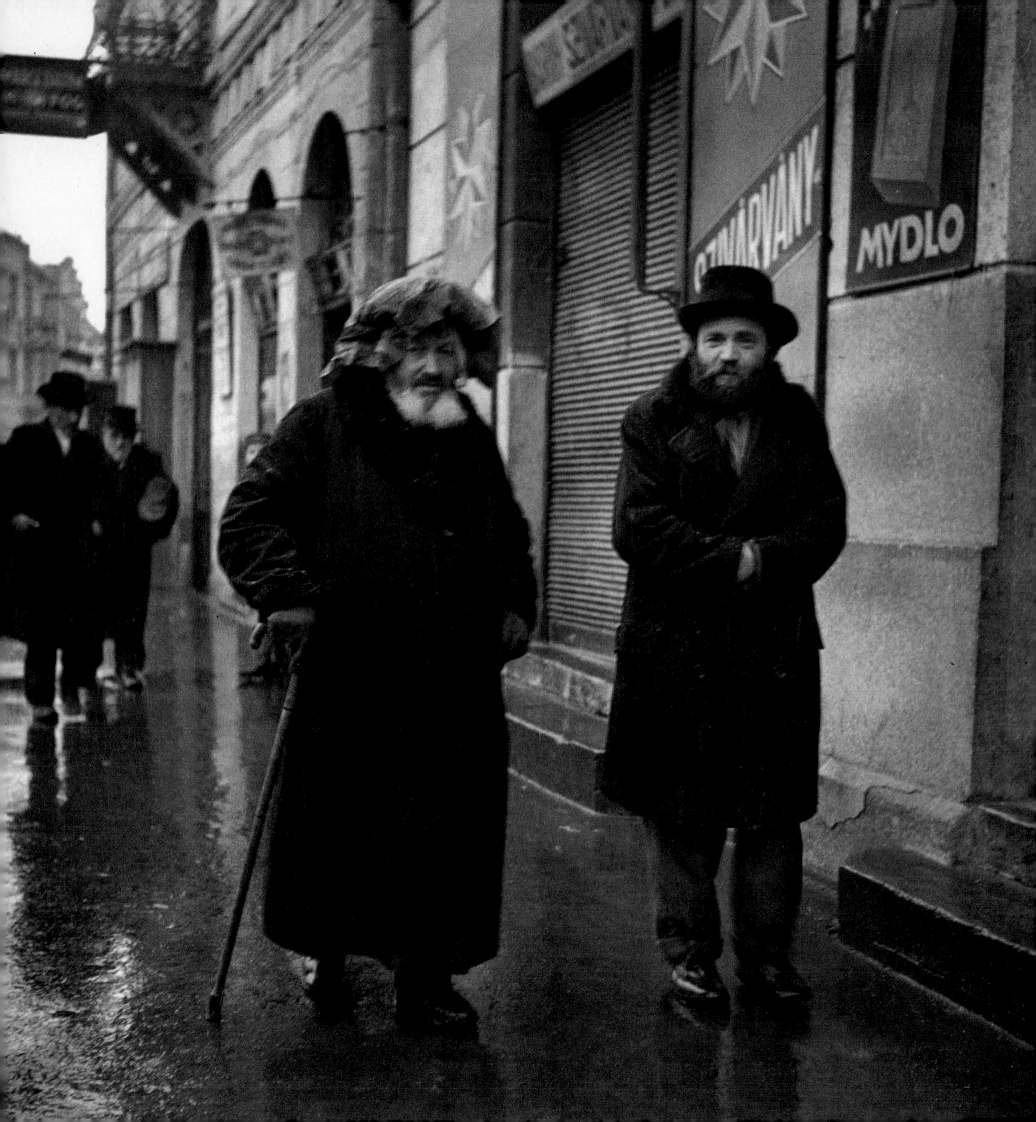

123: Every Jewish community adopted its own "fool," a mentally retarded person unable to care for himself. All the neighbors would look after him in turn. Rabbi Chaim Yosef (a handkerchief protects his fur hat from the rain) has invited the famous fool Meyer Tsits home for dinner. Mukachevo, 1937
124: A merry fool. Mukachevo, 1936
125: A melancholy fool. Uzhgorod, 1936

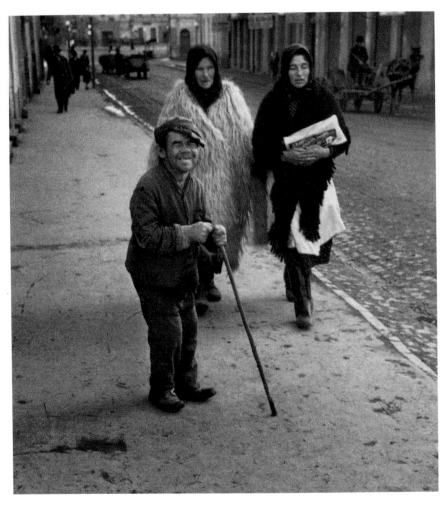

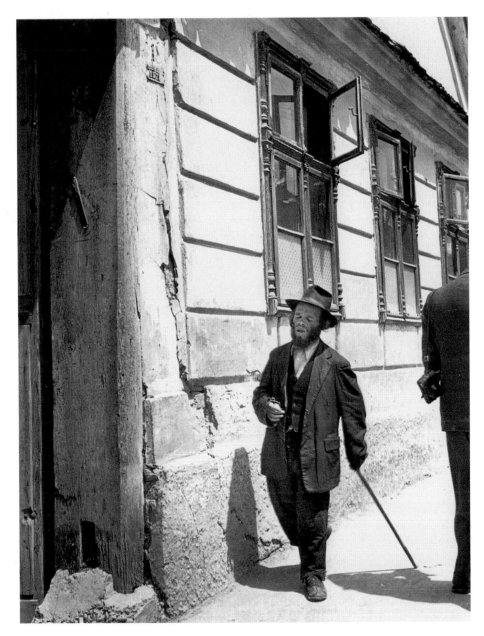

126: A small shop in Teresva, a village in Carpathian Ruthenia, 1937
127: Traveling salesmen passing the Mukachevo city hall, 1937

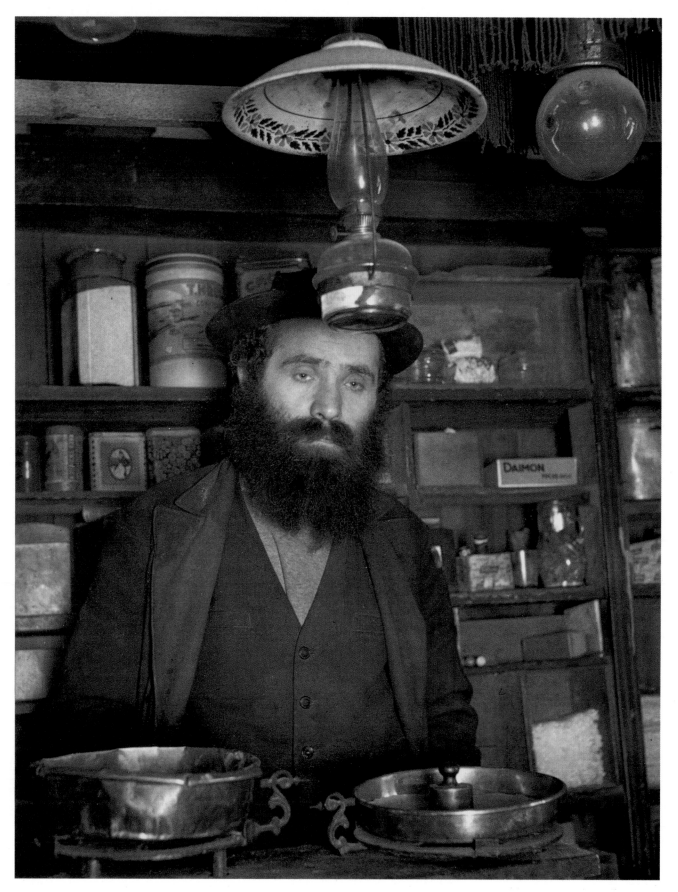

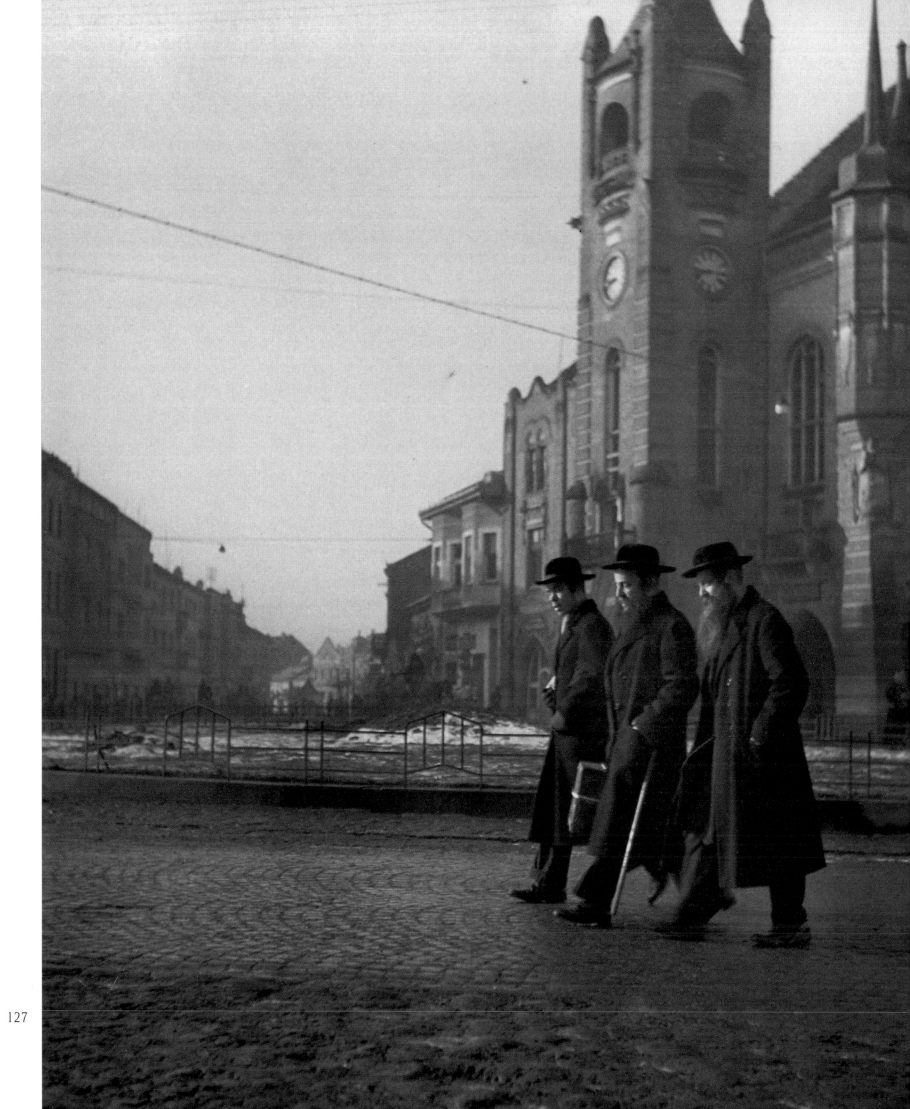

128 and 129: Jewish stores in small towns in Slovakia, 1936

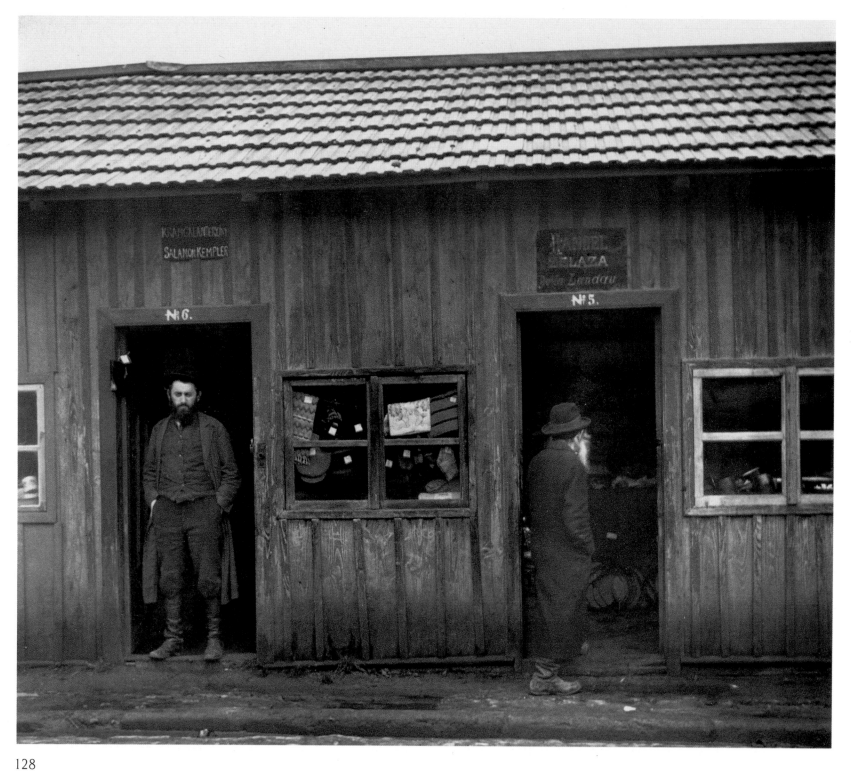

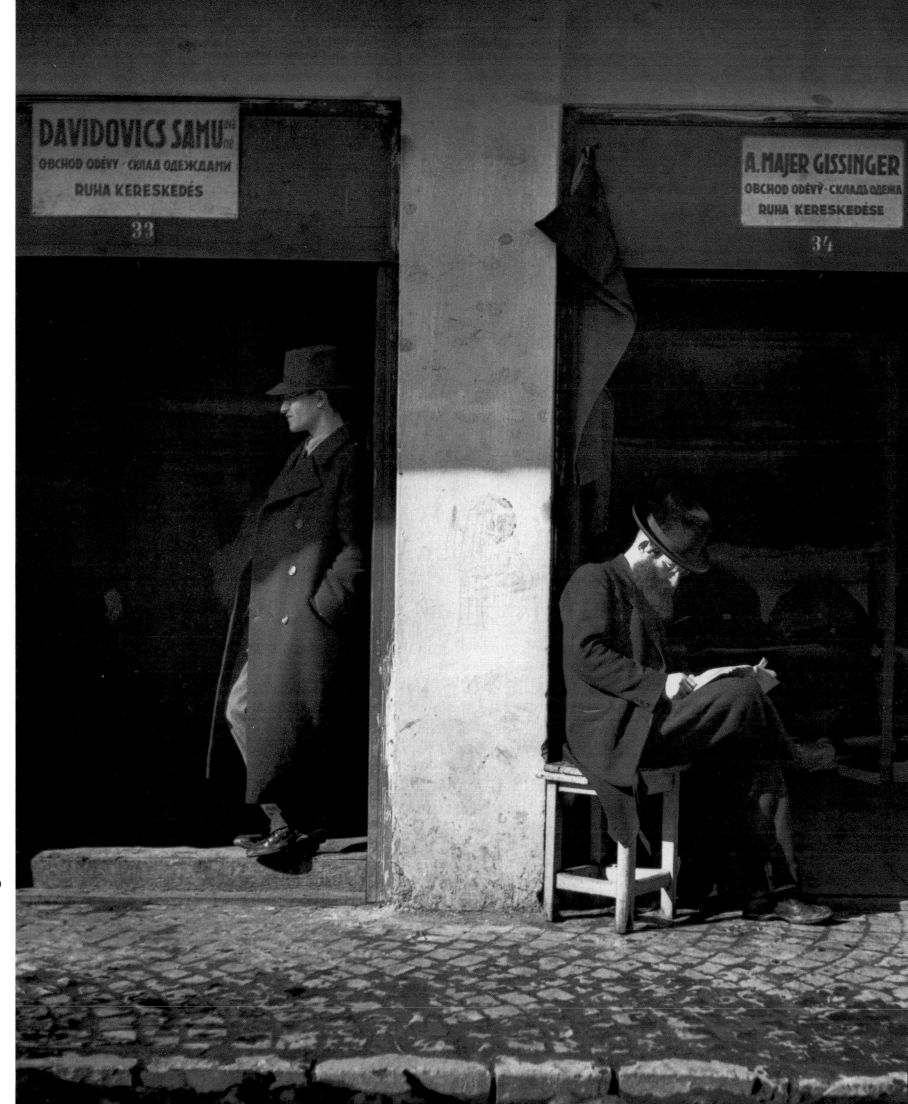

130: Strangers rarely came to his village.
Carpathian Ruthenia, 1938
131: On the road to Teresva, 1936

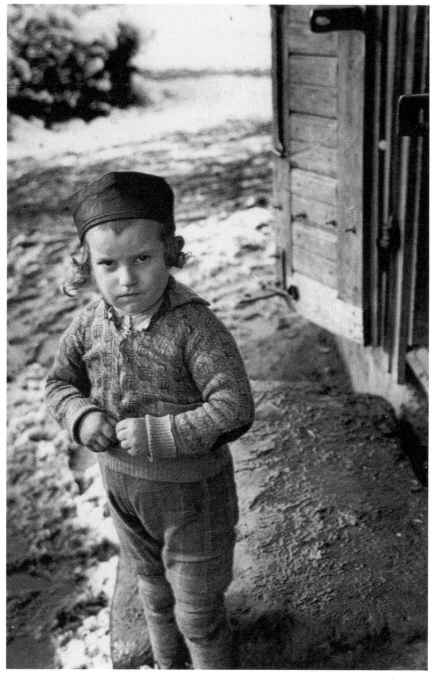

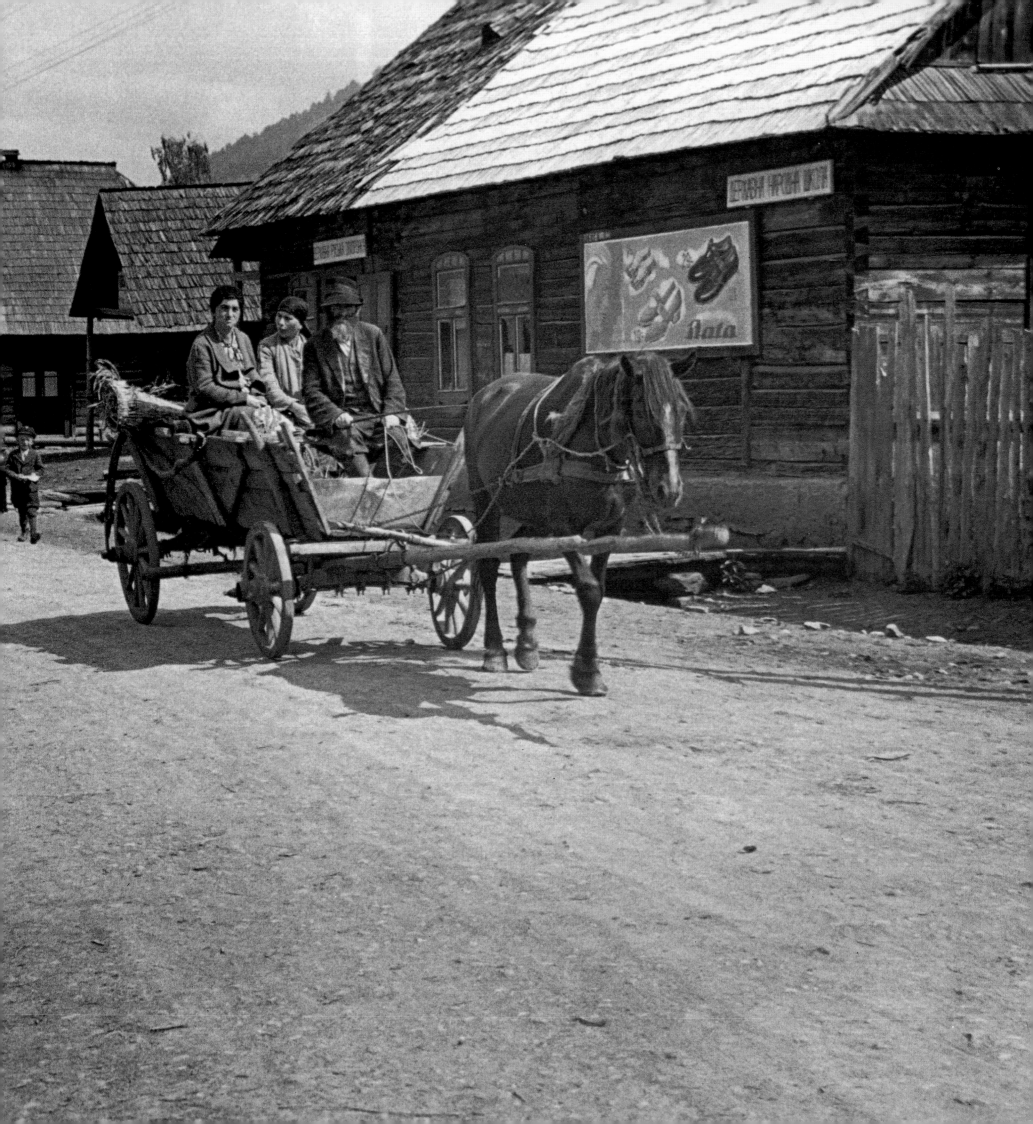

132 and 133: A farmer of Vrchni Apša, 1939

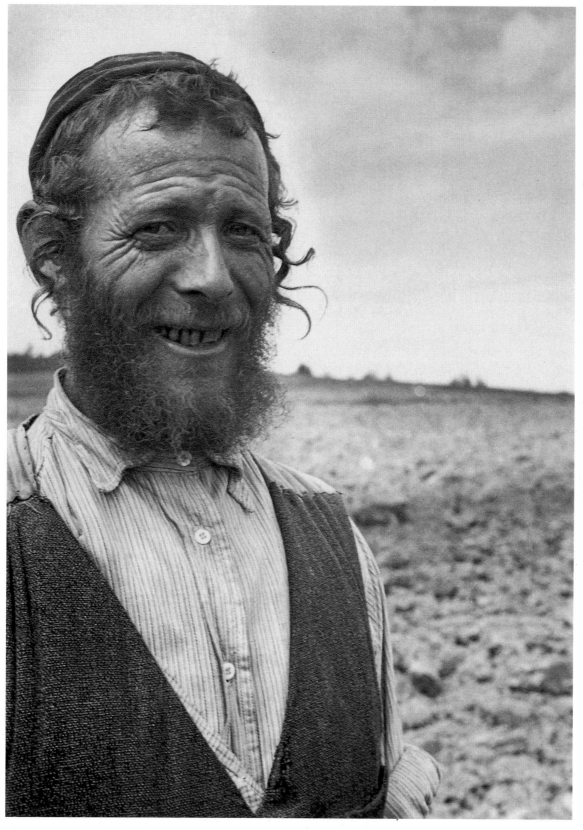

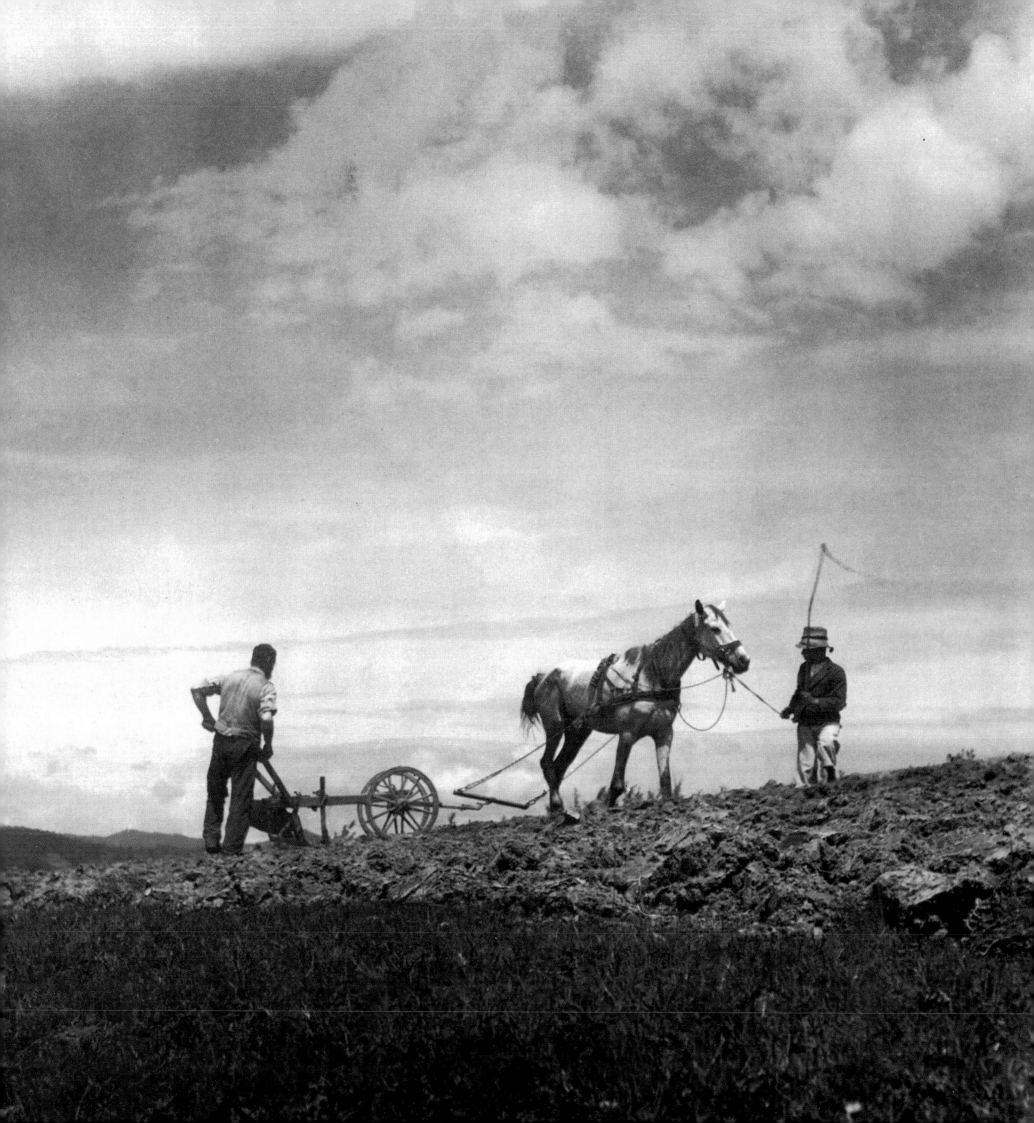

134: The cattle market.
Khust, a town in Carpathian Ruthenia, 1938.
The man in the white jacket is a Gentile
135: Sheep dealers. Khust, 1938

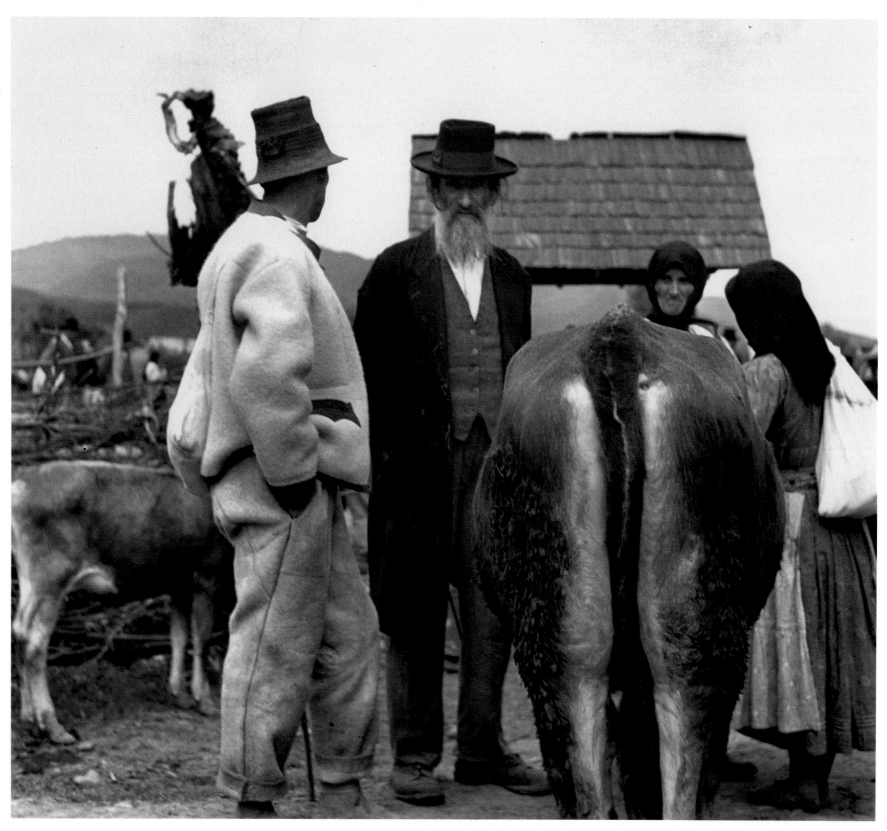

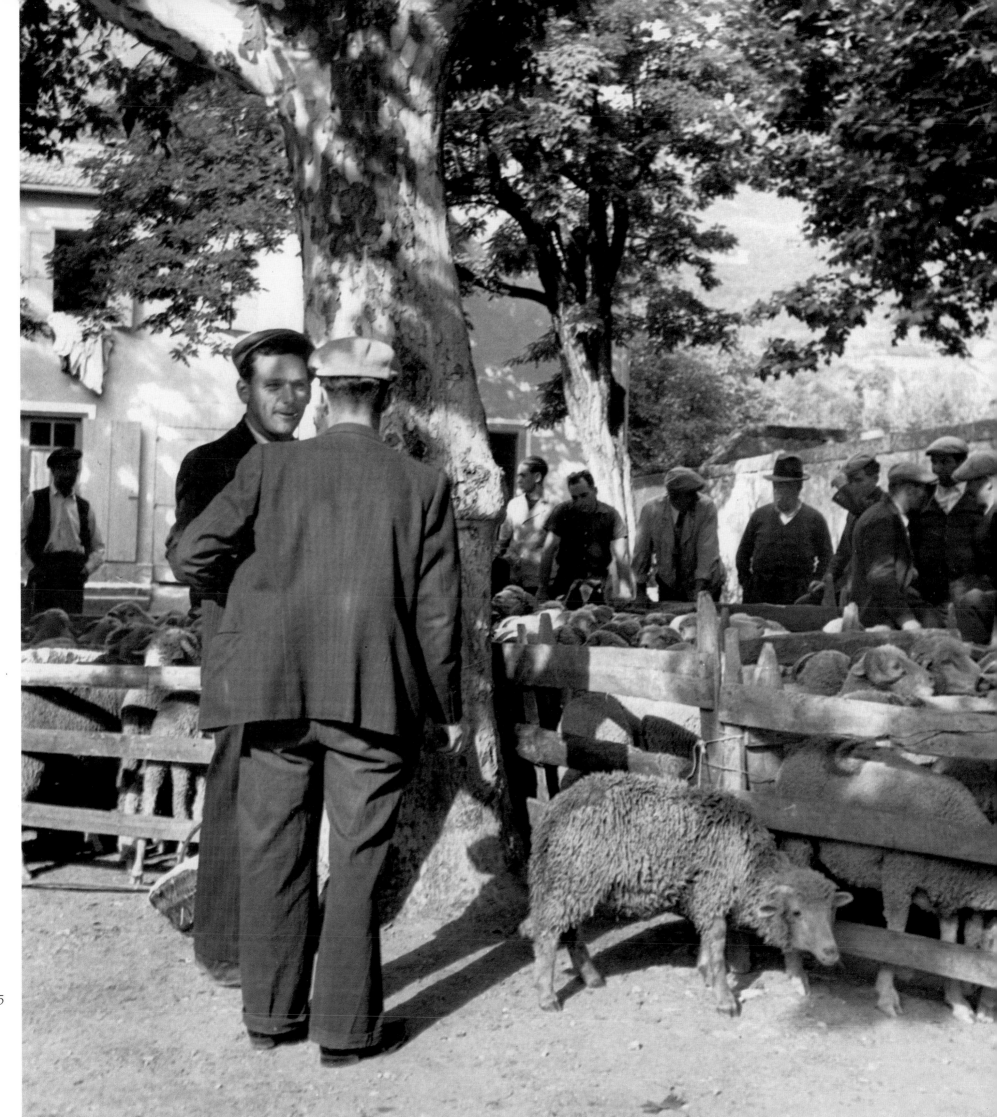

136: Haggling with a Gentile market woman over the price of a hen. Uzhgorod, 1937
137: The sign at the top of the gate welcomes "our lord, our teacher, our rabbi." Uzhgorod, 1937

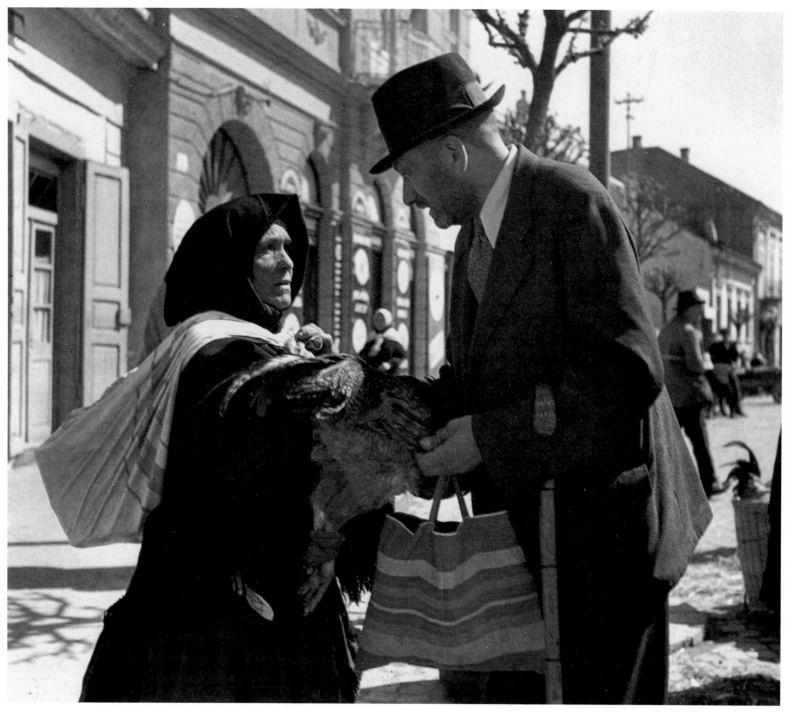

136

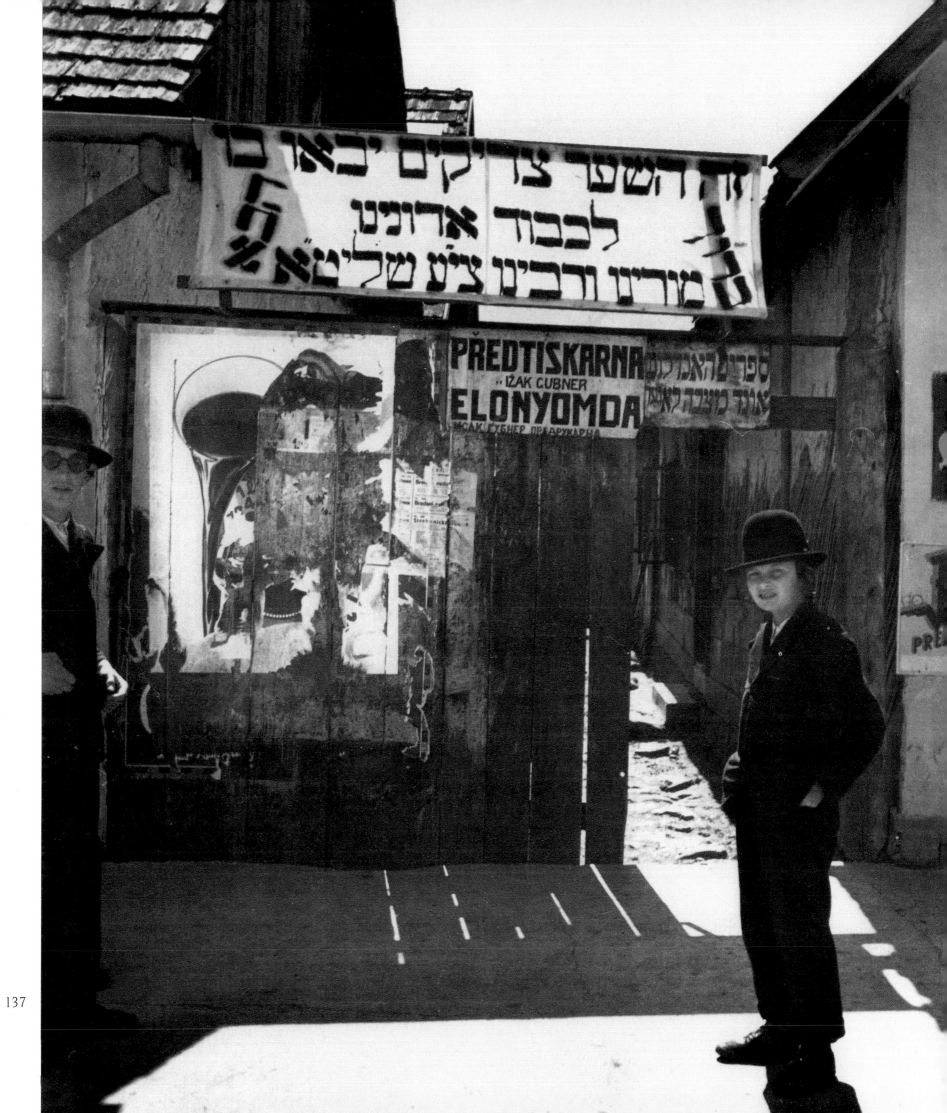

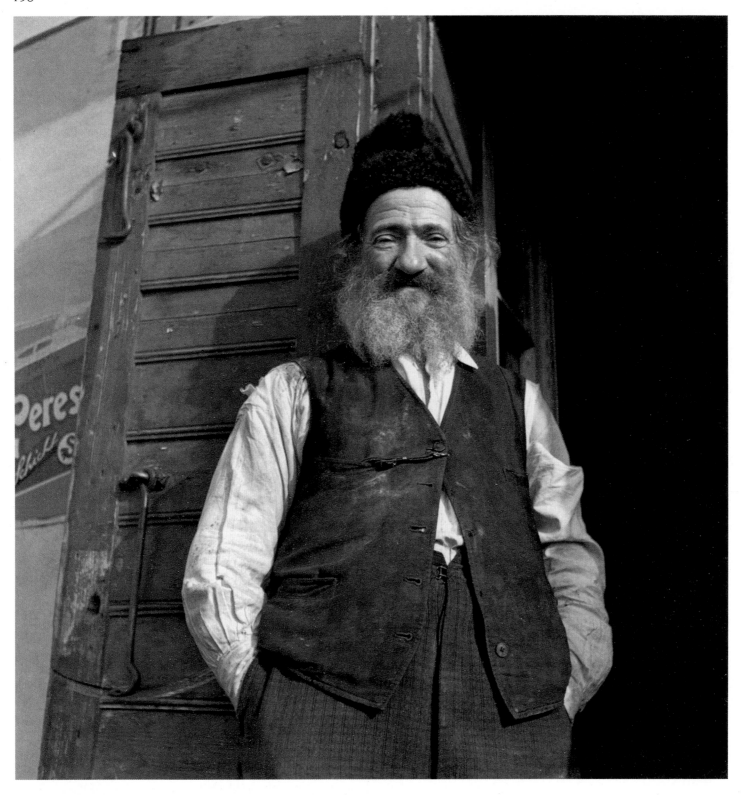

138: A shopkeeper of Teresva, 1937
139: Waiting on a Gentile customer. A village in Carpathian Ruthenia, 1937

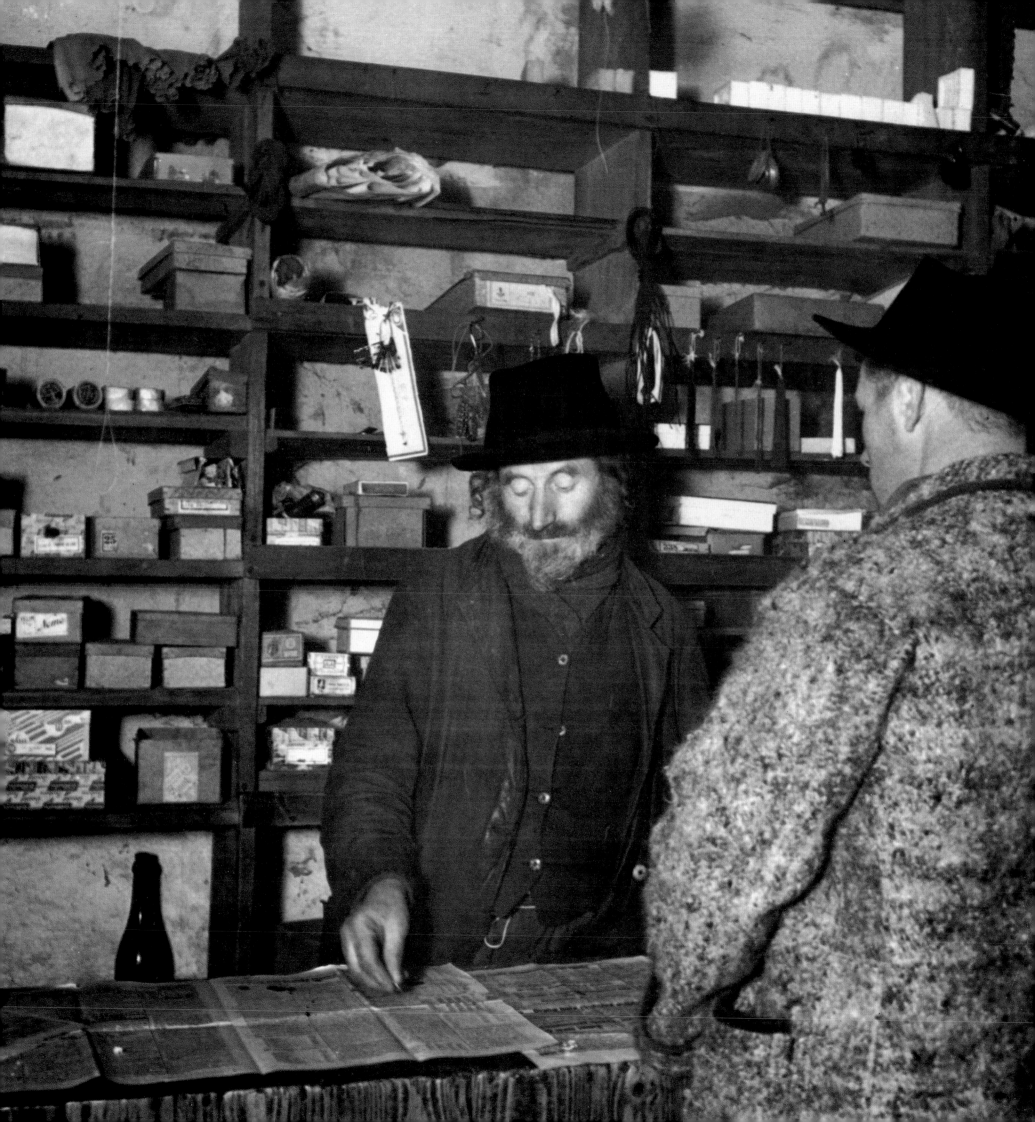

140: The house of a middle-class Jewish family. A village in Carpathian Ruthenia, 1937
141: In a village in Carpathian Ruthenia, these pious Jews made a living by moving logs
down to the river. Three times a day they interrupted their work for prayers. 1936

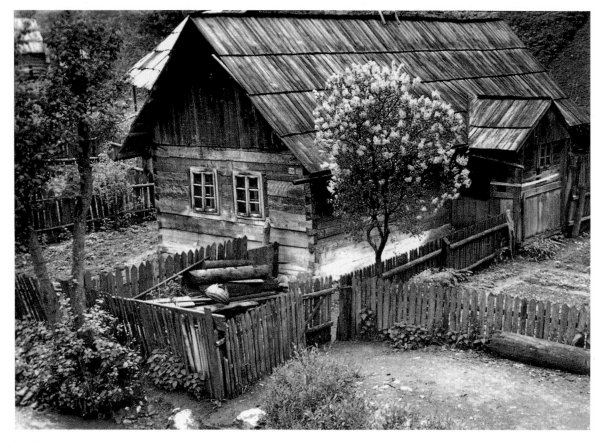

140

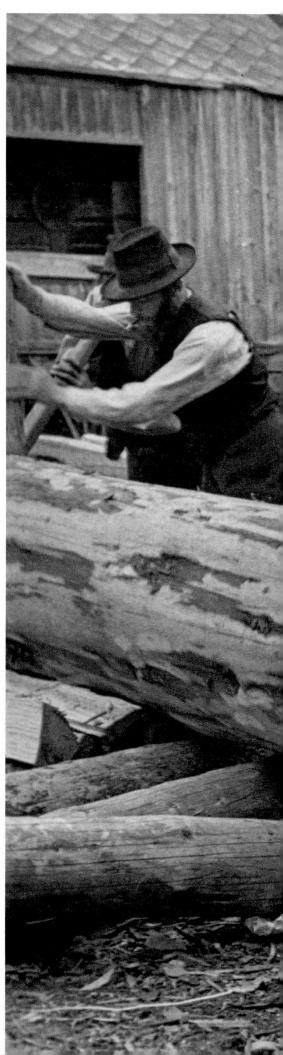

141

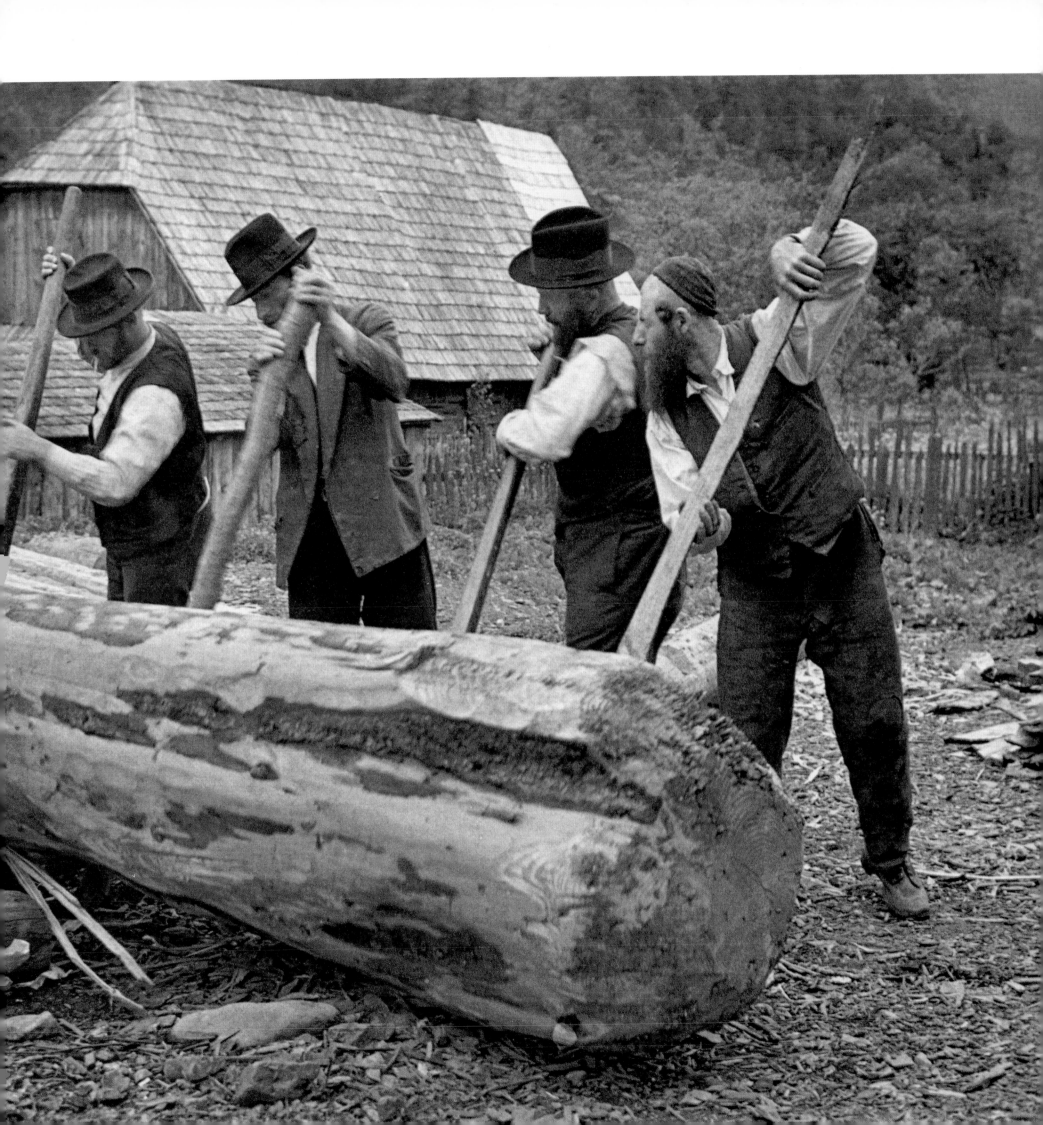

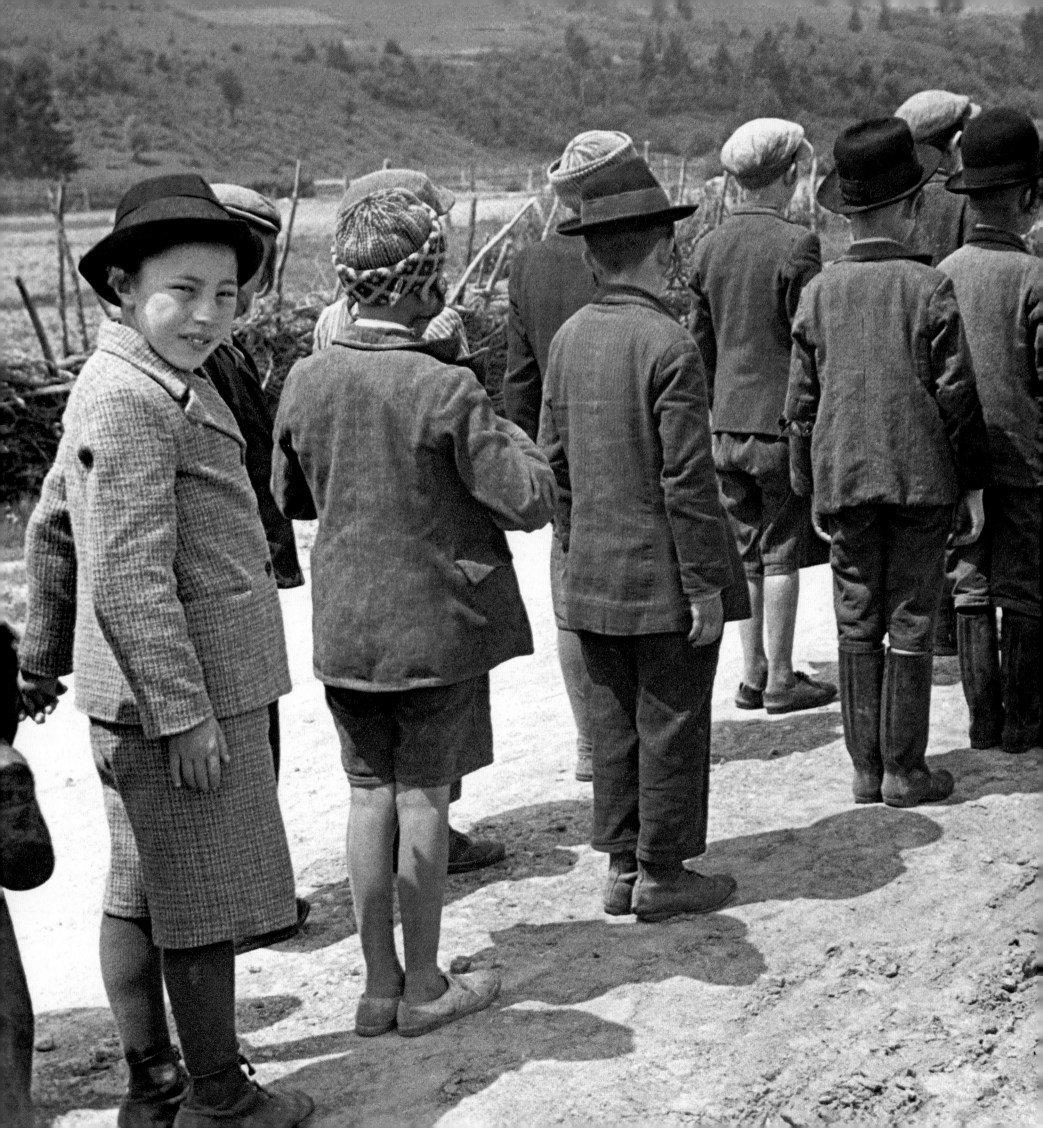

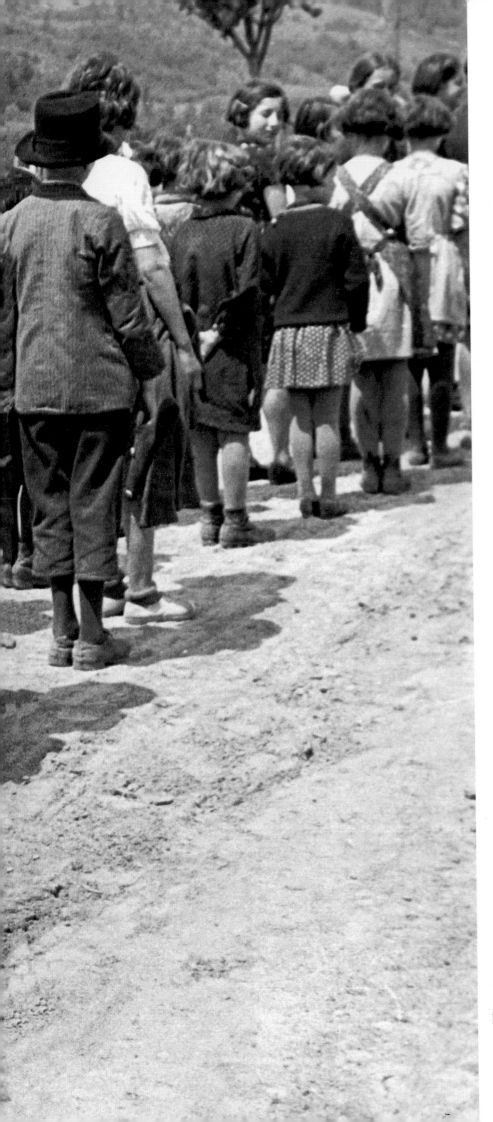

142: Waiting on line for the mikva (the ritual bath); first the girls, then the boys. A village in Carpathian Ruthenia, 1937
143: The mikva, a pool of clear running water, is inside this bathhouse. Carpathian Ruthenia, 1937

142 143

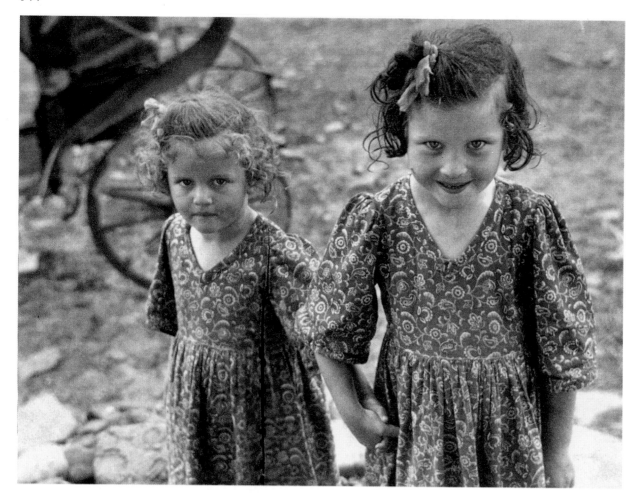

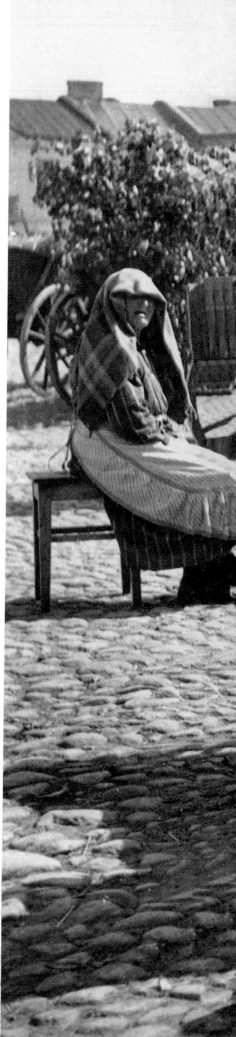

144: Two sisters. A village in Carpathian Ruthenia, 1937
145: The market in the main square of Lask, 1937.
Jews had to set up their stands on the left side of the marketplace

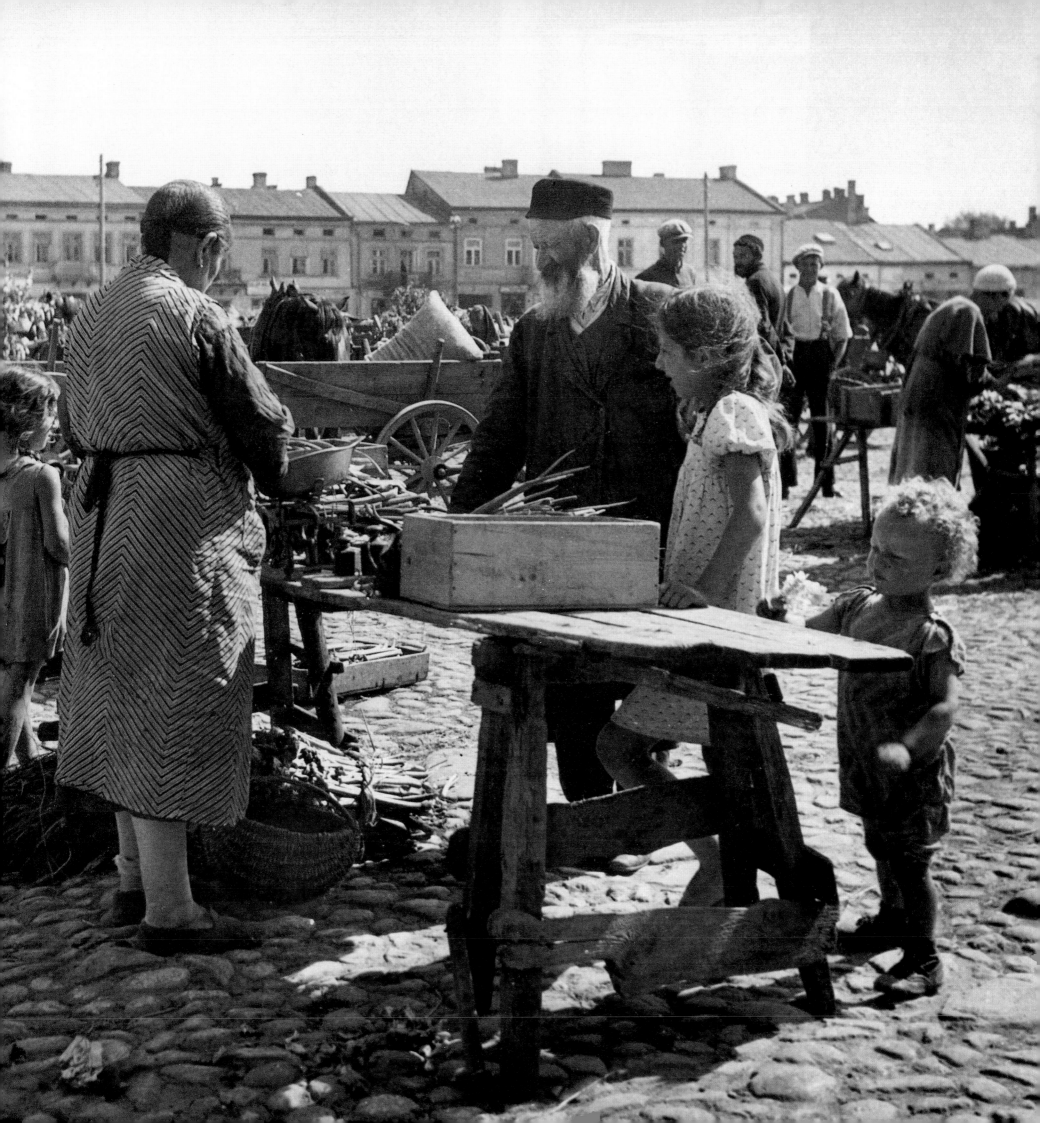

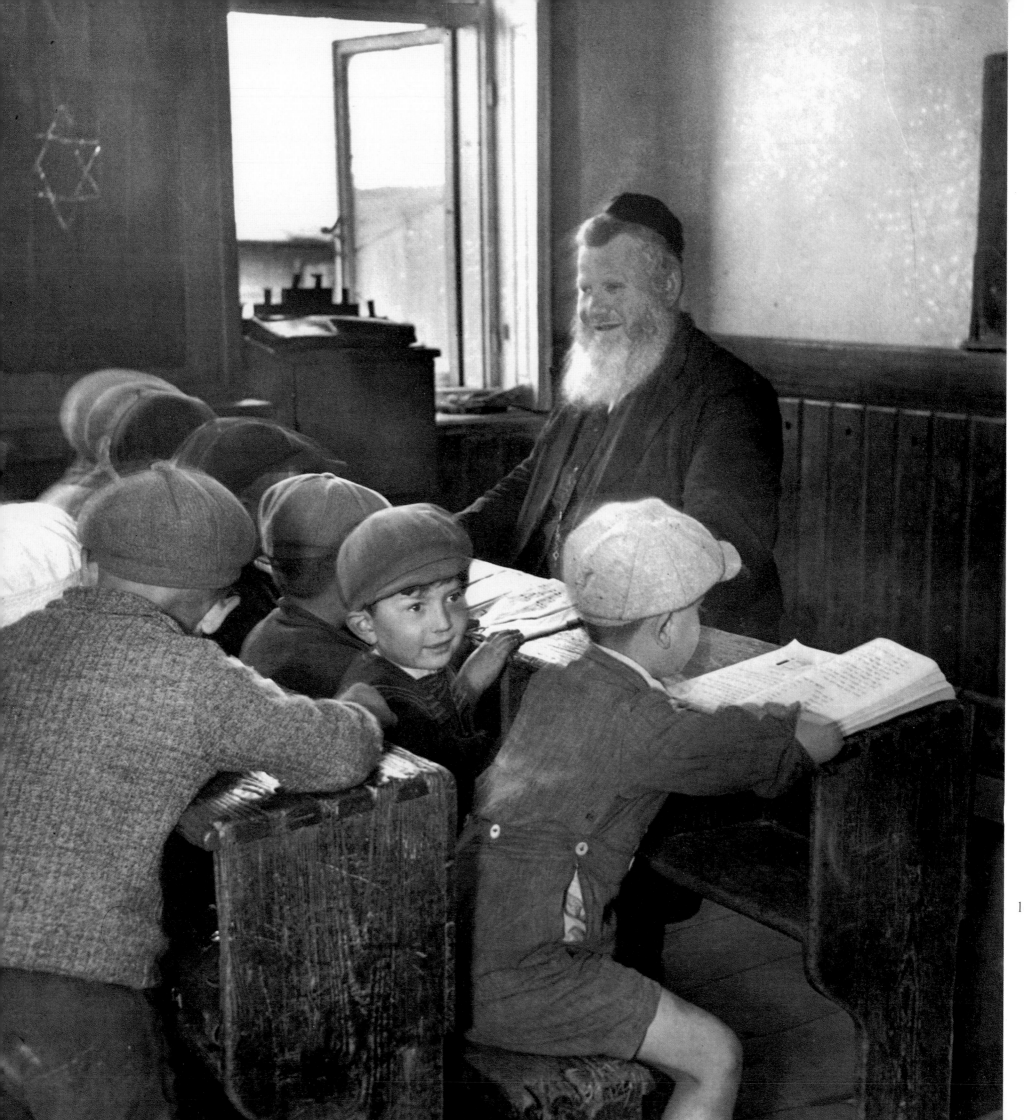

146: The cheder. Slonim, 1938
147: A Jewish boy hiding behind his Russian friend. Slonim, 1938

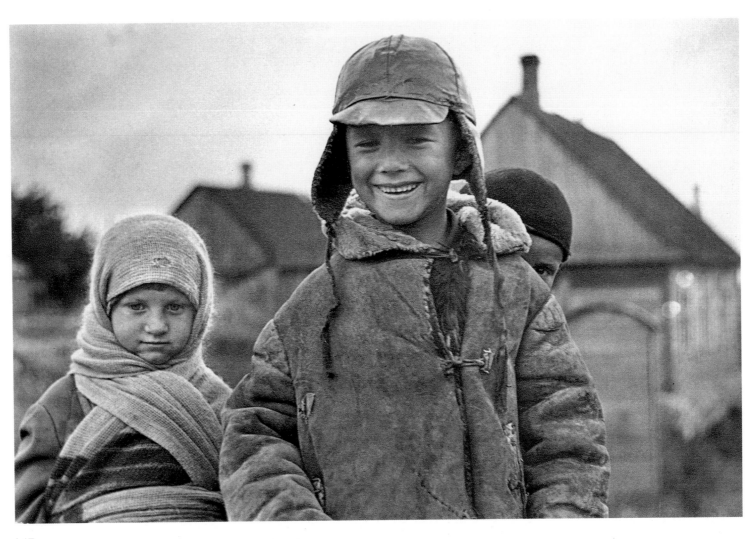

147

148: A country boy. A village in Carpathian Ruthenia, 1936
149: There is no room for her spinning wheel inside her one-room house.
Irshava, a village near Mukachevo, 1935

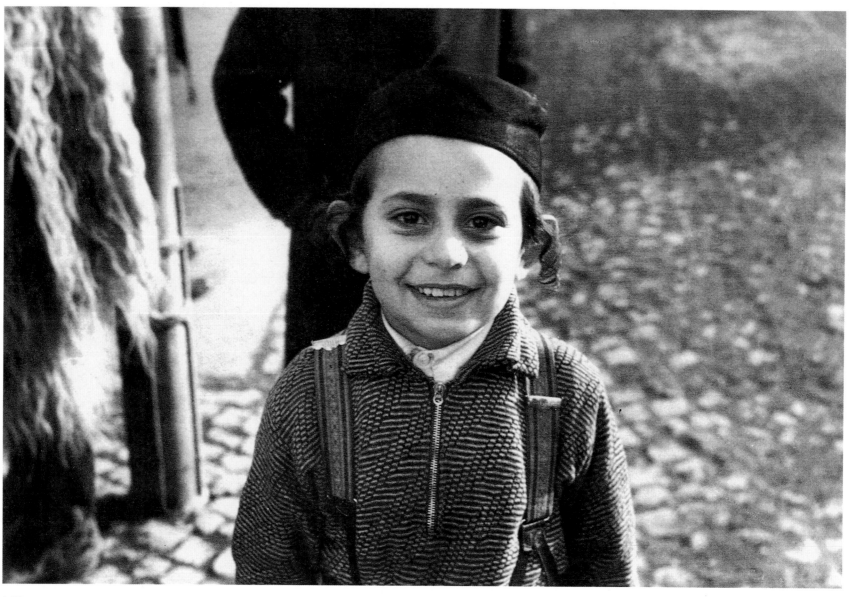

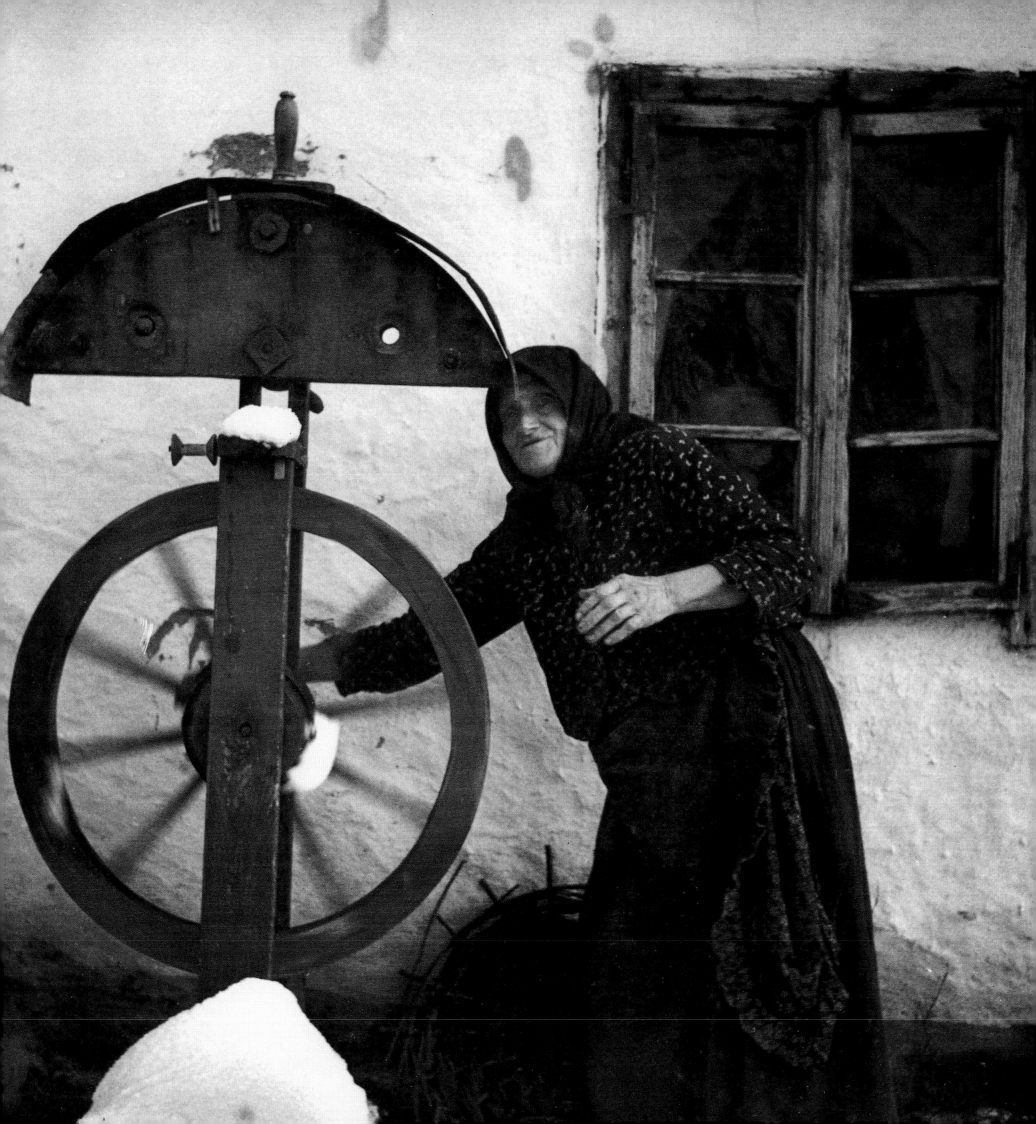

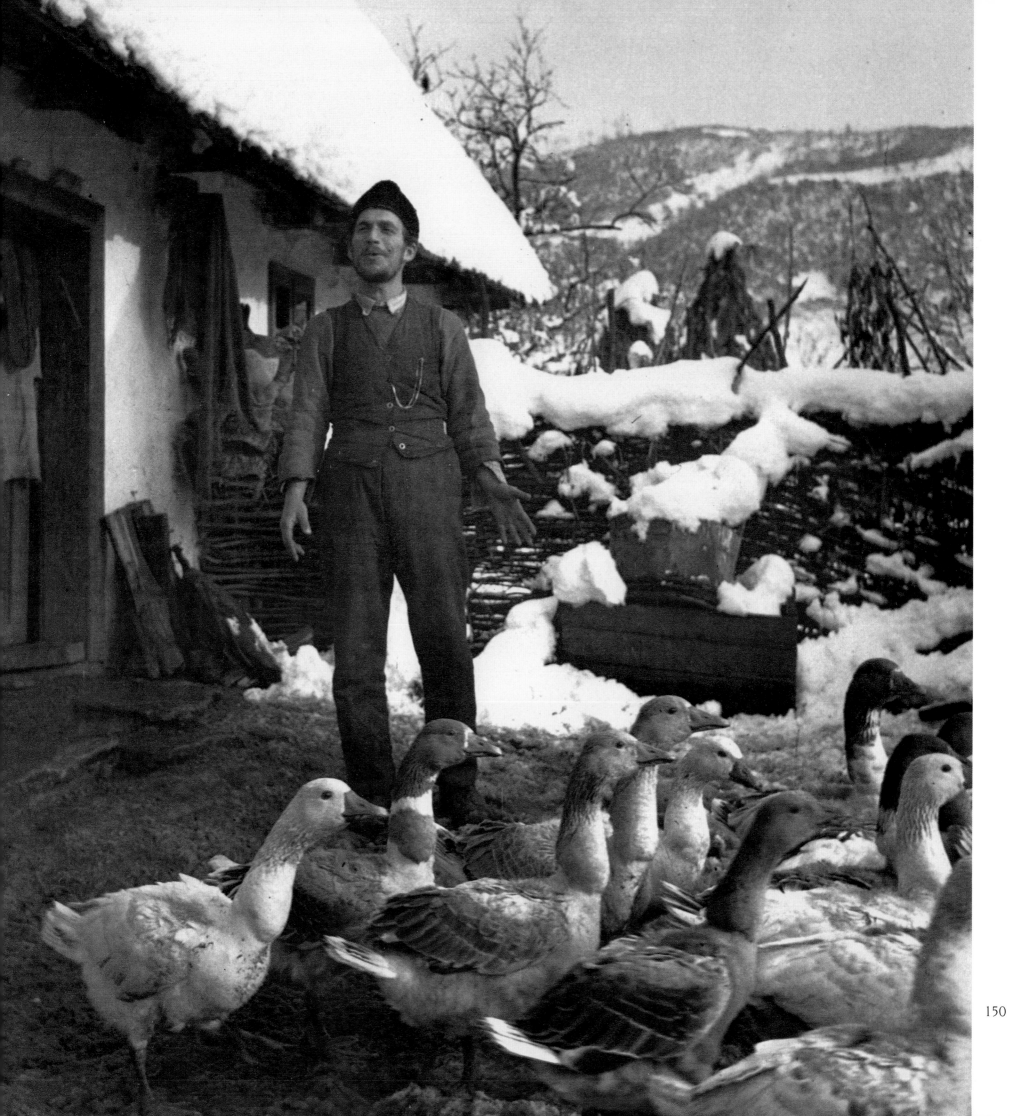

150: Raising geese. Trnava, Czechoslovakia, 1936
151: Trnava, 1936

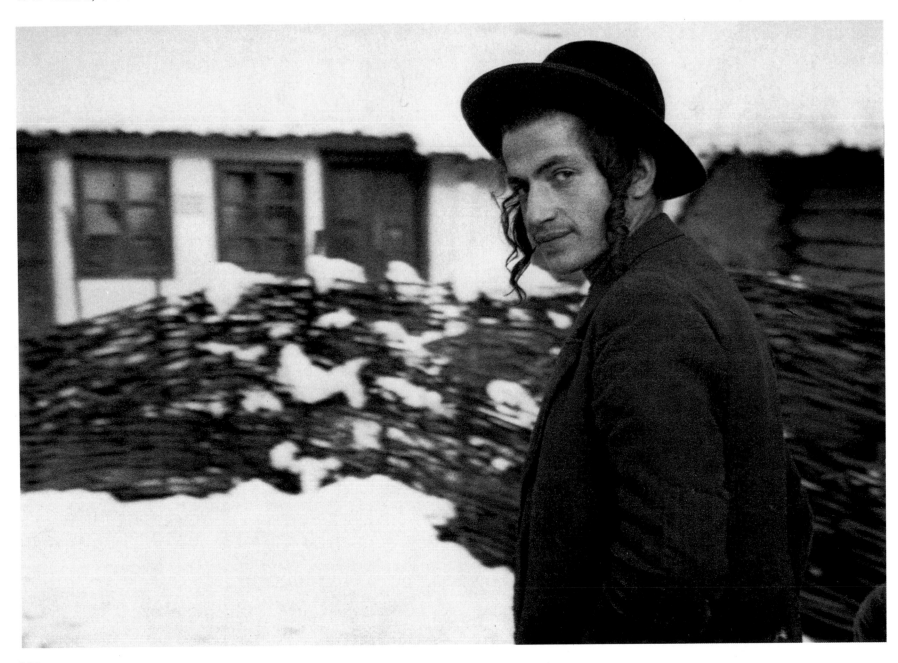

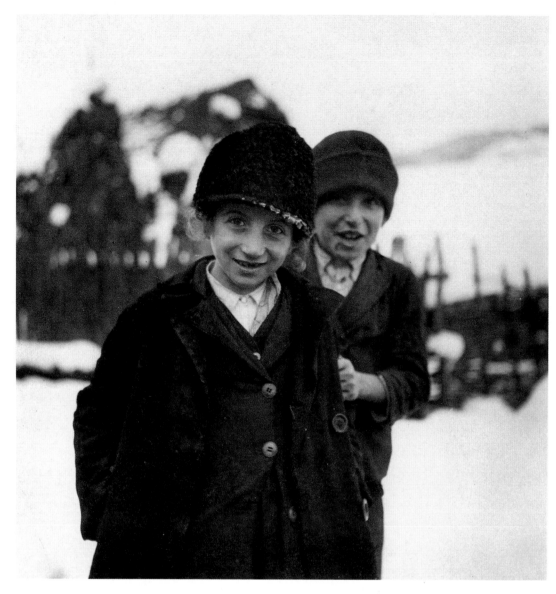

152: Friends. Trnava, 1936
153: The Jewish apple buyer pays cash. Trnava, 1936

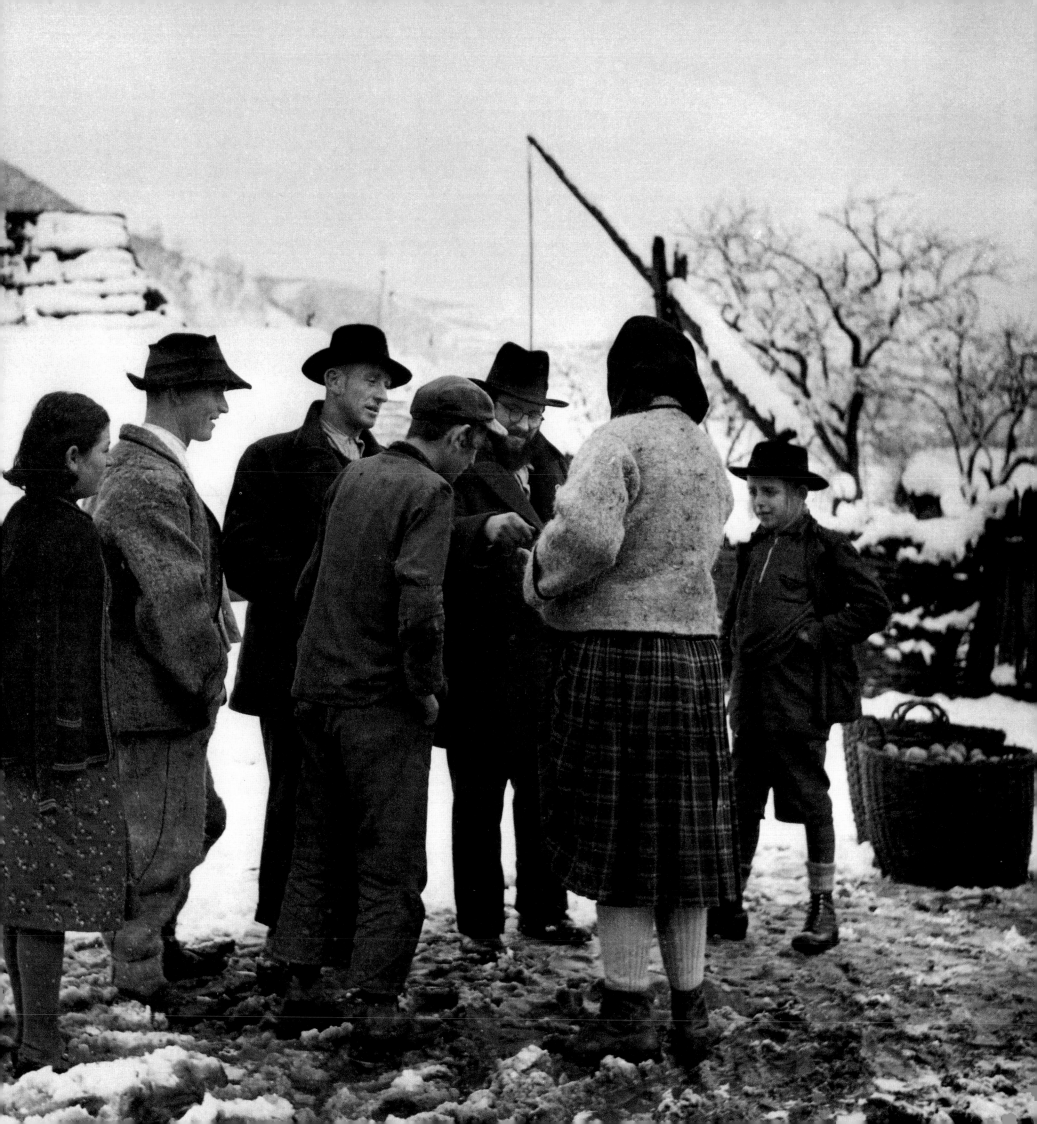

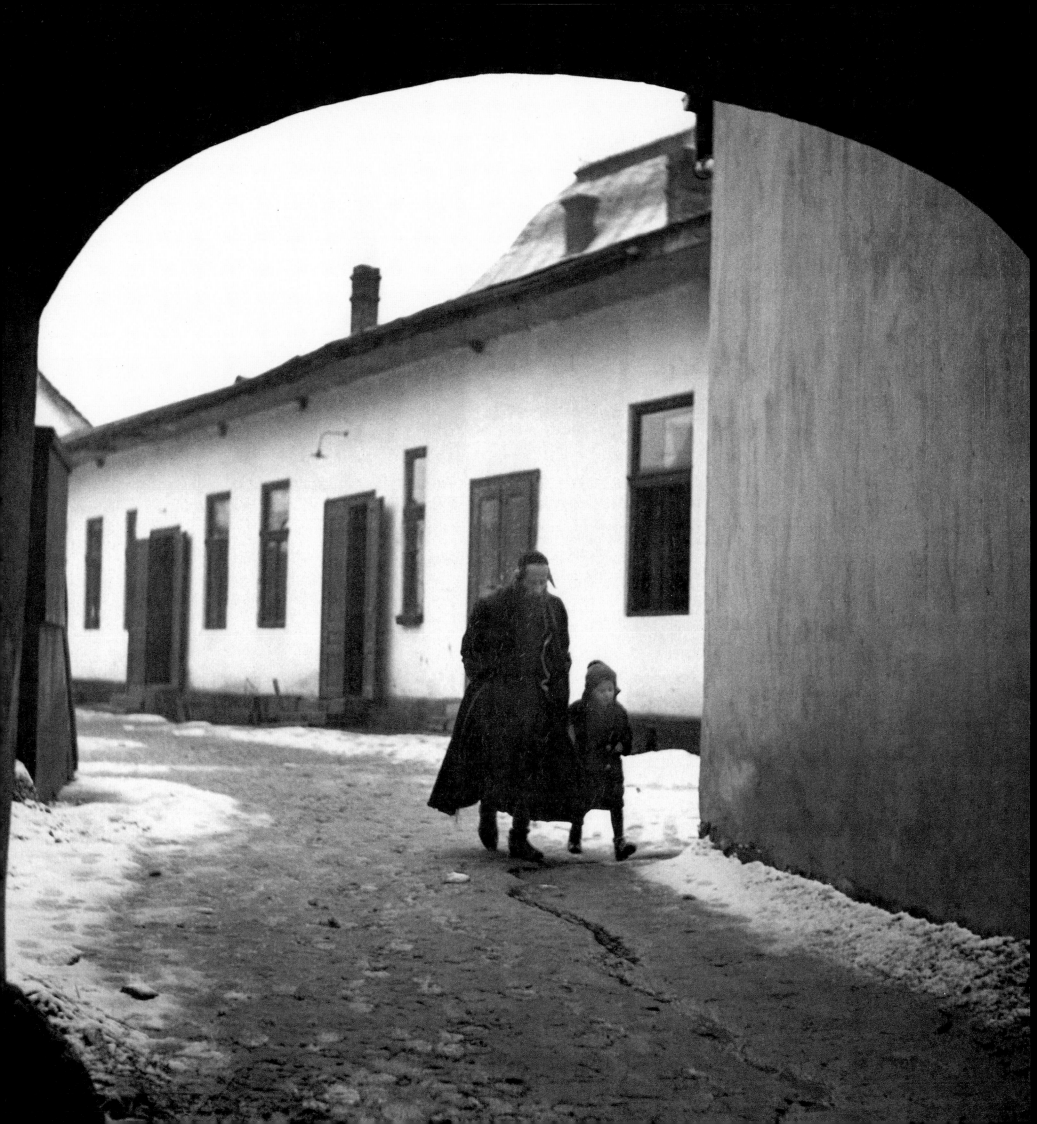

154: On the way to his first day at cheder. Mukachevo, 1938
155: The boy's second day at cheder. He is sitting in the middle. Mukachevo, 1938

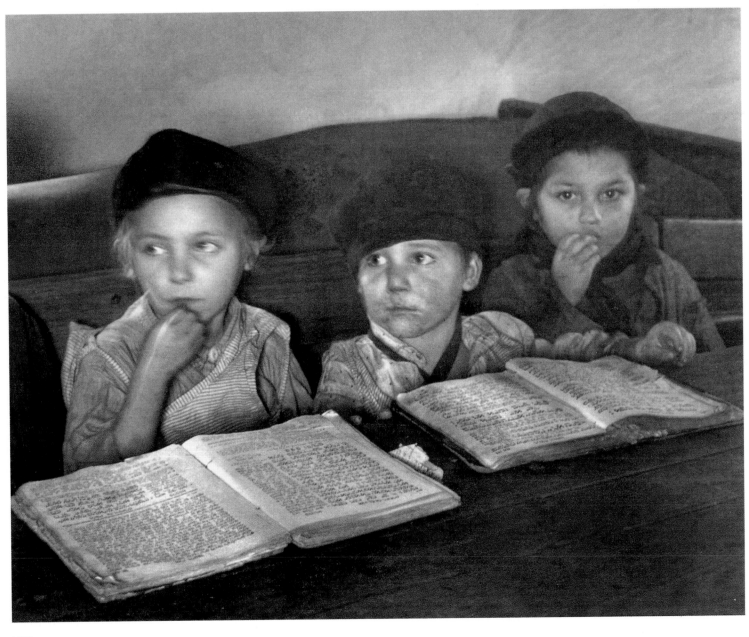

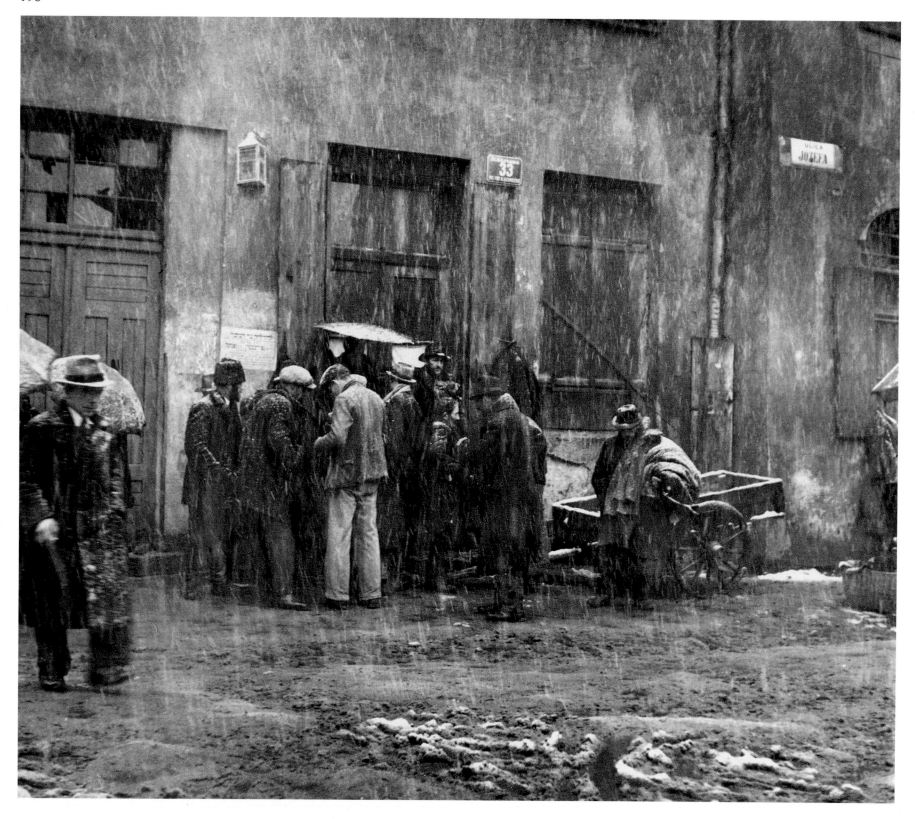

156: The notice on the wall says: *Come Celebrate Chanukah.*
These men are selling old clothes. Kazimierz, Cracow, 1938
157: A street of Kazimierz, Cracow, 1938

158: A square in Kazimierz, Cracow, 1938
159: Isaac Street, Kazimierz, Cracow, 1938

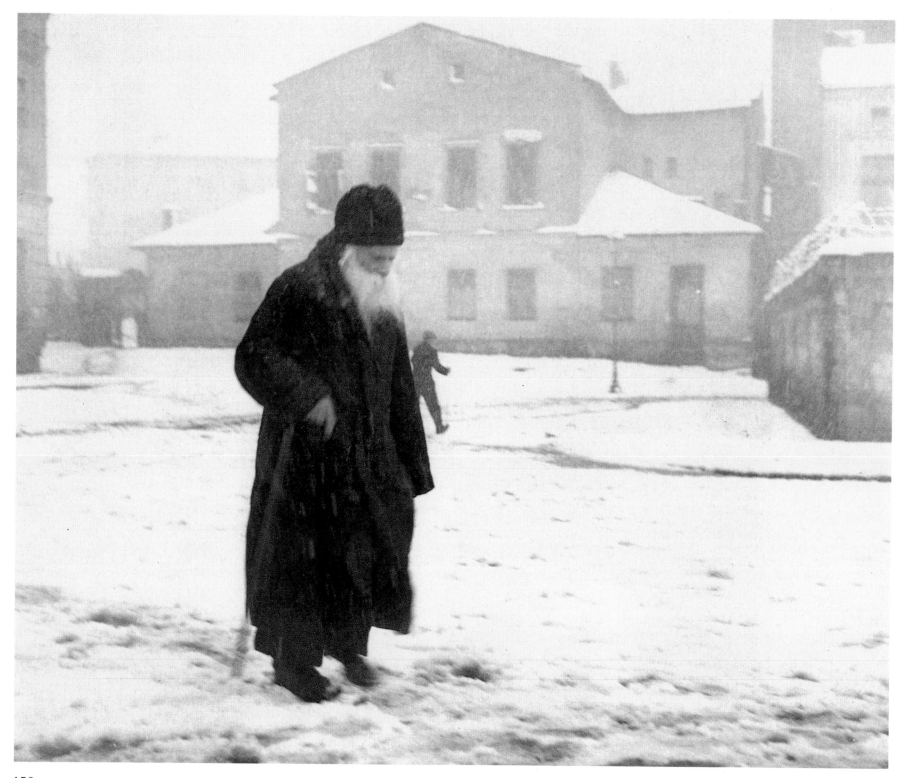

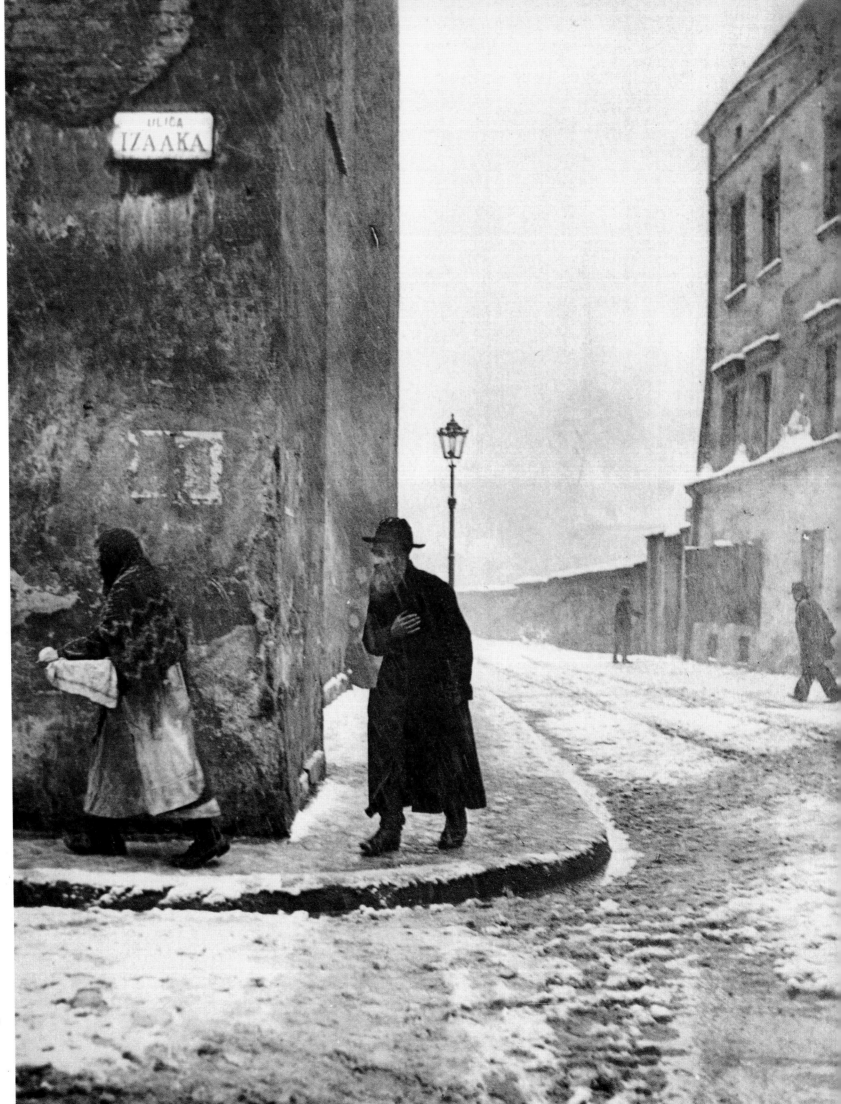

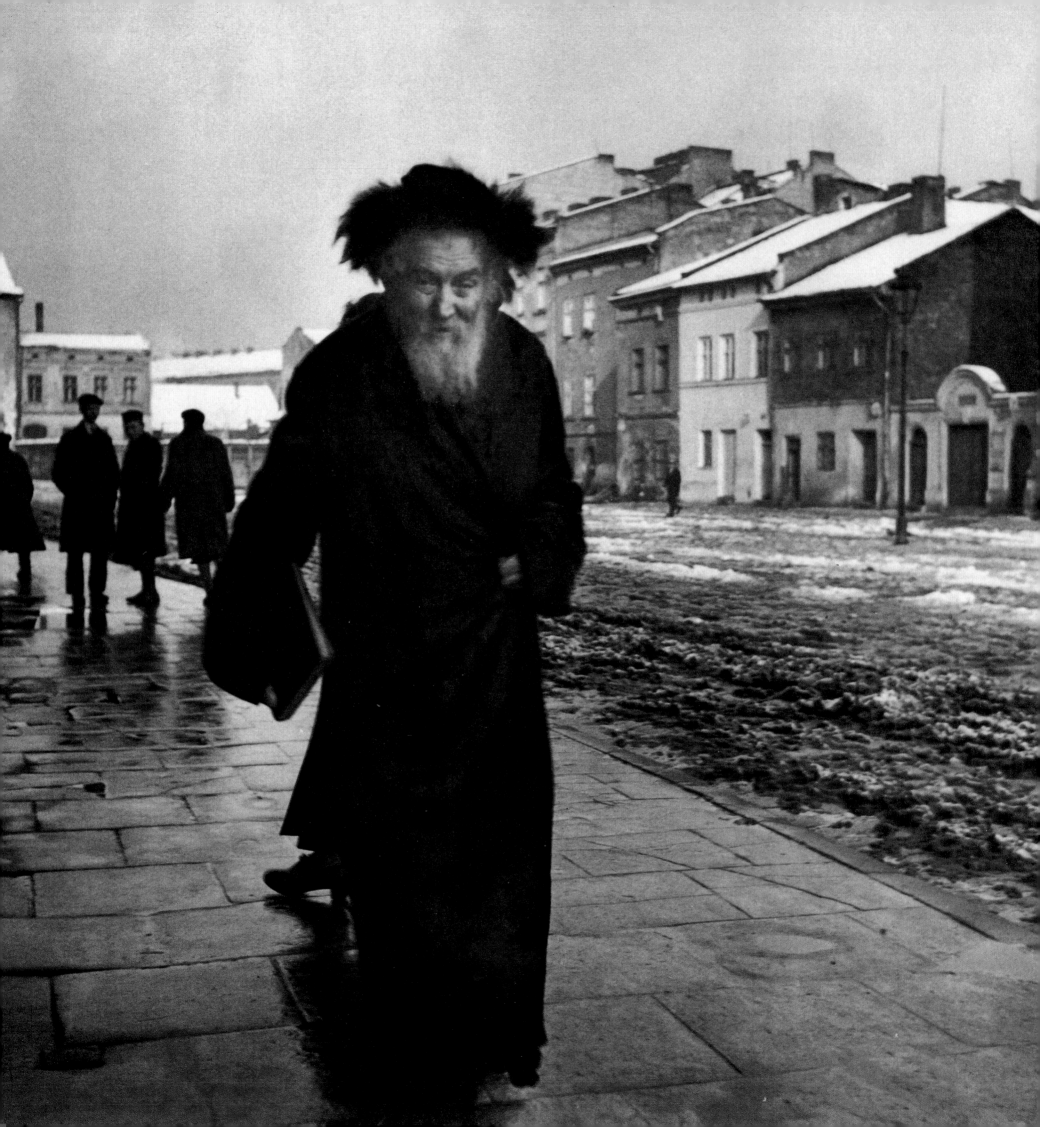

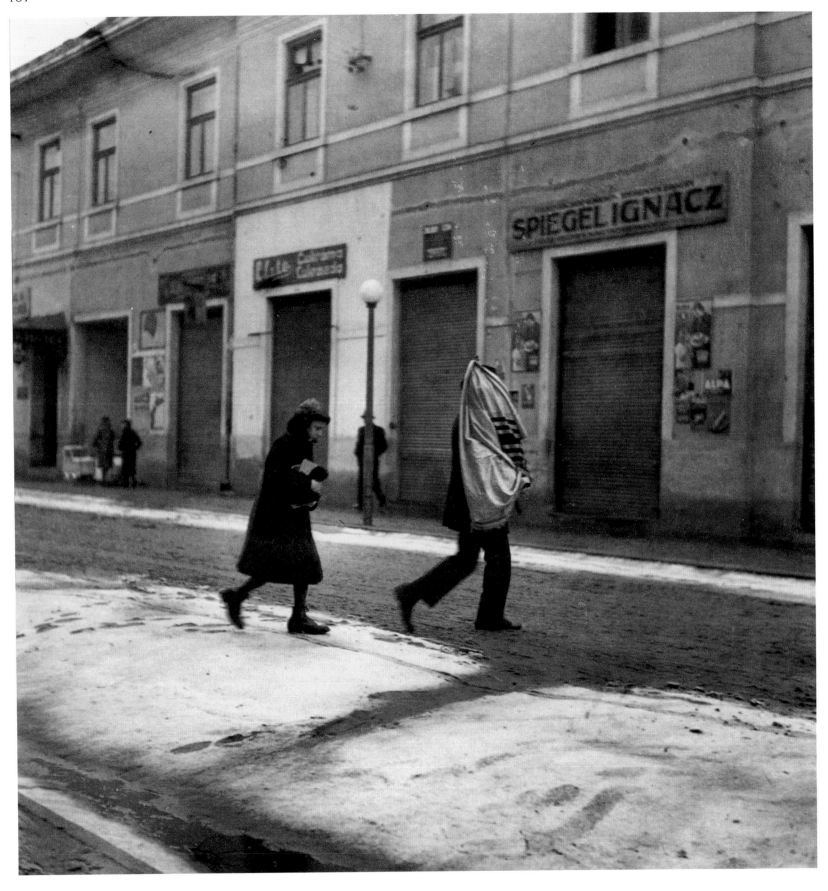

160: A distinguished Talmudist. Kazimierz, Cracow, 1938
161: This Torah is needed by a family that is sitting shivah. Mukachevo, 1937

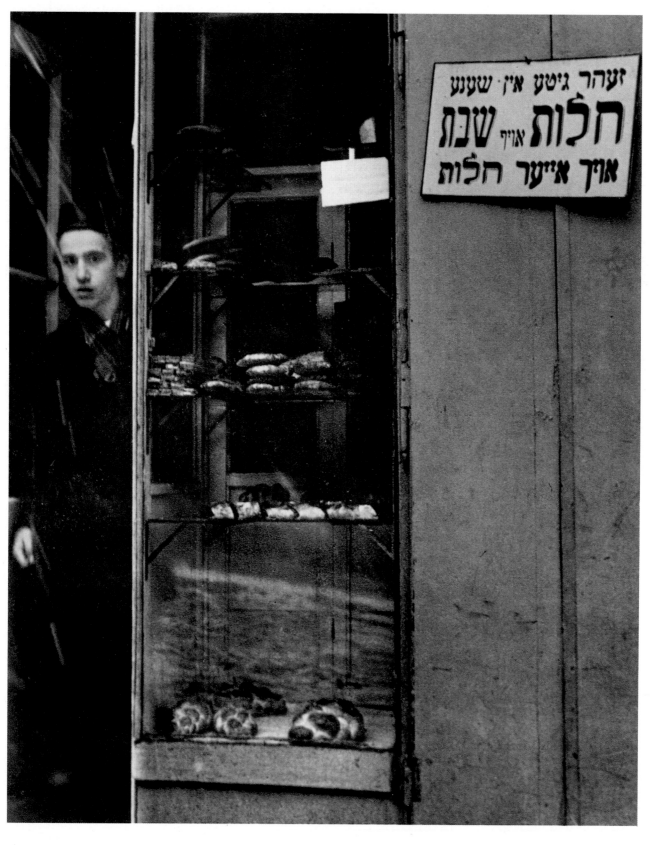

זעהר גיטע אין שעֶנע
חלות אויך שבת
אויך אייער חלות

162: Bakery. Kazimierz, Cracow, 1937. The sign reads:
Very Good and Beautiful Challahs for the Sabbath. Egg Challahs also
163: After morning services on the Sabbath. Kazimierz, Cracow, 1937

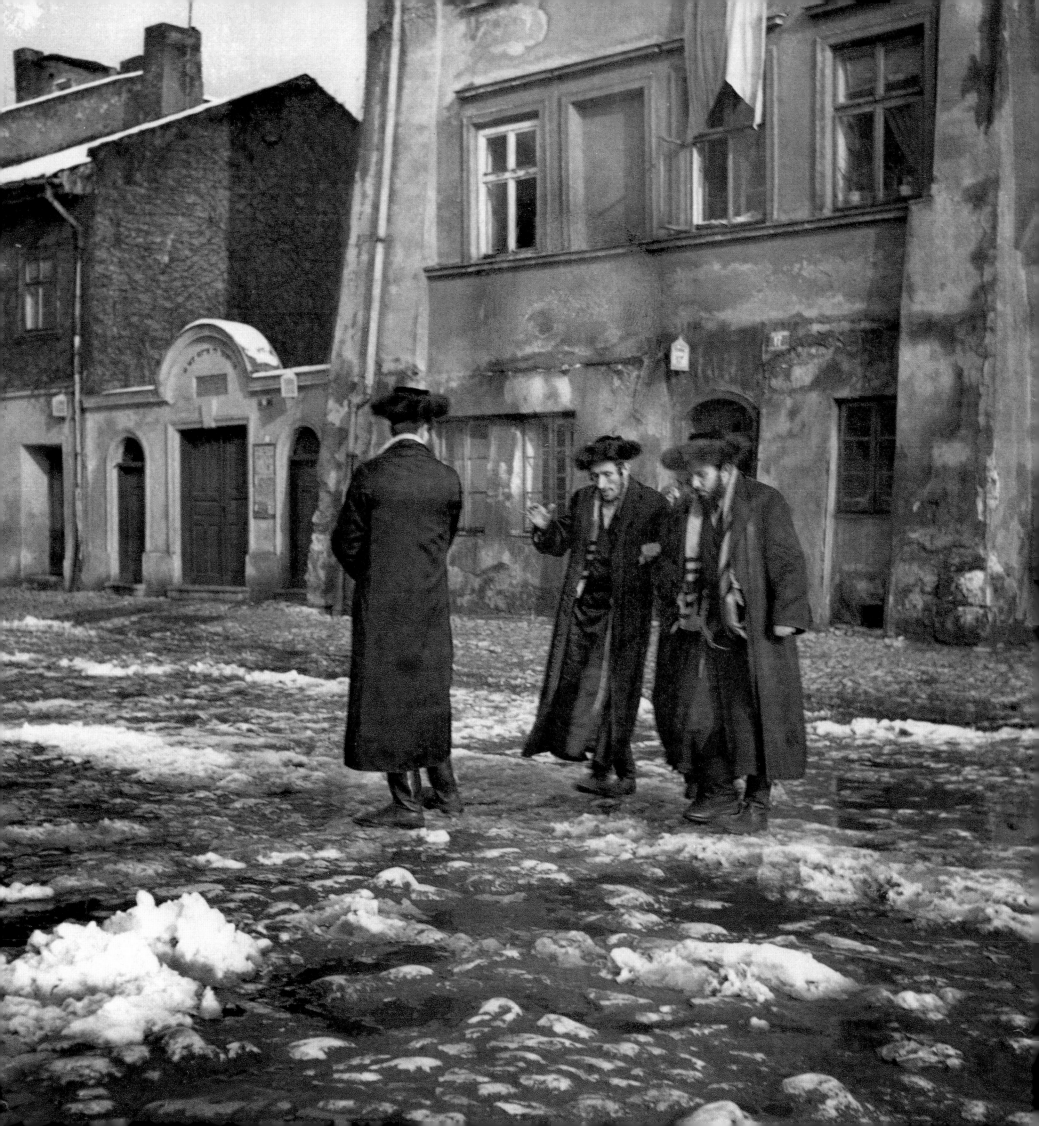

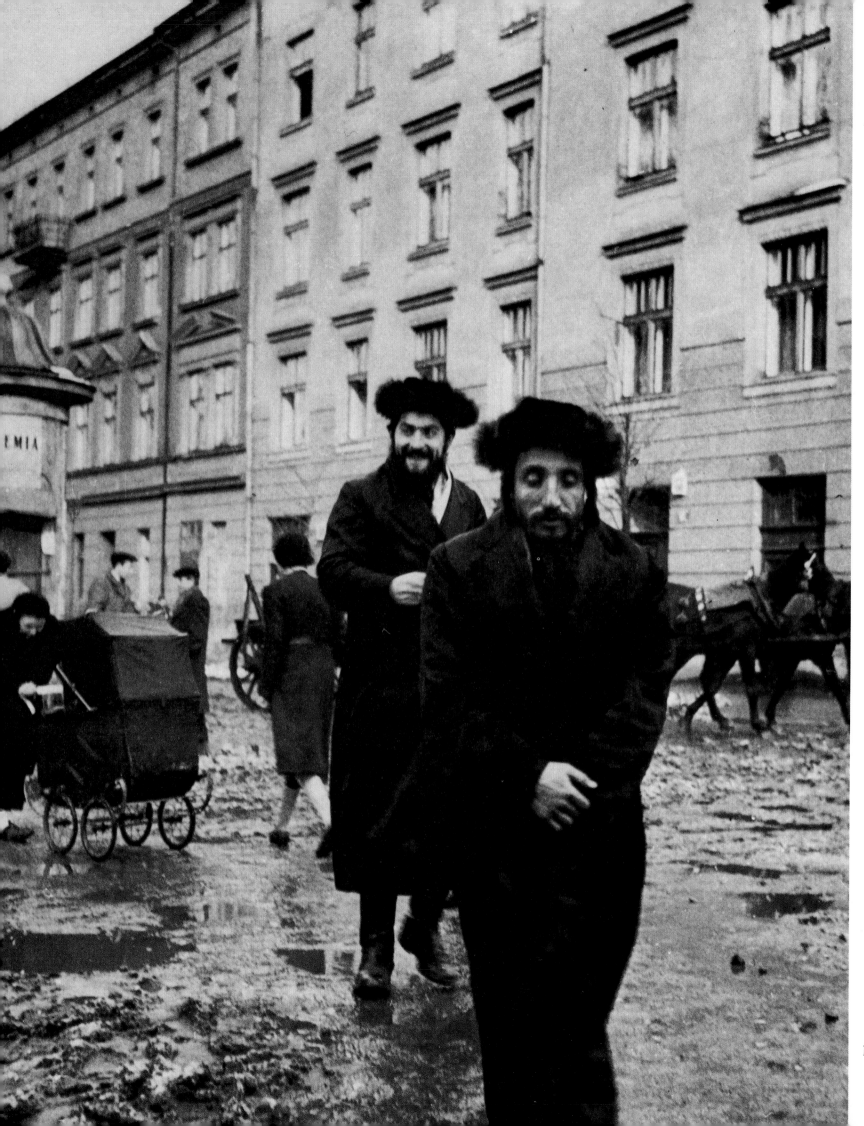

164: Kazimierz, Cracow, 1937
165: The square in front of the synagogue. Mukachevo, 1937

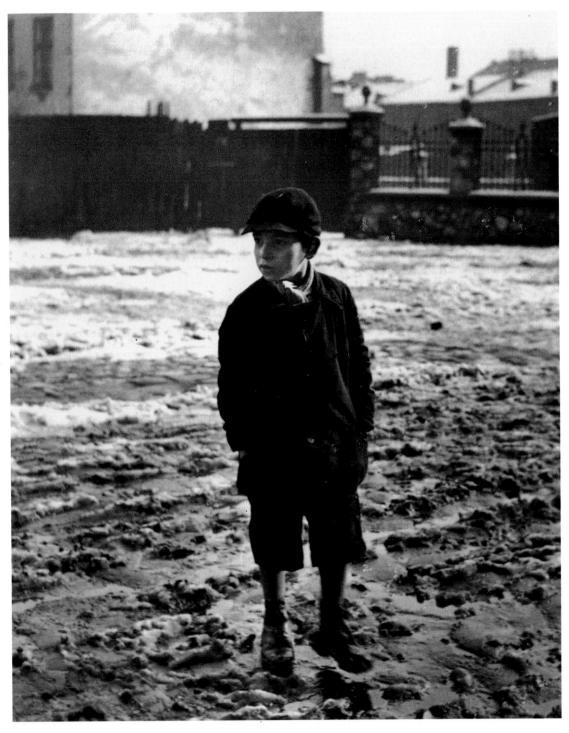

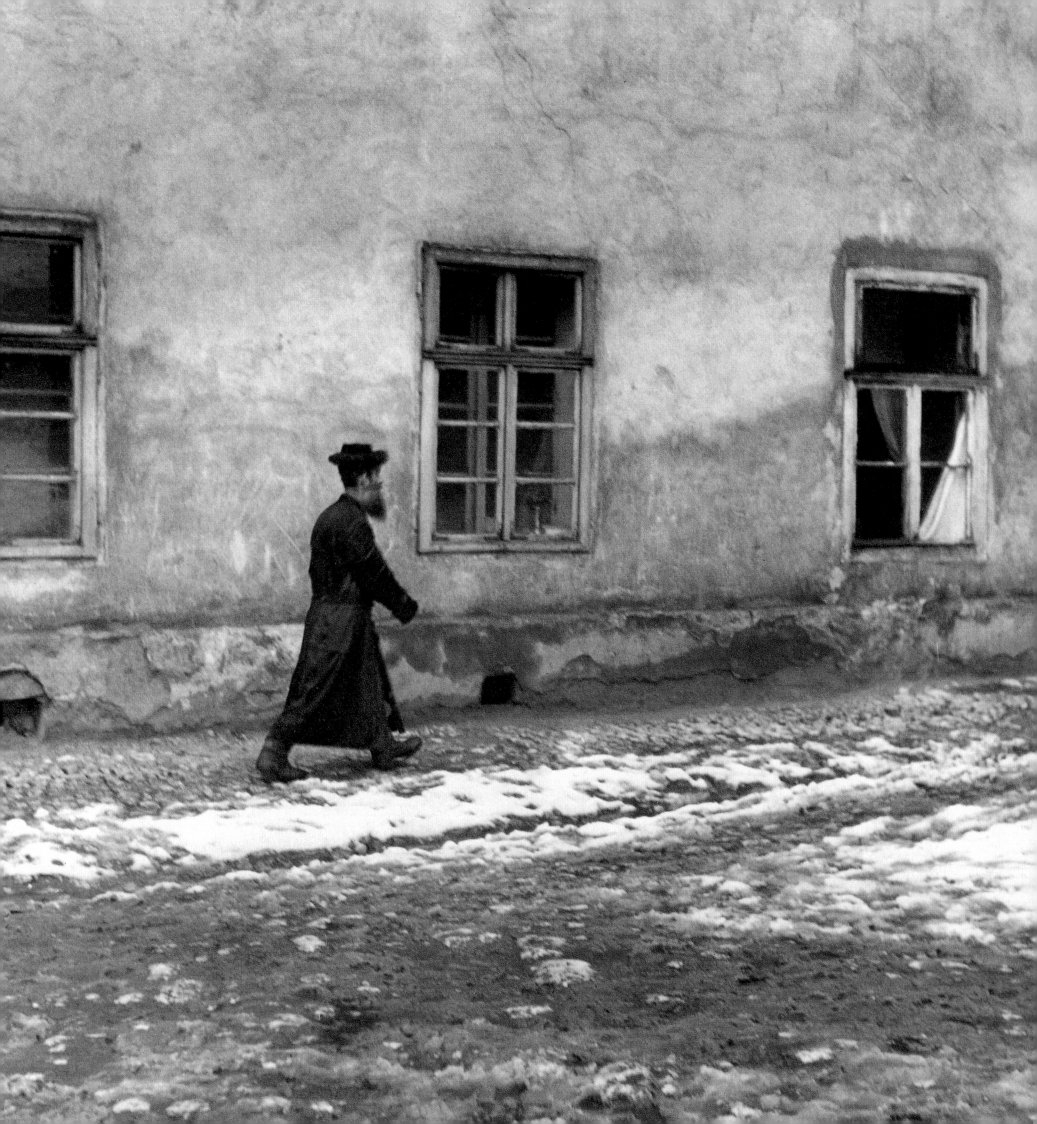

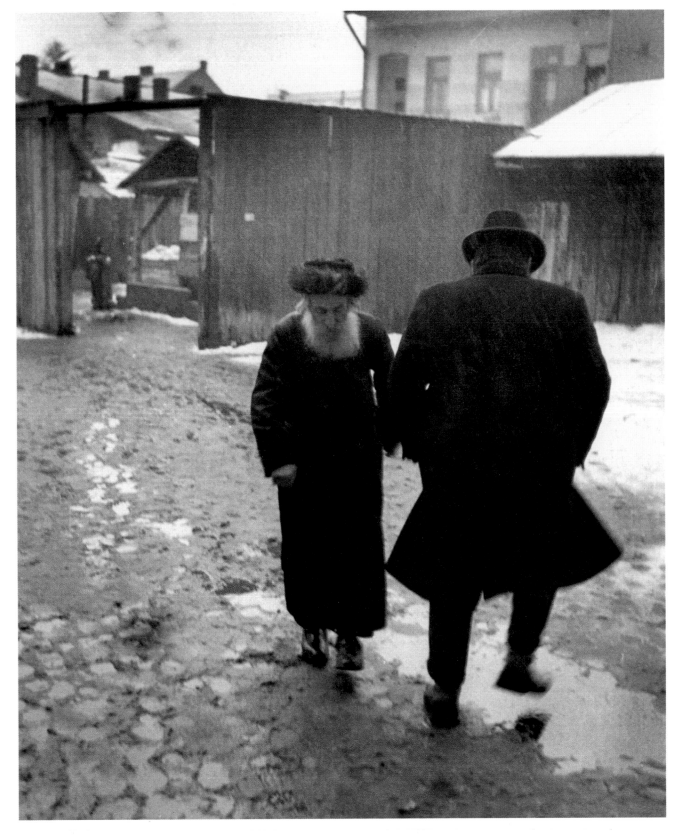

166: Hurrying to hear the tzaddik, the holy man. Mukachevo, 1936
167: A street in Beregovo, 1938

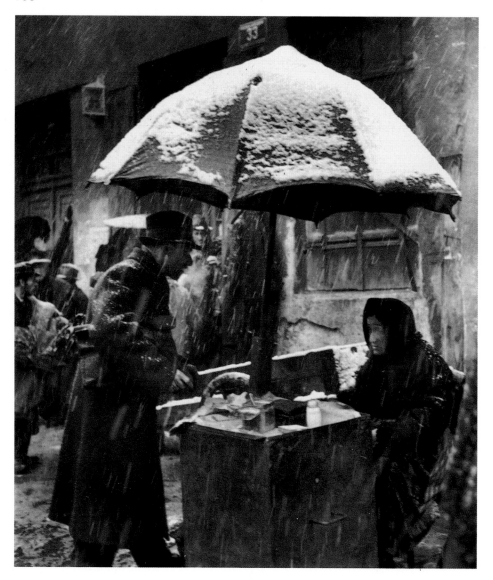

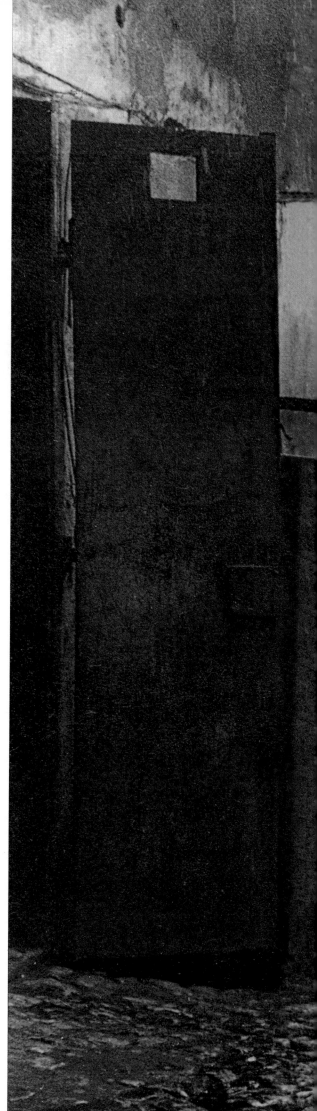

168: The tax collector wants his three zlotys. Kazimierz, Cracow, 1938
169: The entrance to Kazimierz, the old ghetto of Cracow, 1937

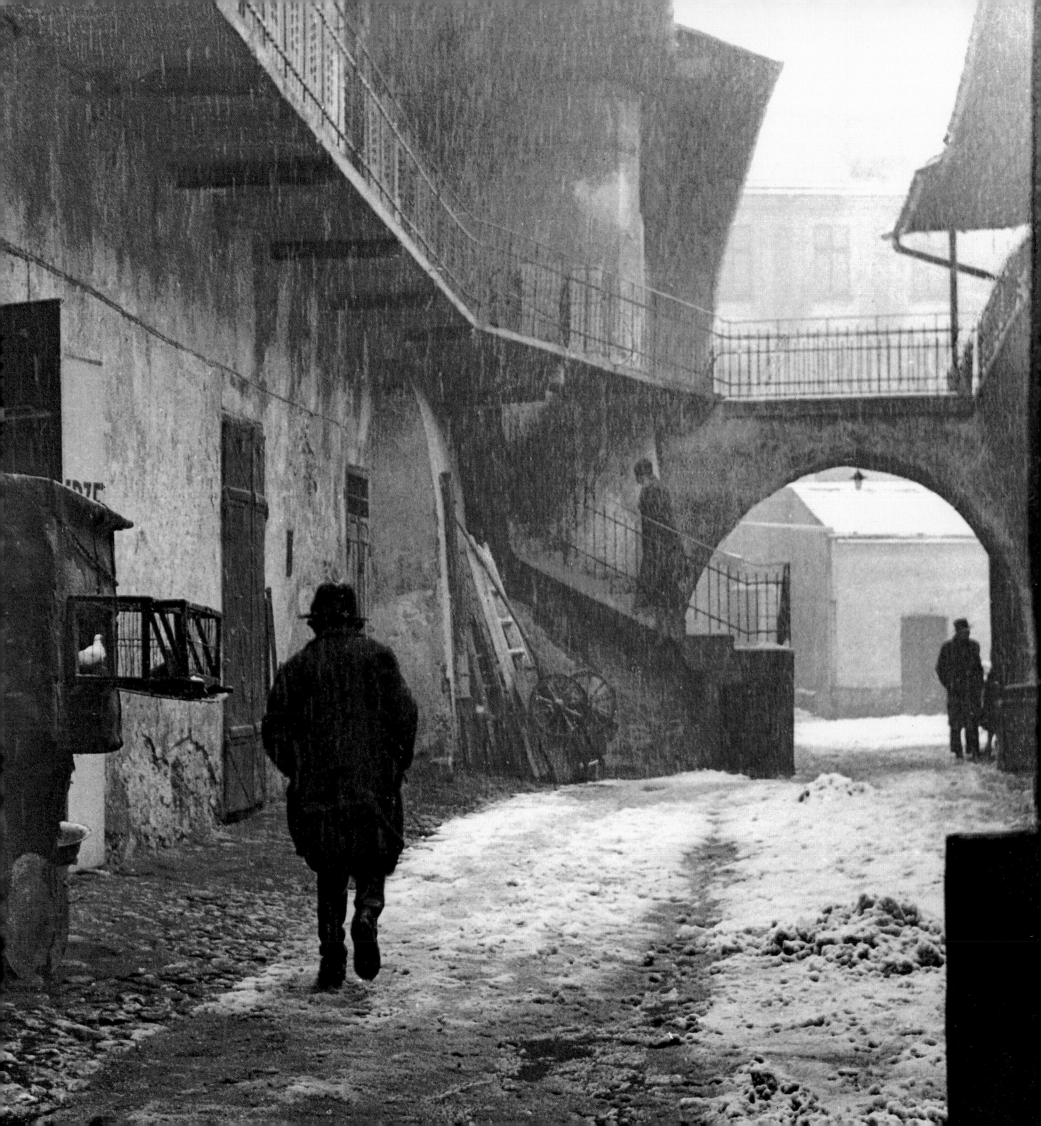

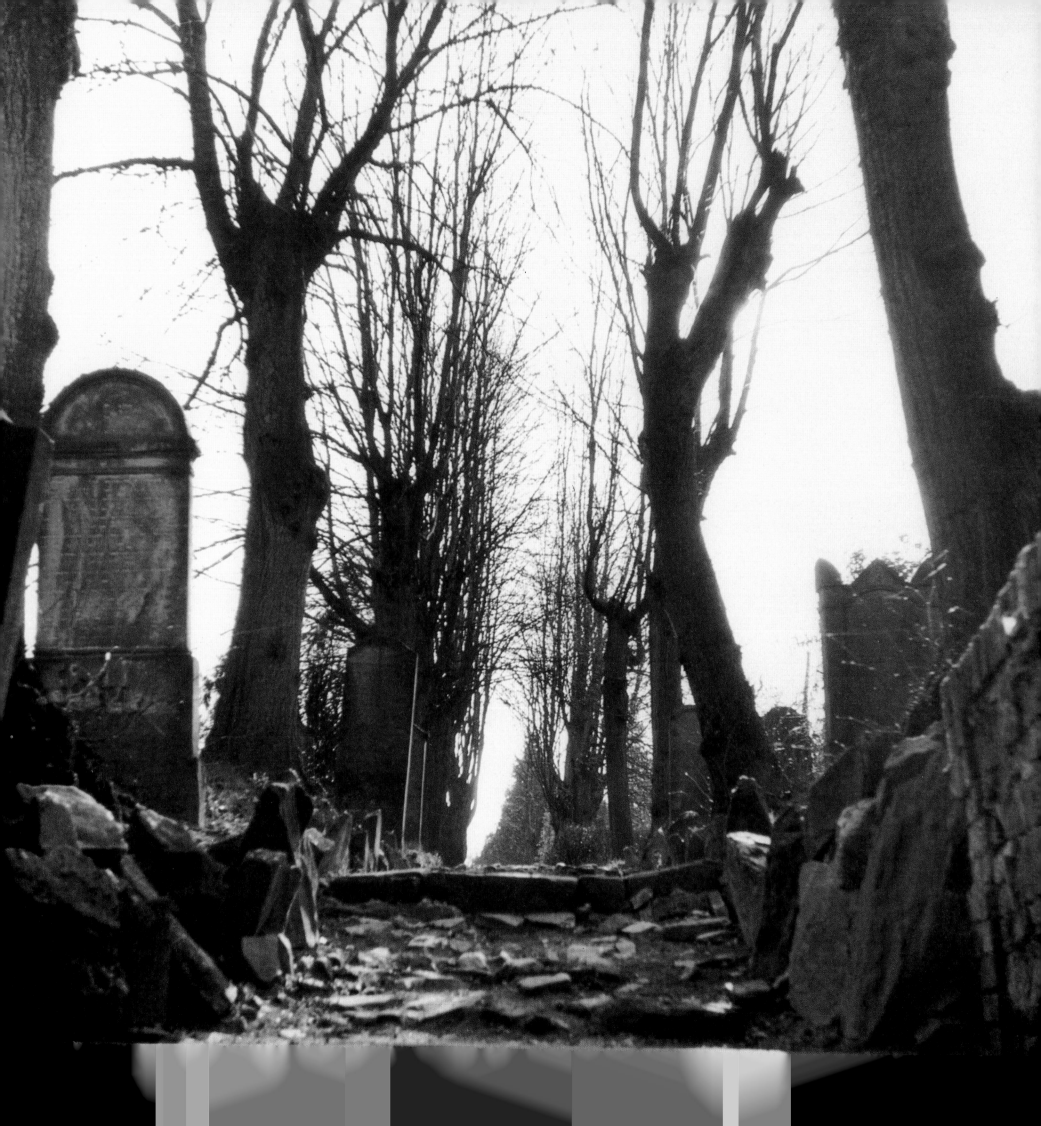

170 and 171: In the old Jewish cemetery of Lublin, 1938

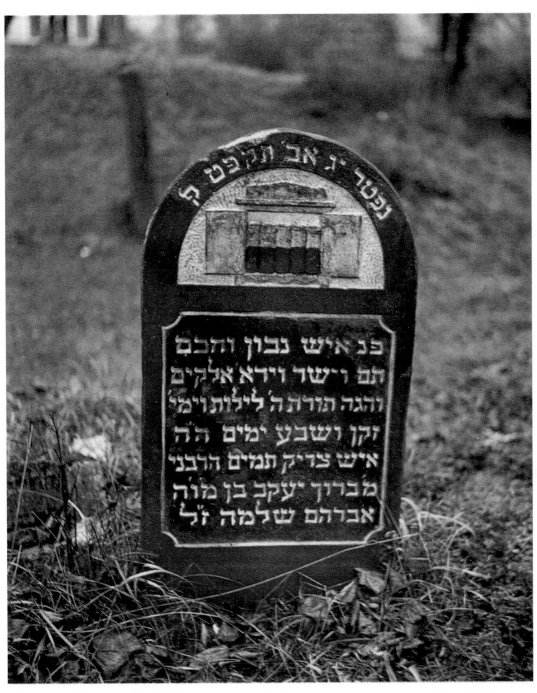

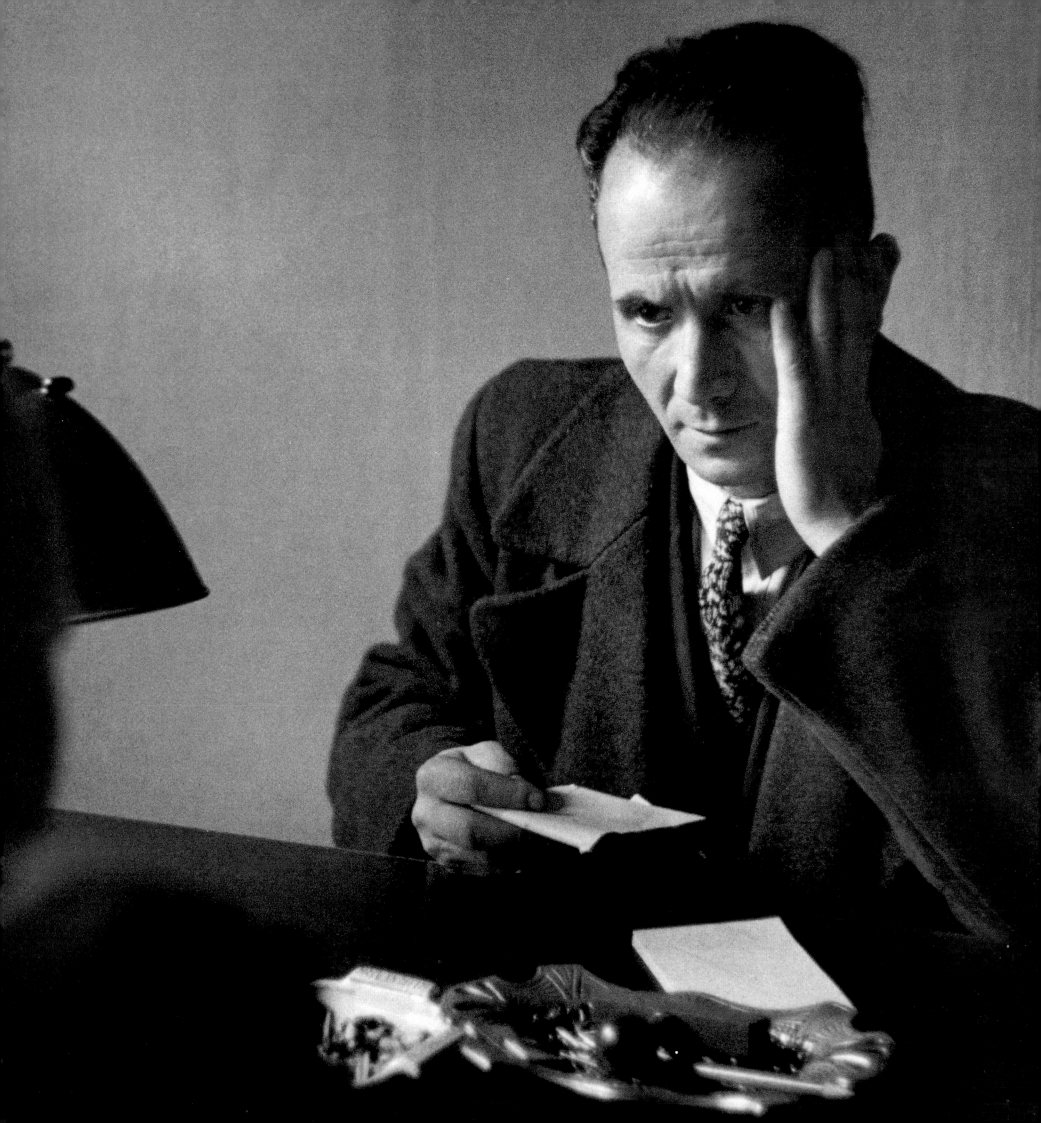

172: At the offices of the Hilfsverein der Deutschen Juden
(Mutual Aid Society for German Jews). Perhaps they can help
him and his family to emigrate. Berlin, 1938
173: Kristallnacht, November 9-10, 1938. Berlin

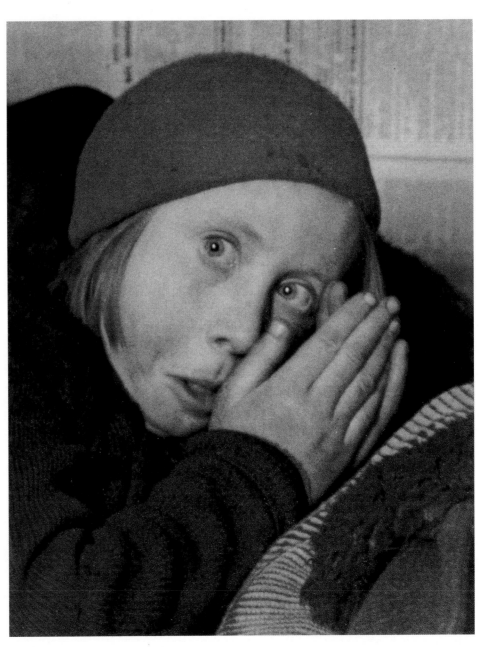

172 173

174: At the end of October 1938, thousands of Polish Jews residing in Germany were forcibly repatriated by the Nazis. They were temporarily housed in military barracks in Zbaszyn, Poland
175: Nettie Stub, eleven years old, from Hanover. Zbaszyn, 1938. Forty-six years later, she found her photograph in the first edition of this book. Today she is Mrs. Siegfried Katz and lives in the Bronx, New York

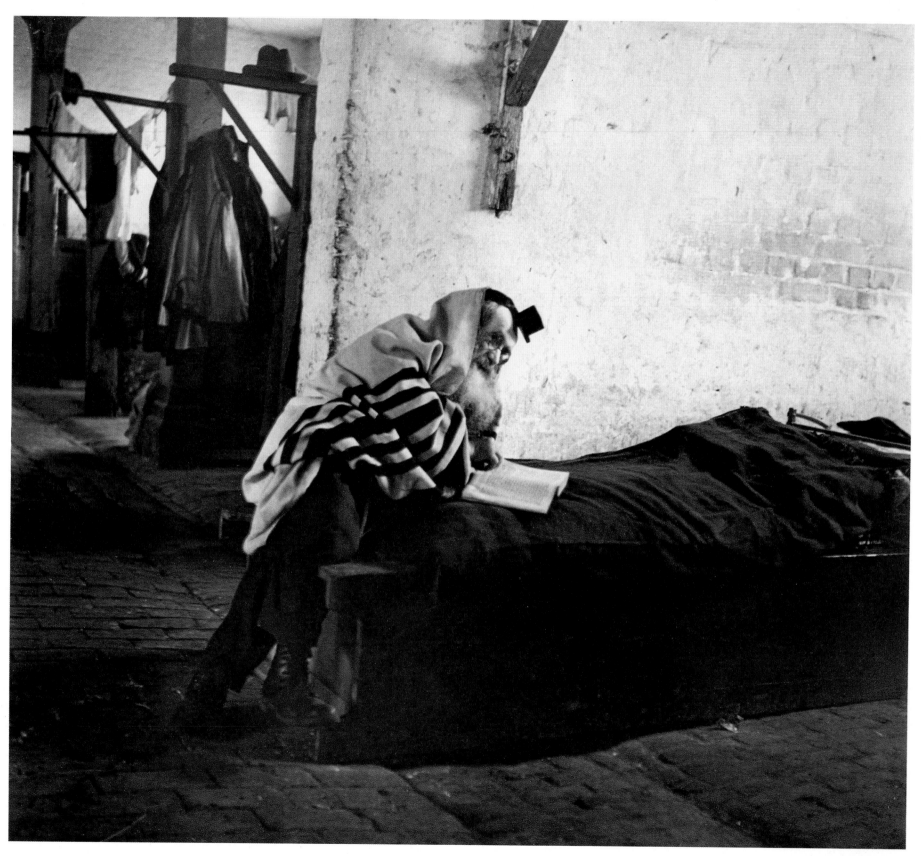

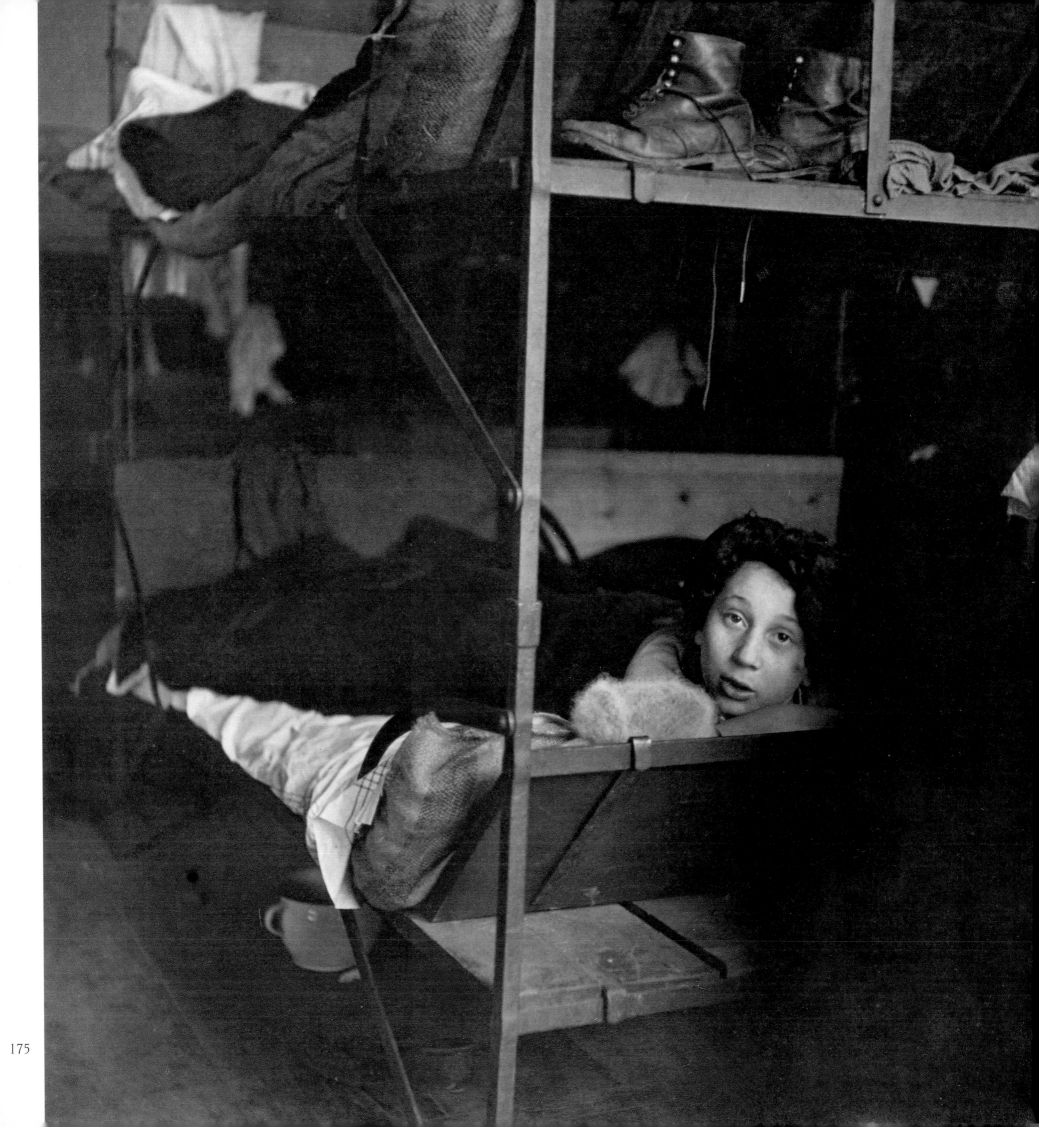

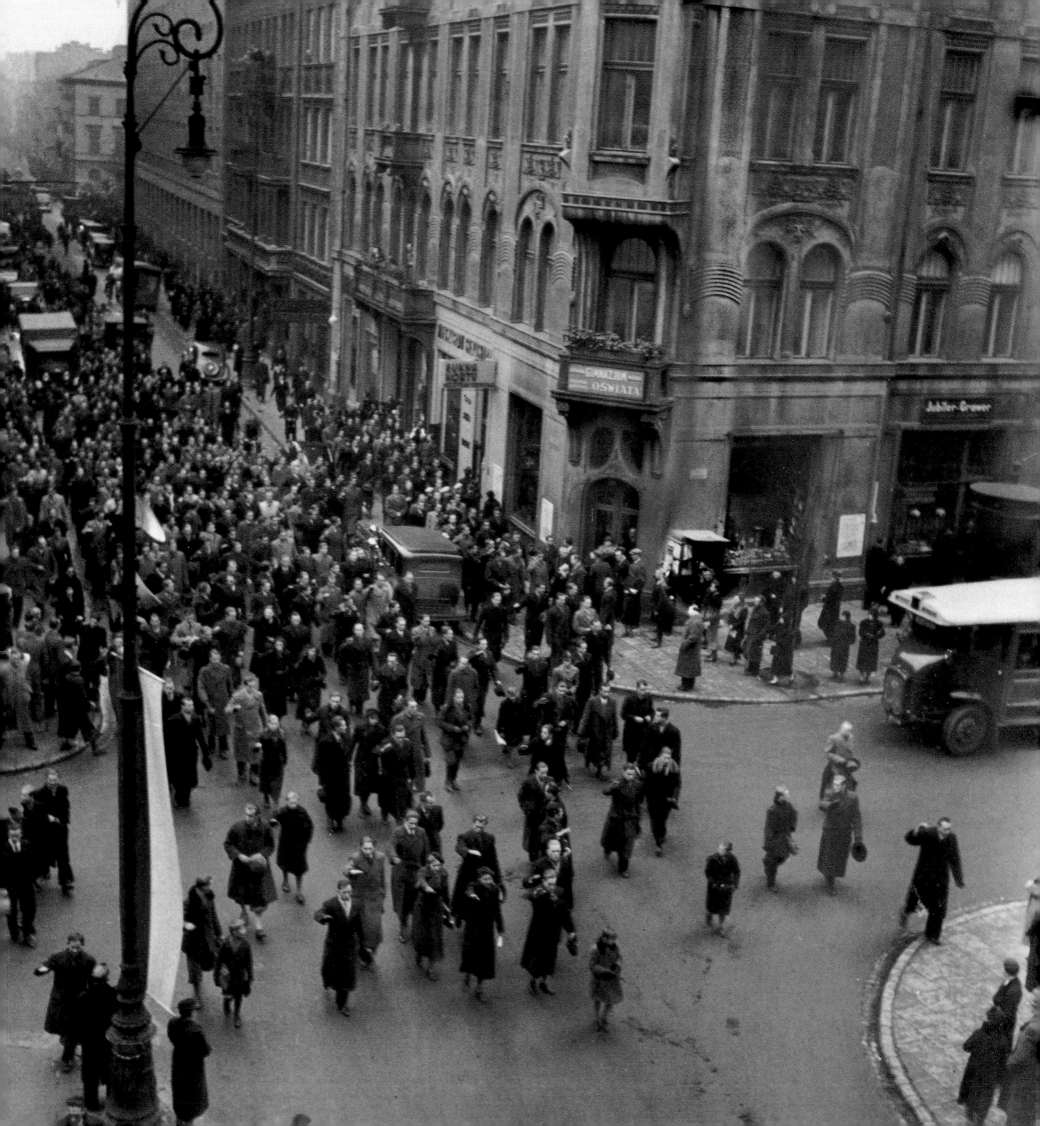

176: An anti-Semitic demonstration by members of Poland's
National Democratic Party (Narodowa Demokracja, known as Endecja).
Some of them are giving the Nazi salute. Warsaw, 1938
177: Softening stale bread. Vienna, after the Anschluss, 1938

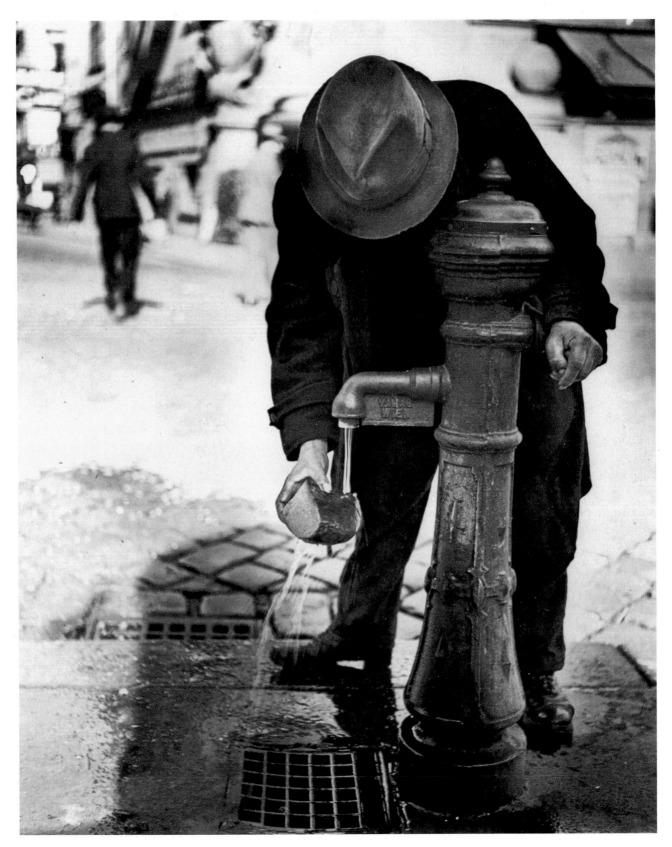

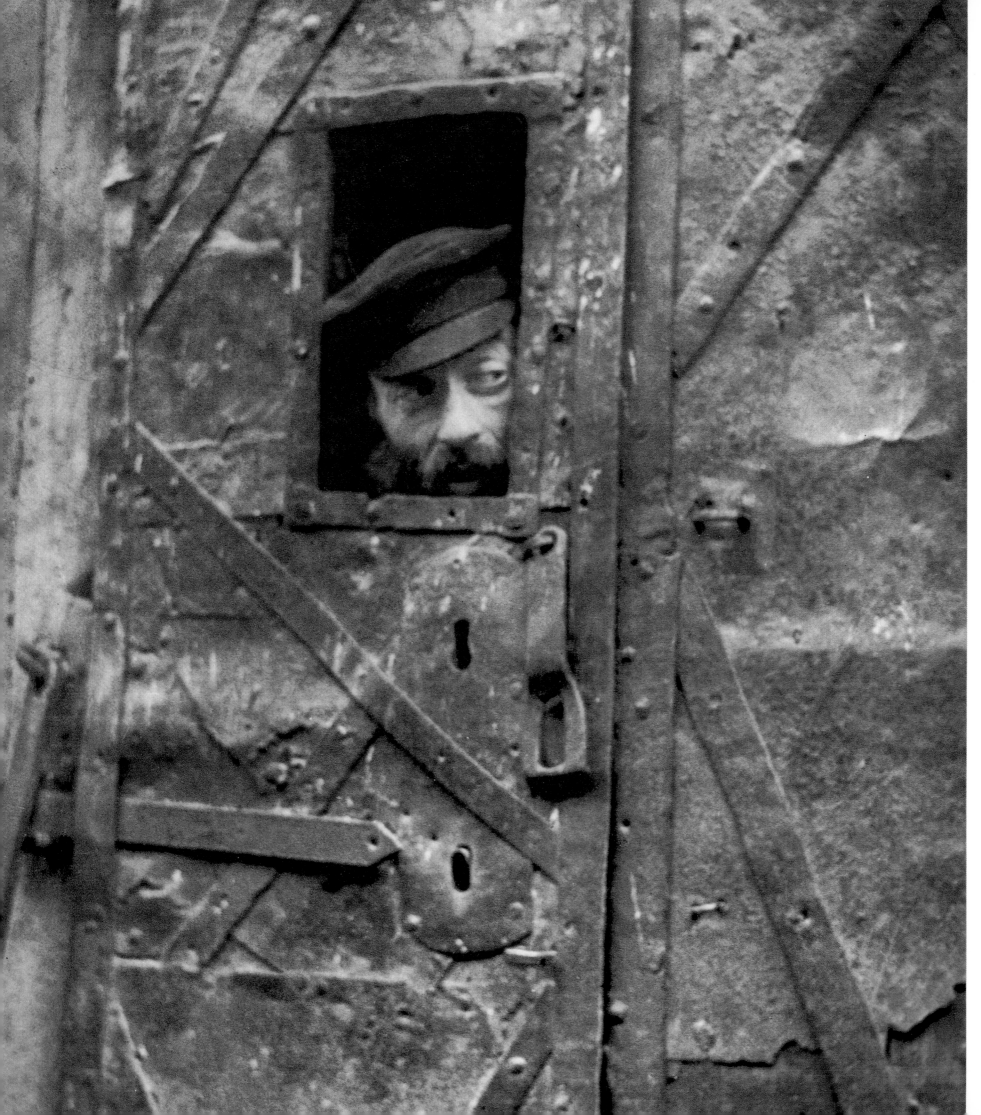

178 and 179:
The father is hiding from the Endecy
(members of the National Democratic Party).
His son signals him that they are approaching.
Warsaw, 1938